T0339493

Building Better Arts Facilities

At the turn of the twenty-first century, a significant boom in the construction of cultural buildings saw the creation of hundreds of performing arts centers, theaters, and museums. After these buildings were completed, however, many of these cultural organizations struggled to survive, or, alternatively, drifted off mission as the construction project forced monetary or other considerations to be prioritized. *Building Better Arts Facilities: Lessons from a U.S. National Study* examines the ways in which organizations planned and managed building projects during this boom and investigates organizational operations after projects were completed.

By integrating quantitative data with case-study evidence, the authors identify the differences between the ways some organizations were able to successfully meet the challenges of a large construction project and others that were not. With empirical evidence and analysis, this book highlights better practices for managing and leading cultural building ventures. Readers of this book—be they arts managers, politicians, board members, city planners, foundation executives, or philanthropists—will find that the book provides valuable perspective and insight about building cultural facilities, and that reading it will serve to make building projects go more smoothly in the future.

Joanna Woronkowicz is an assistant professor in the School of Public and Environmental Affairs at Indiana University, USA. Her work focuses on facility development and investment for nonprofit and public organizations. She received her PhD in public policy from the University of Chicago.

D. Carroll Joynes cofounded the Cultural Policy Center and served as executive director for its first 10 years and is a lecturer and research fellow at the Harris School of Public Policy Studies, University of Chicago, USA. He received his PhD in European history from the University of Chicago in 1981.

Norman M. Bradburn is the Tiffany and Margaret Blake Distinguished Service Professor Emeritus on the faculties of the University of Chicago's Harris School of Public Policy, Department of Psychology, Booth School of Business and the College, and a senior fellow at NORC at the University of Chicago, USA. He is the coproject director for the Humanities Indicators at the American Academy of Arts and Sciences (www.humanitiesindicators.org).

Routledge Research in Creative and Cultural Industries Management

Edited by Ruth Rentschler

Routledge Research in Creative and Cultural Industries Management provides a forum for the publication of original research in cultural and creative industries, from a management perspective. It reflects the multiple and inter-disciplinary forms of cultural and creative industries and the expanding roles which they perform in an increasing number of countries.

As the discipline expands, there is a pressing a need to disseminate academic research, and this series provides a platform to publish this research, setting the agenda of cultural and creative industries from a managerial perspective, as an academic discipline.

The aim is to chart developments in contemporary cultural and creative industries thinking around the world, with a view to shaping future agendas reflecting the expanding significance of the cultural and creative industries in a globalized world.

Published titles in this series include:

1 **Arts Governance**
People, Passion, Performance
Ruth Rentschler

2 **Building Better Arts Facilities**
Lessons from a U.S. National Study
Joanna Woronkowicz, D. Carroll Joynes, and Norman M. Bradburn

3 **Arts and Commerce**
The Colonization of No Man's Land
Edited by Peter Zackariasson & Elena Raviola

4 **Artistic Interventions in Organizations**
Research, Theory and Practice
Edited by Ulla Johannson Sköldberg, Jill Woodilla and Ariane Berthoin Antal

5 **Rethinking strategy for Creative Industries**
Innovation and Interaction
Milan Todorovic with Ali Bakir

6 **Arts and Business**
Building a Common Ground for Understanding Society
Edited by Elena Raviola and Peter Zackariasson

Building Better Arts Facilities
Lessons from a U.S. National Study

Joanna Woronkowicz,
D. Carroll Joynes, and
Norman M. Bradburn

 Routledge
Taylor & Francis Group

NEW YORK AND LONDON

First published 2015
by Routledge
711 Third Avenue, New York, NY 10017

and by Routledge
2 Park Square, Milton Park, Abingdon, Oxfordshire OX14 4RN

*Routledge is an imprint of the Taylor and Francis Group,
an informa business*

First issued in paperback 2015

© 2015 Taylor & Francis

The right of Joanna Woronkowicz, D. Carroll Joynes, and Norman M. Bradburn
to be identified as author of this work has been asserted by them in accordance
with sections 77 and 78 of the Copyright, Designs and Patents Act 1988.

All rights reserved. No part of this book may be reprinted or reproduced or
utilised in any form or by any electronic, mechanical, or other means, now
known or hereafter invented, including photocopying and recording, or in any
information storage or retrieval system, without permission in writing from the
publishers.

Trademark Notice: Product or corporate names may be trademarks or registered
trademarks, and are used only for identification and explanation without intent to
infringe.

Library of Congress Cataloging-in-Publication Data
Woronkowicz, Joanna.
 Building better arts facilities : lessons from a U.S. national study / by Joanna
Woronkowicz, Caroll Joynes, Norman Bradburn. — First Edition.
 pages cm. — (Routledge research in creative and cultural industries
management ; 2)
 Includes bibliographical references and index.
 1. Centers for the performing arts—United States. 2. Arts facilities—United
States. I. Joynes, Caroll. II. Bradburn, Norman M. III. Title.
 NA6880.5.U6.W67 2015
 725'.830973—dc23
 2014031788

ISBN 978-1-138-81996-2 (hbk)
ISBN 978-1-138-12579-7 (pbk)
ISBN 978-1-315-74405-6 (ebk)

Typeset in Sabon
by Apex CoVantage, LLC

Contents

Figures

Tables

Acknowledgments

This research project was launched as a result of a series of informal discussions with Peter Linett, a nationally known consultant in the arts and education sectors. Based on his experiences out in the field, and that of several of his colleagues across the country, indications that there might be a significant overinvestment in bricks and mortar by cultural organizations were starting to appear, and they believed this was cause for concern about the health of the sector as a whole. Peter Linett, Adrian Ellis, Alan Brown, and Duncan Webb all provided valuable insights into the scale, the seriousness, and the possible implications of this surge in building. Equally influential, Russell Willis Taylor, former president and CEO of National Arts Strategies, has from the outset been an inspiration, a thoughtful interlocutor, a source of excellent ideas about how to disseminate our findings, and a source of encouragement and humor when it was most needed.

The Andrew W. Mellon Foundation provided substantial support at the beginning of this project, and later assisted by funding some additional research that we needed to do in order to write this book. Staff members Susan Feder and Diane Ragsdale were both pivotal in ensuring that this project came to a successful completion. The Mellon Foundation has done remarkable work over the years in sponsoring inquiry and research into the arts and culture sector, and we are deeply appreciative that they so generously assisted us on this large, complex, and time-consuming project. We also received generous support from the Kresge Foundation and the John D. and Catharine T. MacArthur Foundation. Two convenings held at the Pocantico Conference Center as the project took shape, and then again in the task of determining the implications of what we found, were turning points in the evolution of this book. Being guests at Pocantico—thanks to the generosity of the Rockefeller Brothers Fund—was both an enormous help and a great pleasure for all who participated. Without it, the project would not have proceeded as smoothly as it did. We want to thank in particular the then-director Charles Granquist and Judy Clark, who currently serves as director.

Betty Farrell and Will Anderson at the Cultural Policy Center at the University of Chicago's Harris School of Public Policy have provided us with help at every stage, including careful reading of various versions of the chapters. And NORC at the University of Chicago, with several members of its able staff, continue to help us with many of the logistics of the study. The rigorous way in which they do this gives us, and the many people we interviewed, confidence about how the information collected would be handled and kept secure.

We also want to express our appreciation to the research team for the precursor to this book, Set in Stone, which, in addition to ourselves, included Rob Gertner (University of Chicago), Peter Frumkin (University of Pennsylvania), Anastasia Kolendo, and Bruce Seaman (Georgia State University). We also want to thank our research assistant, Sonju Park, who did an enormous amount of work early in the project.

Without the cooperation of the many staff members, trustees, and others involved in each of the projects featured in this book, this study would not have been possible. They gave generously of their time, and their insights, and they could not have been more helpful. Building facilities of this scale and complexity are not for the faint of heart; it requires stamina, determination, and patience, among many other characteristics. We were impressed at how candid people were both about the hurdles they encountered, and at how generous they were in talking to us so that we could help those who build in the future learn from the experiences their predecessors went through. (All of the key individuals we interviewed at the institutions featured in this volume are mentioned individually in the various chapters.)

Preparation of the manuscript received careful attention from research assistants Grant Penfield Haugen and Kris Derek Hechevarria, and to them we extend our thanks.

We want also to express our appreciation to the School of Public and Environmental Affairs, Indiana University-Bloomington; to the Harris School of Public Policy at the University of Chicago; and to NORC at the University of Chicago for their ongoing support of this project.

It has been a pleasure to work with David Varley, our editor, and the staff at Routledge. Their support of the book and efficiency throughout the publication process has made our job that much easier.

Finally, the authors wish to extend their deep appreciation to Scot Ausborn, Abby O'Neil, and Wendy Bradburn, who were both patient and supportive as we worked on this research project over the last few years. Our hope is that its impact out in the field in the coming years will have made their efforts to help us as we worked on this seem worthwhile.

Introduction

On October 5, 2006, the Carnival Center for the Performing Arts opened in Miami, Florida. Architect Cesar Pelli designed the center, which ended up costing $478 million—a large percentage of which came from public funds. The Carnival's creators conceived the center as a home for a number of the region's performing arts organizations, as a destination for popular touring acts, and, perhaps most importantly, as one element in a broader effort to spur economic development in downtown Miami. Even before the center opened, those involved faced a number of challenges, including an almost doubling of the project's budget and a significantly delayed opening. Then, in the first 18 months after opening, the center's management found itself dealing with a $2.5 million deficit—the result of smaller than projected audience sizes and significant budget miscalculations. Miami-Dade County added a $4.1 million bailout package to the $3.75 million it had already provided for operations. But this was not enough. It was then that Adrienne Arsht, a wealthy banker and philanthropist in Miami, donated $30 million to help save the Carnival Center, which was then renamed the Adrienne Arsht Center for the Performing Arts.[1] In the nine years since its inaugural performance, the Arsht Center operated in the black about half the time. In 2011, the center posted a deficit of approximately $690,000, and it still depends heavily on county subsidies and revenue from hotel taxes.[2]

The Adrienne Arsht Center for the Performing Arts is one of many examples of cultural building projects that started out with a grand vision and correspondingly ambitious goals, but then encountered serious hurdles in trying to achieve those goals. Another example—the Fresno Metropolitan Museum in Fresno, California—closed its doors on January 12, 2010, after a longer-than-planned renovation process with a higher-than-planned renovation price tag. The museum took three years to renovate its facility, at a cost of $28 million. After defaulting on its $15 million loan and having the city take it over, the museum found itself in serious trouble; it had a debt of between $4.4 and $4.8 million. In this instance, staff layoffs and budget cuts were not sufficient to save this arts organization. Unlike Miami, Fresno produced no knight in shining armor willing to step in to save the museum.[3]

On Michigan Avenue in Chicago, the Spertus Institute of Jewish Studies, home of the Spertus Museum, stands out among its neighboring historic brick buildings. Krueck and Sexton Architects designed this striking, very modern structure with an angular glass façade that cost about $55 million to build—$38 million of which went towards the design and construction of the building. The organization borrowed $52 million and had paid off about $8.5 million as of June 2009. The project opened in November 2007. Like other projects, staff cuts, management changes, and reductions in operating hours came with the opening of the facility.[4] The organization still has a long way to go before pulling itself out of the hole it helped dig for itself; at the end of 2012, it reported a deficit of about $1.8 million.

* * *

The frequency of stories like these involving organizations that find themselves in financial trouble after pursuing major building projects and the role that the public (including board trustees, executive staff, foundations, philanthropists, and local governments) plays in the sustainability of arts organizations are two of the major reasons why we decided to conduct a study on cultural building in the United States. On one hand, the sustainability of arts and culture organizations and the arts sector as a whole is important to maintaining cultural vitality across the country. On the other hand, not everyone believes that maintaining cultural vitality is a priority, and, therefore, not everyone believes that the public (particularly taxpayers) should be required to pay for doing so. These projects sometimes not only take a toll on the organizations that launch them, but also on those that help pay the tab. Not only do wealthy philanthropists sometimes see their investments disintegrate or fall into deep distress, but taxpayers also sometimes see their hard-earned money devoted to failing projects that may prove unable to deliver a public good. Unfortunately, given the sheer scale of cultural building in the United States in recent decades, these issues all too frequently erupted in the arts organizations that built the facilities, in the cities in which they were located, and in their local communities.

There was, as it turns out, a significant cultural building boom that took place at the turn of the twenty-first century among performing arts centers, theaters, and museums.[5] According to building permit data, cities[6] throughout the United States invested close to $16 billion in the construction, renovation, and addition of cultural facilities between 1994 and 2008. If we take into account the additional expenses of furnishing these facilities and equipping them with technological amenities, and the cost escalations that frequently take place as projects move from groundbreaking to opening (i.e., the costs not present on building permits), we estimate that somewhere between $24 and $25 billion was spent on cultural facility projects during this time period. On average, an individual cultural building project cost approximately $21 million, with some that cost hundreds of millions of dollars.[7] Some of these projects were expansions and renovations

of existing buildings, but many were entirely new facilities. A large number of them were comparatively vast in size, and also technologically advanced in their operational capabilities. Some were iconic civic identity projects designed by internationally known architects and embraced by civic leaders, built with complex public–private funding arrangements. Others were more generic structures, built entirely with donated money. There were single-use structures and hybrid facilities that combined the functions of galleries, performing arts venues, and community centers. Most of them were, at least indirectly, promoted as a means to revitalize languishing neighborhoods or regions or as a magnet for bringing more tourists to cities.

This most recent building boom—which peaked in 2001 with the total cost of building at $1.8 billion—was the product of a wide range of decision-making processes. The decision makers were fueled by a number of different motivations, including a passion for the arts, a desire to leave tangible legacies, aspirations to create the best facility in the field, a devotion to a particular organization, or sometimes just civic pride. To some extent, they were enabled by the general economic climate where money was available, bonds could be floated with relative ease, and there were plenty of wealthy and generous donors to go around.

The decade from 1990 to 2000—the period in which these ideas were hatched and where the planning took place for what would become the modern boom in cultural building—was characterized by an unprecedented rate of growth and a pervasive atmosphere of economic exuberance. Population growth in the United States was 1.2% per year (a rate more than 30% higher than in prior and subsequent decades). Overall, the educational level of the U.S. population, as measured by the proportion of the population aged 25 or over who graduated from college, grew from about 20% in 1990 to about 25% in 2000. On the economic front, the growth in gross domestic product was fairly constant in the country as a whole, clocking in at around 3.5% per year from 1970 to 2000.[8] Those who were responding to the perceived needs and opportunities for cultural building were living in a climate of steady, strong economic growth—one that they evidently believed could be projected well into the future without much worry. Given the overall economic climate, it seemed reasonable to expect that undertaking substantial long-term financial commitments would be relatively low risk. Macroeconomists were referring to the lack of cyclical downturns as "the great moderation," and many of them believed that the decline in economic volatility was permanent. What they did not foresee, of course, was that economic growth in the 2000s, when most of the buildings would come on line, would essentially fall off a cliff.

As a result of this dynamic period in history, when myriad visionaries, planners, and project managers were responding to the nation's extraordinary growth by investing in ambitious new cultural infrastructure projects, we now have a cultural landscape awash with arts organizations struggling to stay afloat. In contrast to the three organizations we have highlighted,

not all new cultural buildings are disasters for their sponsoring organizations. For example, the Nelson-Atkins Museum in Kansas City managed to renovate a historic building and add a modern wing at a cost of $200 million and bring the project in on time and within budget. The Goodman Theater remodeled two old theaters in downtown Chicago into a successful theater complex that has exceeded expectations.

But for those organizations that ran into trouble as a result of pursuing a building project, the economic downturn in 2008 made it even more difficult for them to remain fiscally stable. While there was less money to go around, these organizations came to feel growing pressure to raise money for maintaining a costly facility. Before building, organizations tended to make unrealistic projections about earned revenue that would arrive after the building project was completed and the new facility's doors opened. The overused maxim, "If you build it, they will come" that accompanied the 1997 opening of the Guggenheim Museum in Bilbao, Spain, was, if not explicitly used, often a guiding principle for ambitious cultural building projects. Unfortunately, it is starting to seem as if the maxim should be, "If you build it, they *may* come." Even with the harsh consequences of what happens when the Bilbao principle does not produce the wished-for results, many cultural organizations continue as if full-bore optimism is merited.

* * *

The recent cultural building boom is one of several that have occurred in the history of the United States. One such era, what Steven Conn, a noted American cultural historian, refers to as the "Gilded Golden Age," encompasses roughly the second half of the nineteenth century and the first part of the twentieth century.[9] This much earlier "Victorian," or Gilded Golden Age, of cultural building had both important similarities and differences when compared with the major building boom that began in approximately 1998 and ended with the Great Recession.

A major point of commonality during both eras has been the desire for a set of permanent institutions to house and promote the cultural and educational aspirations of communities. People wanted to have museums, concert halls, opera houses, and libraries in their communities. But creating these institutions, including sorting out how to plan them, pay for them, and maintain them, meant that before they embarked, they grappled with at least three fundamental questions, none of which had easy answers:

1. What role should culture play in the development of a democratic society?
2. What is the proper relationship between culture and commerce?
3. Who pays (and then who decides, and who then should be the beneficiaries)? In other words, should culture be considered a public good, and therefore be a publicly funded priority, or should it become the domain of private philanthropy? Or should both participate?

How these questions were answered helped determine the cultural landscape for decades to come, and in this second wave of building that just concluded in the last few years, the results prove to be just as influential (for better or for worse) as the years unfold.

One striking aspect of the domain of arts and culture during the Gilded Golden Age was the striking fluidity in the relationship between "highbrow" and "lowbrow" culture.[10] It resulted in an easy mixing of entertainment and education, and the kind of varied audiences that would seem quite unfamiliar to us now. Theaters were places, for example, where Shakespeare was often performed (far more often than today), but usually only in bits and snippets, heavily edited and filled with contemporary allusions and satirical flourishes, and delivered in an atmosphere both noisy and raucous. Loud applause could be followed moments later with spoiled fruit being tossed or shouts of "off the stage!" when what was being presented failed to meet expectations. Audiences had no hesitation expressing their opinions about the performances and about the performers themselves. And it is important to note that while they may have been fairly inexpensive art forms to attend, they were almost all the product of for-profit enterprises. These included both museums and performing arts venues (which could have been anything from a neoclassical stand-alone edifice to an immense vaudeville stages), and even libraries at this time were open by subscription, and not free. There was very little in the way of nonprofit theater or music available to the broader public.

What happened in the later part of the nineteenth century was that audiences began to gradually self-segregate into two camps: those who preferred simple entertainment and those who (with a sometimes envious gaze focused on Europe and its high-culture temples) wanted to see and hear more serious, traditional works and to do this in quiet, elegant surroundings. This led to the appearance of a large number of new theaters and performing arts venues, as well as museums, that communicated to potential audiences, in ways both direct and indirect (dress codes, for example), that those who attended should comport themselves in a disciplined and discreet manner. The division was based in part on economics and social class, with new for-profit facilities being built for the elite who were consuming culture in a manner that mimicked what was available in Europe. This was counterbalanced by the building of large-scale, for-profit popular entertainment venues.

But museums were a different matter. Those who wanted to build museums believed that what they offered could directly impact the chances of producing good and responsible citizens, but also help ignite the longer term economic prospects of this young and ambitious republic. In other words, culture and commerce needed to work in tandem, with the idea that a carefully fashioned didacticism, along with inspirational presentations, could aid directly in educating the broader public. The result would be better citizens and better workers. This practical and instrumental element corresponds to some degree to what one finds now in science/technology museums: a

purposeful effort to excite, inspire, and encourage the curiosity (particularly of younger) people who might go on to study science, and perhaps become scientists, later in life. There was a powerful practical vision at work here. The notion was that a young nation needed access to useful things—which is to say the practical arts. Hence museums of science and industry, and ultimately free public libraries, would fill that need. And art and music would inspire and educate a more refined and thoughtful citizenry. Or at least that was the hope.

So, on the one hand this late nineteenth-century era was characterized by an ambitious project to put America on the map as the inheritor of the great traditions of Western Europe. The Gilded Golden Age, with its plans to construct hundreds of neoclassical, white, Georgian marble Beaux-Arts buildings throughout the East Coast and the Midwest, in cities that were becoming larger and more prosperous every year, produced the first great wave of cultural structures in the United States. They included museums, performing arts venues, municipal parks, hospitals, and universities. They were for the most part the products of the vast new industrial fortunes being built in America.

Unlike in Europe, however, which tended to cluster most of the cultural institutions in political capitals such as Paris, Amsterdam, Rome, Vienna, and London, this first cultural building boom in the United States was decentralized. Given that this young country lacked the enormous collections accrued over centuries by monarchs, the aristocracy, and the Church, along with enormous structures that had housed them, they opted for a much more decentralized model—one that required curators and those interested in building collections that would ultimately be given to museums to travel to Europe, to attend auctions, and to cultivate other wealthy donors. So towns and cities throughout the country began this process. And they often took on the character of booster projects: cities competed with one another, often quite openly. Conn concludes:

> This was the moment when most of the nation's great art museums got their start: The Boston Museum of Fine Arts (1870); The Metropolitan Museum of Art (1870); The Philadelphia Museum of Art (1876); The Chicago Art Institute (1882); The Detroit Institute of Art (1885); The Cleveland Museum of Art (1913). New York's American Museum of Natural History was joined by the Field Museum of Natural History in Chicago (1893) and the Denver Museum of Nature and Science (1900). These museums were joined by libraries and concert halls as well. Philadelphia's Academy of Music, built in 1857, has survived as perhaps the finest "wedding cake" style opera house in the United States. Symphony Hall in Boston opened for listeners in 1900; Chicago's symphony moved into its new home in 1904 and in 1919 Detroit's orchestral ensemble played its first concert in its new hall.

Beyond the role these institutions were intended to play (including addressing the tension between democratic inclusivity and separation of elite cultural activities from "working-class" entertainment), and the evolving relationship between culture and commerce that partially drove them, at least in the earlier part of the first building boom, the question of who pays for them and has responsibility for sustaining them needed to be resolved. And this took place over an extended period.

In the later nineteenth century up until the Great Depression, many of the major cultural building projects were led by the economic and social elite of the industrial cities in which they were built, but local government often played a role as well. This could include donating the site (as in the case of the Metropolitan Museum of Art and the American Museum of Natural History) or providing zoning assistance, in some cases exercising eminent domain, and often approving some kind of cash infusion to be used at the outset to get the project going. But the responsibility for actually raising the money, planning, building, establishing an endowment, and then maintaining these facilities resided with wealthy patrons and supporters of the arts who served on the governing boards of these institutions. It is important to keep in mind what a stark contrast this was with the model in Europe, where ultimately the state would take care of nearly all aspects of cultural building and programming. Philanthropy on the model Americans practice has in fact only very recently begun to appear.

Even more profound than the philanthropic model was the U.S. federal tax code. Without innovations in the tax code that began in 1894 and culminated in the 1960s, this surge in the number of building projects launched by cultural institutions would not have taken place on anything like the scale that it did. The new tax code provisions made it possible for donors to get a significant tax break by contributing to charitable, educational, and cultural institutions. This constituted a form of indirect, not direct, support, but it radically redefined the nonprofit landscape in America. In 2009, for example, more than $300 billion was donated—$12.3 billion of that was directed to arts and culture organizations. The total amount given each year has grown exponentially over the decades.

What is particularly striking when one compares these two building booms is the shift in what serves as the ultimate drivers of these ambitious and expensive projects. During the Gilded Golden Age, a city would announce that it had "arrived" by demonstrating that it could accumulate and display cultural capital—this most often took the form of a museum, a concert hall, or a large theater. These were most often elaborate, elegant and expensive buildings conceived and paid for by those with the great industrial fortunes of the later nineteenth and early twentieth centuries. As Conn describes it, "wealth was turned, by a kind of alchemy, into culture and civic responsibility; . . . those who promoted and paid for and patronized these cultural institutions raised all of us above the crass world of merely

making money." This included cities like Philadelphia, New York, Chicago, Pittsburgh, Cleveland, and Kansas City.

But as things gradually changed, and America evolved into a postindustrial economy, cultural institutions came to be seen less as necessary desirable and beneficial public amenities, and more as engines of economic development for towns, cities, and whole regions than in the past. Their role was now to help make a city an attractive and interesting place to live, which, in turn, would help businesses recruit employees and bring new companies in from other parts of the country. Boeing moved its headquarters to Chicago from Seattle in 2001, in part, because of the opportunity to bring the executive staff to a city with a high concentration of cultural institutions in the city's center. Chicago was in competition with several other cities around the country, and companies often announce publicly these kinds of competitions.

An ancillary trend has been to try to create a major signature structure, often calling upon high-profile, world-renowned architects to create a visible civic identity in the way that the Sydney Opera House did for that Australian city. No longer simply imitating one another with a new neo-classical Beaux-Arts building, as was the case in the nineteenth and early twentieth centuries, they now hire the likes of Norman Foster, Zaha Hadid, Renzo Piano, and Santiago Calatrava to create a signature design that would set them apart from the pack and buy them global recognition. Milwaukee built a new museum and hired Calatrava to do something dramatic and unique. Very little money was left to fill the museum with art works, but the structure gained international attention and has worked well as a civic identity project. Its precise economic impact has not been determined, however.

More or less the same spirit of rivalry exists now that prevailed in the earlier building boom, but the fundamental motivations now are different. We are now much less comfortable than our forbearers discussing the importance of these institutions for the moral uplift they might provide or the inspirational character of the theater, music, and dance performances residents and visitors will see and the general importance of close acquaintanceship with cultural tradition. We are much more at ease making the claim that culture is good for business.

But this instrumental relationship between cultural infrastructure investment and prosperity is, it turns out, much more ambiguous, indirect, and complicated than its proponents had hoped. Witness the glaring inaccuracies in the majority of economic impact studies that were commissioned in order to argue for both private and public investment in some of these enormously expensive projects. Sometimes the projects languish, new businesses do not spring up around it, the neighborhood does not become more desirable, and the newly constructed buildings put enormous pressure on cultural organizations that usually do not have a lot of budgetary leeway.

As we shall see, the consequences for an organization of a new building are difficult to predict.

* * *

This book is about cultural buildings and the challenges of building them. From studying the process of planning and building facilities that help form the infrastructure of the nation's cultural institutions, we identify the differences between the ways some organizations were able to successfully meet the challenges of a large construction project and others that were not. We base our findings on a large body of data we collected on the cultural infrastructure in the United States for which we produced a variety of resources for organizations and cities to use in building facilities.[11] We started by compiling a comprehensive list of all museum, theater, and performing arts center construction projects in metropolitan statistical areas (MSAs) in the United States launched between 1994 and 2008. We then coupled this comprehensive inventory with demographic data (e.g., population growth, educational levels, income) for each MSA to understand the context in which building projects were pursued. For a nationally representative sample of organizations, we also gathered much more comprehensive and detailed information on the planning processes of building projects and on current operations. We conducted surveys with the executive director and/or a board trustee of each organization and/or the primary project representative, covering topics such as the decision-making process that went into pursuing the building project in the first place, the organization's governance structure, financing of the project, and the postcompletion assessment of the organization and the project. In addition, we visited projects in 12 cities and conducted interviews with organizational and project representatives to observe in greater depth how cultural organizations decide to build and the consequences for them after the buildings were completed.[12]

In the chapters that follow, we tell the stories of several cultural building projects in cities across the United States that were both initiated and completed during the recent building boom. These stories take place in cities large and small, in cities with rich histories of cultural activity, and in cities with relatively nascent cultural activity. We use these stories to illustrate the more general principles, drawn from our larger study, that we believe differentiate more successful from less successful projects. We see a diverse cross section of community members taking part in the building projects we study. Furthermore, we see the strategic ways in which an organization's leaders can work with their communities to overcome a wide range of challenges.

In Chapter One, we provide two contrasting examples of projects that, taken together, illustrate how the idea for a new cultural building develops over time and how multiple forces shape the final product. Chapter Two focuses on one form of cultural building—the performing arts center (PAC)—and shows how two very different cities with strikingly different economic bases went about building their own. Chapter Three details the

amount of building that went on in the southern region of the country, and highlights two very different organizations that built in close proximity to one another. Chapter Four investigates the practice of building cultural facilities in smaller cities, and how these cities have their own special challenges in improving their images and bringing new cultural possibilities to their citizens. Chapter Five turns to the particular issues facing museums, and the risks and vulnerabilities that face them when embarking on a building program. In Chapter Six we pull together the major themes that we have found in studying the organizations that built during the modern building boom and formulate conclusions that will help arts organizations avoid some of the pitfalls we have seen repeated in cultural building projects across the country.

Readers of this book—be they arts managers, politicians, board members, city planners, foundation executives, or philanthropists—should find that the stories in this volume provide valuable perspective and insight about building cultural facilities, and that these, in turn, serve to make building projects go more smoothly in the future. As varied as the process of planning and building cultural facility projects can be, and unique as each of these organizations and the communities that build are, we argue that there emerges a clear set of guidelines for pursuing these projects successfully. We have tried to make these accessible and describe them in a manner that enables those tasked with leading a project to learn from them. More importantly, though, by using the data we collected on a representative sample of organizations that pursued building projects, we have provided a tool to help project managers put their own situations in context. By gathering the information, ideas, and accounts of the experiences of those who have built, we have provided what we hope is useful guidance for future leaders of cultural building projects—the result of which can be the greater viability of nonprofit arts and culture organizations that can effectively deliver on mission and serve their communities.

NOTES

1. Kaleem, Jaweed. "Great Expectations Remain for Miami's Adrienne Arsht Center in Its Fifth Season." *The Miami Herald*. October 24, 2010.
2. Unless otherwise noted, all organizational financial information comes directly from Internal Revenue Service (IRS) 990 forms accessible from the Urban Institute's National Center for Charitable Statistics (NCCS) or Guidestar.org.
3. Johnson, Reed. "The Fresno Metropolitan Museum of Art and Science Closes Its Doors." *Los Angeles Times*. January 12, 2010.
4. Kapos, Shia. "The Battle for Spertus: Struggle for Soul and Financial Stability Plays Out in Jewish Institute's Flashy New Home." *Crain's Chicago Business*. June 29, 2010.
5. Museums, as defined in this book, include traditional art museums, ethnic museums, history museums and historical societies and organizations, and cultural art centers focusing primarily on exhibiting art. They do not include

children's museums, science museums, natural history museums, halls of fame, and specialty museums, including museums devoted to the study and/or display of a single object (e.g., Balloon Museum), one industry (e.g., Police Museum), or a person (e.g., Ernest Hemingway Museum). Theaters are defined here as single-use performance spaces, which means largely those with their own resident companies. PACs are spaces that host Broadway tours or multidisciplinary performance acts (e.g., comedians, pop concerts, dance groups, theatre groups); cultural art centers primarily focus on performance centers, dance theaters, opera houses, symphony halls, concert halls, and auditoriums. We include university-owned institutions, but not those owned by high schools, middle schools, or elementary schools. We include local and state government-owned organizations, but not those owned by the federal government.

6. Throughout this book, we use the terms metropolitan statistical area (MSA), metro area, and city interchangeably, but all are meant to reflect the U.S. Census Bureau's definition of an MSA. In certain instances we also refer to a city's downtown, which is essentially its urban core.

7. Woronkowicz, Joanna. "An Overview of Cultural Building in the United States: 1994–2008." Working Paper. Cultural Policy Center, University of Chicago, 2012.

8. Woronkowicz, et al. "Set in Stone: Building America's New Generation of Cultural Facilities." Cultural Policy Center, University of Chicago, 2012.

9. Conn, Steven. "Golden Ages Then and Now: America's Cultural Infrastructure in Historical Perspective." The Ohio State University, 2012.

10. Levine, Lawrence. *Highbrow/Lowbrow: The Emergence of Cultural Hierarchy in America*. Cambridge: Harvard University Press, 1988.

11. These resources are all available on the study's website at the Cultural Policy Center at the University of Chicago (http://culturalpolicy.uchicago.edu/setinstone/). They include a full report of findings from our data analyses, various working papers, and videos.

12. A description of the study methodology is provided in the appendix.

1 Two Case Studies
Chicago and Philadelphia

When we mean to build,
We first survey the plot, then draw the model;
And when we see the figure of the house,
Then must we rate the cost of the erection;
Which if we find outweighs ability,
What do we then but draw anew the model
In fewer offices, or at last desist
To build at all?

—Shakespeare, *Henry IV, Part 2*

On December 1, 2000, the renowned Goodman Theater opened its new facility in downtown Chicago. Spanning a full city block from north to south and half a block from east to west, the theater is within easy walking distance of several other major downtown theaters that make up the North Loop Theater District. Among these, the Goodman is the acknowledged leader, and is generally considered one of the nation's premier theater companies.[1]

The Goodman was not always part of the top tier of great American theaters. Nor did it always have an impressive facility. Prior to moving to its extensive new quarters, the Goodman leased an underground space from the Art Institute of Chicago, directly adjacent to the museum. At the time the theater was established, and then throughout much of its early history, there was no identifiable need for an enhanced facility. From about 1930 to 1970, the theater functioned primarily as a school of drama, and had only an intermittently active professional acting company. To accommodate the organization's work, then, the facility had been quite sufficient for several decades.

It was in the mid to late 1970s, under the leadership of William Woodman, that the Goodman underwent a major transformation. In 1976, it severed its ties to the Art Institute and incorporated as the Chicago Theatre Group, Inc. In 1978, it shed its drama school and began focusing on strengthening the work of its professional acting company. It was at this same moment that Roche Schulfer began his long career with the Goodman.

Starting as Woodman's assistant, Schulfer would go on to become the theater's new managing director in 1979. Five years after that, in 1985, he would begin his partnership with the Goodman's new artistic director, Robert Falls. Together, these two men would launch the theater's dozens of world premieres, help it win a Tony award for best regional theater, and complete a $52.5 million capital campaign for a new building that would, in turn, help place Chicago on the map as a key destination for regional theater.[2]

The two men began exploring the idea of constructing a new facility around 1988. At that time, the Goodman's existing theater was, in their minds, "a disaster." According to Schulfer, "It was poorly designed to begin with, poorly maintained by the Art Institute over the years, and [the organization] had totally outgrown the facility."

For years, the facility had served the Goodman Theater Company's needs, but when the company began to expand its repertoire the facility's inadequacies became evident. Given that, Schulfer and Falls concluded, "If they had any impetus to being the leading theater in Chicago, and one of the leading theaters in the country, and a world-class arts organization, they had to develop a new facility."

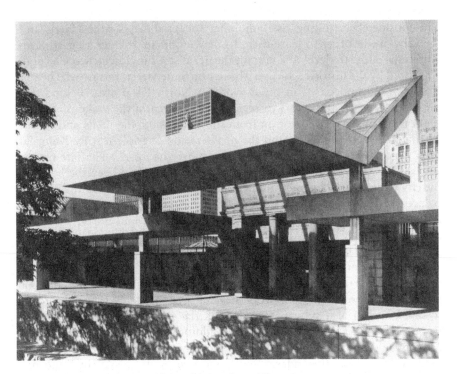

Figure 1.1 Exterior view of the old Goodman Theater.

Credit: Courtesy of the Goodman Theater.

The Goodman board agreed, but not until they had assured themselves that the idea for the project as a whole was plausible, at least in terms of its financial viability. More specifically, they needed to feel assured that they could actually raise the money to pay for the new building. They took their task very seriously and proceeded with caution; it took the board nearly seven years to approve both a construction plan and a budget. During this time, there were some resignations by members who were skeptical about the project. In response, the board made sure that it successfully recruited new members who understood and believed in the arguments for a new facility and fully supported the expanded operation it would require. They also made the decision to raise all of the money before breaking ground, and they took this seven-year period to raise the money for the project. Schulfer recalls a member of the board saying, "You know, we're not going to break ground until we have enough money to complete the project, because once the building opens, the fundraising stops."

In other words, the board believed they would be more successful at raising money for capital costs before the project was built than if they were still fundraising when the building project was underway.

There was also, throughout this period, another factor that would help make the new theater a reality. In the mid-1980s, the City of Chicago had considered acquiring two adjoining vacant theaters—the Harris and the Selwyn—in order to lease them to the Goodman Theater as part of an ambitious effort to develop a vibrant theater district in downtown Chicago. Anchored by the historic Chicago Theater on State Street, this new "Theater Row" would be located in the downtown North Loop area. Behind this project was a broader effort to resuscitate the area in the wake of "white flight from the city, competition from suburban shopping malls and North Michigan Avenue retailers, and the proliferation of triple-feature Kung-Fu and 'blaxploitation' films at downtown movie houses."[3] The late-mayor Richard J. Daley expressed his desire to revive what had been the heart of the city and recreate an entertainment district where live theater and cinema palaces once thrived. With the Goodman Theater's willingness to abandon its longstanding venue and move a few blocks west and north, the then-mayor Rich Daley (Richard J. Daley's son) started to draft the plans to make a North Loop Theater District a reality.

But it was not until 1992 that the board decided it would be feasible to move to the site of the two old theaters in the Loop. Still in play at that point were two additional adjacent properties that were needed if they were going to build on top of a subway line. It took the city almost five more years to negotiate the acquisition of the two additional sites, but in 1997, with Mayor Daley's full support, Schulfer publicly announced the Goodman's plans to move from the underground stage adjacent to the Art Institute and build a new facility in downtown Chicago.

By this time, the board members of the Goodman had also raised $17 of the $21 million they had pledged to the project. Furthermore, and

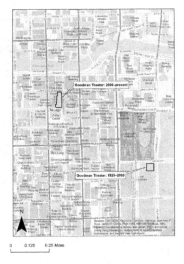

Figure 1.2 Map of old and new locations of the Goodman Theater.

Credit: Map created by Thomas Bunting.

largely due to the mayor's involvement, the city contributed an additional $18.8 million using tax-increment financing (TIF) funds. The remaining money needed would come through private investment in the facility's retail and restaurant spaces, plus bridge financing provided by a consortium of Chicago-area banks.

Altogether, these sources would bring the total to $53.2 million, which was the initial goal for the project. In addition, approximately $6 million of this total would go into an endowment fund. The project broke ground in November of 1998 and, in the end, came in on time and on budget. The 125,000-square-foot facility includes an 856-seat main stage theater (the Albert Ivar Goodman Theater), plus a smaller 400-seat theater (the Owen Bruner Goodman Theater).

Both the Goodman and the North Loop Theater District have continued to grow since the opening of the new space. A decade after the opening, the theater's ticket revenues have consistently grown; in 2010, total ticket revenues had almost doubled from 2000, and almost tripled the amount they were in 1990. Since 2000, total contributions have remained relatively stable, but have risen significantly from the time before the new facility was built. In addition, as the mayor had hoped, the North Loop area added a host of new pre- and post-theater restaurants, and the area saw the completion of major renovations of other nearby historic theaters. The project was a success at almost every level—for the theater, its audiences, the neighborhood and for the City of Chicago. Roche Schulfer, the man who spearheaded the idea and brought it to completion, agrees: "It has been enormously successful . . . it's been all that we hoped for and more."

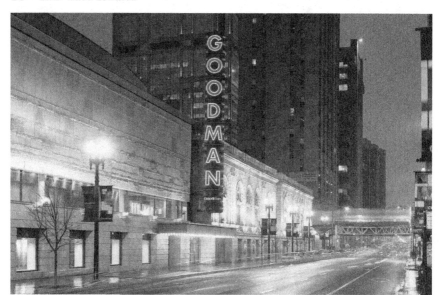

Figure 1.3 Exterior view of the current Goodman Theater.

Credit: Courtesy of the Goodman Theater.

* * *

For over a century, the Philadelphia Orchestra has been widely recognized as one of the world's great symphony orchestras. Founded in 1900, it has been at the top tier of orchestras in the United States (and the world) along with the other "Big Five"—the New York Philharmonic, the Boston Symphony Orchestra, the Chicago Symphony Orchestra, and the Cleveland Orchestra. Some of world's best-known conductors made their careers with the Philadelphia Orchestra's legendary musicians. For almost 30 years, Leopold Stokowski was the orchestra's music director. Following him, the renowned Eugene Ormandy held the baton for almost 45 years, and then Riccardo Muti spent 12 years leading the orchestra from 1980 to 1992. Over this time, the orchestra grew in both size and status. It was the first orchestra to produce an electric recording, and the first to make a commercially sponsored radio broadcast and to appear on a national television broadcast.[4,5]

Given its size and its stature, there were many in Philadelphia who thought the orchestra deserved its own concert hall. From its inception, it had been performing in the Academy of Music, a building it shared with both the Opera Company of Philadelphia and the Pennsylvania Ballet. Even though it was a recognized architectural landmark, this facility lacked the acoustical quality required for audiences to fully appreciate what had become widely

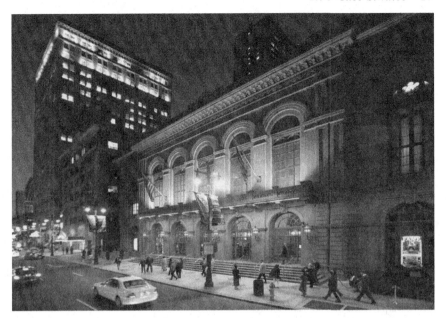

Figure 1.4 Exterior view of the Academy of Music, Philadelphia, Pennsylvania.

Credit: Photo by Nick Kelsh; Flickr.

known and admired as the "Philadelphia Sound." Furthermore, the space was not a viable one in which to make recordings. As a result, Riccardo Muti had to find alternative venues for recording sessions. This became one of several arguments for thinking about the possibility of a new, more suitable, dedicated space.

In the early 1980s, the orchestra's board proposed to build a new concert hall. There had been prior proposals—for example, when Stokowski suggested they think about a new building in the 1930s, and when Ormandy did the same in the 1950s—but these ideas never gained traction. In the 1950s, the Academy of Music underwent a renovation, but it was largely architectural and did not include the acoustical enhancements the orchestra yearned for.

In its first iteration, the new concert hall would combine the functions of a performance space and a hotel situated on a single plot of land located directly across the street from the Academy of Music. This idea, however, quickly disappeared when the developer with whom the board was working proved unwilling to give up any of the space he had allocated for a parking garage. In spite of that, the board continued to pursue the idea, commissioning a study to determine whether building a concert hall was, in fact, feasible. In 1983, the board officially approved the idea, and in 1986 it purchased the option for a tract of land just a short distance from the orchestra's home at the Academy of Music.

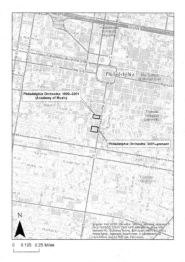

Figure 1.5 Map of old and new locations of Philadelphia Orchestra performance space.

Credit: Map created by Thomas Bunting.

The reasons for building the new concert hall were, from the board's point of view, obvious. The orchestra's current home was seriously over-crowded; there was insufficient space for the facility's other tenants, the ballet and the opera. In addition, the board saw the idea of a new concert hall in the center of the city as an exciting economic development opportunity. The study they commissioned concluded that building a new concert hall downtown would help not only the orchestra, the opera, the ballet, and the Academy of Music, but would also benefit the city of Philadelphia, particularly in the longer term, through the creation of a new downtown arts district. In other words, the new facility would help not only the resident arts organizations, but also the community at large.

Despite the optimism, there was a substantial contingent of community leaders who opposed the idea, including several members of the orchestra's board. During the 1980s, the board had experienced a generational shift in membership. A strong group of corporate leaders became trustees, and a group of older members began to cycle off. The two groups had starkly opposing views on the proposed facility project. The "new money" contingent was pushing to build, while the "old money" generation, many of whom had a deep and longstanding attachment to the old building, was uncomfortable with the idea of the orchestra abandoning its home at the Academy of Music.

When the board finally made the decision to go ahead with the project in 1986, philanthropists Leonore Annenberg and Andy Pew—two

longstanding board members—announced their resignations. Annenberg thought the project was a terrible idea, and Pew was anxious about the future of his leadership role. In spite of these grumblings, in 1988 the board of the orchestra exercised its option to purchase a $16 million site, using a $20 million line of credit, which was their only option because they had only managed to get a few million dollars in firm commitments.

Six months later, the Philadelphia Orchestra's executive director, Stephen Sell, who had been a key proponent of the concert hall project and who was its designated leader, died of lung cancer. Joseph Kluger, age 34, who was at that point the orchestra's general manager, was selected to become its next executive director. In this new role, Kluger and the board struggled for about three years trying to raise money for what had in the meantime had become a $100 million concert hall. At this point, however, the board had only raised $23 million. When it seemed that fundraising efforts were stagnating, Kluger started exploring the idea of obtaining public funds for the project. "I found," he said, "that in the last 50 years, these facilities really hadn't been built without public-sector funds."

Together with his board, he began to lobby for support from the incoming mayor Ed Rendell, using as a lever the idea that this new arts facility would be a powerful engine for economic development. With Rendell's help, the orchestra framed the project as part of a larger development strategy to create an arts district that would be called the "Avenue of the Arts," which would include another half dozen institutions. By positioning the project as an economic development opportunity, it was much easier for the orchestra to go to the state for support, especially when they were able to ally with other arts organizations that would be part of the newly proposed cultural district. In 1993, the State of Pennsylvania contributed $70 million to the arts district project, $35 million of which was allocated specifically to the new concert hall for the Philadelphia Orchestra. In turn, the state's contribution spurred an additional $12 million contribution from Sidney Kimmel—a local philanthropist—and $30 million in private contributions, bringing the total raised for the concert hall to about $100 million. By that point, however, the project's estimated budget had escalated to nearly $145 million, and prospects of more major gifts appeared very uncertain. "We hit what I would describe as a fundraising plateau" said Kluger. "We had maxed out the money we could raise from the orchestra's subscribers."

The project at this point took a dramatic and abrupt shift. Over drinks one evening, Kluger and the mayor's wife came up with the idea of creating a performing arts center by merging two separate projects into one. One of the arts organizations, the Drama Guild, which was part of the group of organizations that received support from the state, had unexpectedly gone under. The initial plan was that the "Avenue of the Arts" would have *both* a multipurpose facility that the Drama Guild, several theater groups, and chamber music organizations could use and also a major concert hall for the

orchestra. That evening, Kluger and Mrs. Rendell decided it would be a better idea to use the money that had been allocated to the now-defunct Drama Guild to help build a *single* facility that would be home to the entire group of organizations (minus the Drama Guild). That way, they could position it as a "community" project and, in so doing, reinvigorate the donor community. For Kluger, the key impact of this would be that the orchestra could "revert back to its primary mission . . . making music rather than managing real estate projects . . . and everyone could live happily ever after." But that was not how events would unfold.

In 1996, the Regional Performing Arts Center (RPAC) incorporated as its own 501(c)(3). It would be home to eight organizations, including its primary tenant, the Philadelphia Orchestra. The RPAC had its own board with representation from the organizations that were envisioned as being the new facility's primary tenants. The project was transferred to RPAC, and the city bought the land from the Orchestra Association (a.k.a., the Philadelphia Orchestra), which allowed it to retire its outstanding loans. The city agreed to ground lease the site for $1.00 a year to RPAC.

The RPAC's facility project, to be named the Kimmel Center for the Performing Arts, broke ground in 1998 and opened in 2001. The 450,000-square-foot facility, with a transparent glass roof more than 150 feet high, includes a 2,500-seat concert hall and a 650-seat multipurpose theater. The building takes up an entire city block. The final cost including the land and the construction of the building came to $235 million.

Ten years later, on April 16, 2011, the Philadelphia Orchestra became the first major U.S. orchestra to file for Chapter 11 protection. The costs of operating the new facility made it difficult for the orchestra to afford its rent. In addition, its earned revenue declined as ticket sales declined, further weakening the organization's liquidity. The result was a substantial operating debt (estimated at about $14.5 million per year). In 2012, the organization laid out a plan before a bankruptcy judge to erase its debts, partly by reducing its enormous pension obligations and partly by relying heavily on optimistic fundraising and ticket sales projections. That plan also included paying its landlord, the Kimmel Center for the Performing Arts, $748,000 in overdue rent from the previous year.[6] On June 28, 2012, the orchestra exited bankruptcy, but it has a long way to go to prove to the community and its supporters that it can remain solvent for the longer term. It faces both the challenges currently facing symphony orchestras all over the country (e.g., aging audiences, alternative ways of accessing music, changing tastes), but also the constellation of issues surrounding the structure that had been built to house this venerable orchestra.

* * *

These two narratives show how the idea for a cultural facility takes shape. From the time the original plans were unveiled to when the buildings opened their doors, these two projects reveal the effects a major new facility

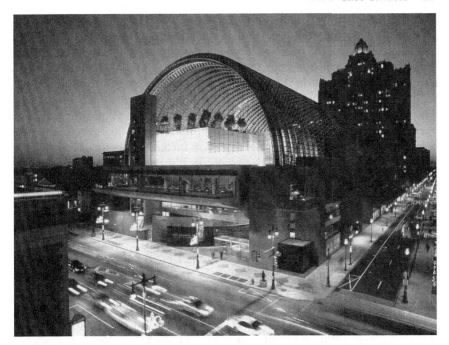

Figure 1.6 Exterior view of the Kimmel Center for the Performing Arts, Philadelphia, Pennsylvania.

Credit: kimmelcenter.org

can have on organizational sustainability. The stories also illustrate some key themes relevant to cultural building projects in general and demonstrate how paying close attention to these themes can impact a project's outcome. The first story shows how decision makers working on a facility project can move an organization forward and help rejuvenate a neighborhood; the second illustrates how sometimes the outcome of a series of decisions concerning construction of a new facility can seriously damage an organization, the reputation of its board, and the community's morale. These strategic decisions made by the leaders of organizations and communities steer a cultural building project toward its ultimate outcome. Sometimes these outcomes are vastly different from what had originally been envisioned. By dissecting the two stories above, and carefully analyzing the unfolding narrative, we can identify important elements of building cultural facilities that affect these projects' outcomes and their organizations' sustainability.

PASSION

The idea behind a building project is typically not a particularly rational one. Very rarely do leaders of cultural building projects go through a systematic process to determine whether the time is right, the need is there, and

all the elements in place to move ahead with a new facility. In fact, the idea for a project most often arises from an inspiring vision and the subsequent passionate pursuit of it by an individual or small group. It could be a civic leader, a philanthropist, a board trustee, or an executive director. This passion might be focused on the art form, on the needs of the community, or on the organization and its future. Moreover, if this passion is ultimately passed on to the board and to the community, it can move a project forward after the initial inspiration for the project fades away. In the case of both the Goodman and the Kimmel we saw passion inspire leaders to propose the idea to build. In the Goodman's case, specifically, we saw passion ultimately drive the development of the idea from conception to the opening of the doors of the new building.

The idea for the Goodman's new facility arose when Roche Schulfer decided his organization had achieved a level of professionalism and excellence that merited a new facility. The Goodman had been slowly evolving into one of the best theater companies in the United States before Schulfer proposed the idea to build. He saw a theater company that was consistently increasing its ticket revenue and contributions in the 10 years prior to building and that had moved back and forth between having its own professional acting company and not. He saw the theater take great strides in the 1970s, first with its incorporation, and then when its leaders decided to focus specifically on strengthening and enhancing the theatrical work of its company.

Schulfer's fame had also been growing along with that of the organization he was leading. At the time he began working at the Goodman as William Woodman's assistant, Schulfer could not have known that he would soon be managing a performance space that would emerge as a proving ground for some of the nation's best actors and playwrights. One of his first responsibilities was to manage "Stage 2," a performance space that hosted David Mamet, whose play *American Buffalo* premiered on the Goodman stage in 1975. Other stellar playwrights soon followed, including Edward Albee and Tennessee Williams. It was also during Schulfer's early career that the Goodman's "Artist Collective" was formed, which included actors Brian Dennehy and Frank Galati—both of whom would become legends in American theater. In the initial years of his career at the Goodman, Schulfer both experienced and contributed firsthand to a stunningly fertile and exciting period in the theater's history. Not surprisingly, one of the results was his early promotion to managing director.

For the Philadelphia Orchestra, the moment of inspiration for what became the Kimmel Center for the Performing Arts took place when its music director, Riccardo Muti, thought his great symphony deserved its own concert hall and concluded that one needed to be built. Like the Goodman Theater under Schulfer's leadership, the Philadelphia Orchestra under Riccardo Muti had been experiencing a tremendous run of successes. The orchestra was considered one of the top tier, both by Philadelphia's cultural

community and by the other members of the Big Five. Moreover, the orchestra had experienced a long and rich history of success because of its stellar sequence of musical directors, who, in turn, were drawn to it by its notable musical accomplishments.

Muti's own fame had been growing alongside that of the orchestra. He was widely credited with having led this distinguished orchestra in new and innovative directions. Before he arrived, the orchestra was known for its distinctive sound—a sound created by its previous directors, Ormandy and Stokowski. Upon his arrival, Muti focused on stripping the orchestra's sound of its lushness and making it more generic in order to be truer to composers' original intentions.[7] The orchestra's new sound would prove to be more amenable to electronic recording—something that Muti believed was very important for the orchestra's future.

In both of these projects, then, the inspiration to build rested upon both a recognition of the high quality of the organization's artistic work and from visionary leadership. Programmatic development, in response to greater organizational recognition, is, in fact, the primary reason that many existing organizations decide to embark upon facility projects in the most recent building boom. For the Goodman, a new theater was very much a testament to the acclaim the acting company had accrued during Schulfer's leadership. Similarly, the Philadelphia Orchestra, with its gifted conductor and longstanding reputation as one of the world's best orchestras, had earned a positive response to its desire for a concert hall commensurate with its stature. To continue on this trajectory—that is, to both thrive *and* evolve—meant, quite literally, to build. A new facility represented what each organization's leadership saw as the defining symbol of their tenure, bringing their institutions, as they did, to a new level of excellence and achievement. Without a new facility, the organization would likely stagnate, and, along with it, so would its leaders.

For both projects, passion ignited the initial idea. But it was only for the Goodman that passion led the project through its successful conclusion. The orchestra's concert hall project was initially proposed and driven by its two primary leaders—Stephen Sell and Riccardo Muti—who had a history of great collaboration. Muti credited Sell with much of the success of the Philadelphia Orchestra: "His presence was of great help in the innovation and modernization of the entire organization."[8]

Working together, these two men were able to convince their board of directors to pursue and spark enthusiasm for the project. In a sense, their excitement for the project helped invigorate the others who were involved. Unfortunately, each man's departure came far too soon in terms of the project's full trajectory, and this had a negative impact on the project's outcome. Three years after Sell's death, Muti resigned as music director of the Philadelphia Orchestra and went on to become musical director at La Scala Opera in Italy. Therefore, long before the details of the Philadelphia Orchestra's concert hall project were even close to being worked out, the project's two passionate advocates would be gone. All of a sudden, it was up to a

new group of leaders to sustain Muti and Sell's passion for the project. In all cultural building projects, passion plays an integral role.

> Theaters should be built, not with reason but with passion. We don't actually need theaters after all. We just want them. So theaters should be whatever we want them to be. This is not rational—it's about desire. If someone wants a frugal theater, then they should make one. If someone else wants an extravagant theater, then we should have one of those too. Rather, in a healthy world the task that lies before us all is not to create the one perfect theater, but to create a diverse range of theaters, some of them frugal and some of them wildly extravagant, some profitable and some not restricted by the need to be profitable, some rational and some inexplicably weird, some successful and some total failures, some conventional and some radically new, some representing the political, social, and artistic establishment and some skewering and roasting that establishment. Good established theater communities like Paris, London, New York, Minneapolis, and San Francisco have all of these. Theaters are not generic passive receptacles into which you can pour any sort of performance. Theaters are entangled with the art they present. So in order to have the widest diversity of art we need the widest diversity of theaters, rich and poor. Rational planning has limited benefits here, to the extent that theaters don't just house art, they are art.[9]

While passion can inspire a project and move it forward, and ultimately help foster culturally dynamic communities with an exciting range of artistic offerings, in the end it is the fusion of this passion with careful, considered rational decision making that creates sustainable projects. Both are important parts of the story of how these monuments to culture get built.

VISION

As with many building projects, the initial inspirational spark that launched the Goodman and the Kimmel projects eventually faded as the sustained hard work of raising money, developing a plan for the new building, and overseeing construction took center stage. After Schulfer went to the board and the idea became weighted down by questions around feasibility, funding, and sustainability, the idea became decidedly less sexy. Similarly, in Philadelphia, the conflicts that arose on the orchestra's board once the initial idea had to be fleshed out ended up deflating much of the initial enthusiasm that had prevailed when civic and cultural leaders were being inspired by a grand vision for a concert hall. Consequently, it became necessary for another player to step in, not only to reenergize the

organizations' board and staff, but also to articulate a clear vision for each project to their wider communities in order to gain much-needed support. In Chicago, that force was Mayor Daley; in Philadelphia, it was Mayor Rendell.

For Mayor Daley, building the new Goodman Theater was just a small part of his much larger ambition to revitalize the city his father had led for more than 20 years and to make his own mark. When Daley became involved during the early stages of the Goodman project, he had only been mayor for a couple of years. This signature component of his broader revitalization project was not only the perfect opportunity to strengthen the city, but also to make a powerful first impression on Chicagoans—one that would ultimately help sustain his role as mayor for another two decades. The success of the Goodman and other theaters was one part of his plan to reenergize the downtown area. Nevertheless, it would be considered a keystone of Daley's legacy for years to come. Even now, after the opening of Millennium Park, the Harris Theater, and the Modern Wing of the Art Institute—Chicago's other major cultural facilities—the development of the downtown theater district, and the revitalization of Chicago's Loop area, is widely seen as one of Daley's key accomplishments, with impacts that go well beyond the arts community itself.

In Philadelphia, it was Mayor Rendell's desire to make his initial years of service to the city memorable ones, coupled with the community's long-standing and strong civic pride that played pivotal roles in bringing the Kimmel through to completion. When Rendell entered office, the city of Philadelphia had consistently been losing jobs and is population. In addition, the city had a $250 million deficit and was known among many as the worst managed of America's largest cities. Rendell was adamant about putting Philadelphia back on track, focusing intensively on economic development in the city center. In his first couple of years as mayor, Rendell estimated that he spent 75% of his time convincing existing business not to leave the city and prospective ones to set up shop there.[10] Therefore, it was clear that helping the major arts organizations in the city expand would be a logical part of Rendell's political platform.

Both the Goodman and the Philadelphia Orchestra's leaders attempted to strategically align their visions for the building projects with those of their mayors. In fact, many organizations we studied tried to align their incentives with these priorities and the incentives they believed likely to work in the community by collaborating with a strong public spokesperson. An effective spokesperson can persuade community residents that they need a particular project as much as the organization needs them. The key is building community support. The relationship, if successful, becomes symbiotic. The leaders of the Goodman and the Philadelphia Orchestra knew that an effective civic spokesperson—such as a popular mayor—could help advocate for the project and build enthusiasm in the community, thus helping build support.

In Chicago, the vision for the Goodman project and Daley's vision for the transformation of the city-center was very much aligned from the beginning. The theater wanted to separate itself from the Art Institute and build a new theater for its repertory company, and the mayor wanted the theater to move downtown. As such, the Goodman and Daley worked in tandem, and what both wanted was exactly what ended up happening. By contrast, in Philadelphia, the orchestra's original vision for a concert hall was dramatically altered in order to present itself as a community-oriented project that would help other arts organizations and would serve more than just the Philadelphia Orchestra's need for a new concert hall. The orchestra and Rendell—while working together—were not able to align incentives to achieve the original purpose.

The courting that took place between Daley and the Goodman appeared to fit the symbiotic model. In other words, Mayor Daley wanted to align with the Goodman as much as the organization wanted to align with him in their pursuit of a facility project. The city had for some time been trying to revive the threadbare downtown area by developing an entertainment district, even before the Goodman introduced the idea of building a new facility. The downtown area of Chicago had been experiencing a decline for quite some time. For example, although the population of the MSA had increased, the city's population had declined by 23% from 1950 until 1990,[11] and city's homicide rate was quickly increasing.[12] Furthermore, the city welcomed the theater taking over the long-abandoned sites of the empty Selwyn and Harris Theaters. Mayor Daley was eager to serve as a spokesperson for the Goodman because the project aligned so well with his reimagining of Chicago's city-center.

Kluger was initially able to persuade Mayor Rendell that a proposed concert hall aligned well with his own plans for city growth by making the concert hall an anchor for economic development in the new downtown arts district. It appeared that the alignment with political powers worked quite well, at least initially, considering that the concert hall project received a substantial contribution from the State of Pennsylvania. But the added funds from the state were still not enough, in part, because the project's budget continued to increase. To further catalyze donations for the building project, then, Kluger and the board took an entirely different route. The project was redesigned to be a performing arts center rather than a concert hall for the orchestra. At this point, the vision of a multipurpose performing arts center diverged from the orchestra's vision of a dedicated new concert hall designed to its own specifications. Instead of being the owner of the facility, the orchestra became merely one of its potential tenants.

Mayor Rendell agreed to serve as a high-profile spokesman, not for the original orchestra hall project, but for one that was radically amended to align with his needs and desires. With a debt that ultimately needed to be repaid and a powerful board that was unwilling to let the project go, the

Orchestra Association had little choice but to alter their original conception of the new facility. Ironically the orchestra's primary motivation to build was to end its shared tenancy at the Academy of Music; yet in order to align with the mayor's platform, it ended up reverting back to shared tenancy with another group of organizations. While the shift the project underwent resulted in a substantial contribution from the State of Pennsylvania, it unfortunately threw the project even further off its original course than it already was.

LEADERSHIP AND MANAGEMENT

In the beginning, with their ideas in hand, the artistic organizations' leaders approached their boards with the goal of getting buy-in, as well as a signal of commitment from board members that they were ready to support the proposed project. In the Goodman's case, it was Schulfer that approached the board. In the Kimmel's case, it was Muti who first went to Stephen Sell, the orchestra's director at the time (Sell died in 1989), and Sell approached the board. Both leaders were met with similar cautious responses, but each organization then proceeded to take quite different paths.

As is the case with most of the projects we studied, both the Goodman and the Kimmel Center experienced some level of leadership turnover after the announcement came that the organizations would likely be pursuing a building project. At the time the board of the Goodman Theater started to seriously consider pursuing a building project, a few trustees who were not in support of the idea resigned. In Philadelphia, when the orchestra's board began to take the first steps in pursuing the concert hall project, a significant contingent of the board made their opposition to the idea widely known. Many trustees opposed the idea of undertaking the construction of a large new building because they were emotionally attached to the Academy of Music and did not want the orchestra to depart from the historic facility. Moreover, among a few specific trustees there was apprehension about the role they would play helping oversee the orchestra in a new concert hall. In other words, they thought that a new concert hall would alter the political landscape of the organization. As such, and also similar to the case of the Goodman, there were resignations from the Philadelphia Orchestra's board at the time the board decided to move ahead with the facility project.

Yet, the Goodman Theater took these resignations in stride by strategically focusing on restructuring the board to make it "building ready." The remaining executive and board leadership made it their priority to replace those who left with strong and supportive new members who could lead the project through to its completion. In contrast to the Goodman's approach, leadership for the Kimmel Center project continued to aggressively pursue the project while gradually recruiting new trustees, even though many

members of the board who remained were not entirely comfortable with the idea of a project or with how it was unfolding.

More importantly, there was almost no safe, neutral forum for the Kimmel Center project in which the more reluctant board members could express their concerns and trepidations. As Kluger described it, there was a very strong and somewhat intimidating cohort of trustees who made it uncomfortable for other members to express dissenting opinions.

> You had this gang of CEOs who would stand at a board meeting with 40 people and say, "You know, I'm the CEO of XYZ Corporation, and I've analyzed this project. Here's what I think is a good thing to do. I need a motion to go ahead with it." Half the people who voted yes did so because they weren't going to stand up and vote no in the face of these powerful people recommending it. And the other half who voted yes think, "Hey, you think you know what you're doing. So I'm voting yes because you're paying for it, and I'm not."

When Schulfer approached the Goodman board with his idea for a facility project, he was met with cautious enthusiasm. While many members of the board agreed that the organization needed a better space to perform in, they also were very aware of the challenges that lay before them if they chose to pursue a building project. As a result, Schulfer and his board worked together methodically to find appropriate ways to ensure the feasibility of the project in order to make the board feel the organization's finances would be secure and that the organization would remain sustainable for the long term. First, the board of the Goodman made it clear that to proceed with the project, they would raise the necessary funds before construction started (which they did in fact do before they broke ground in 1998). To the board, this strategy meant not spending money before they had it in hand and not permitting the proposed budget to increase. That budget was $53.2 million, and the board never let that number grow. Importantly, $6 million of that was to be devoted to an endowment—a "lockbox" for the organization in case they ran into hard times. There was also consensus that a large portion of the funds to be raised would come directly from the board. Leadership made it clear that a substantial donation would serve as the signal of each board member's serious commitment to the project.

In contrast to the Goodman, the board of the Philadelphia Orchestra started to spend money and take major steps toward building a new facility before they had a chance to stabilize the board's structure and replace the board members who had resigned with new people. With a fractured board, and without full consensus, the trustee group took out a $16 million loan from a local bank to purchase an option on the lot where the concert hall was to be located, even before the board had settled on a firm budget. At the time the board bought the option to buy land the concert hall was

forecast to come in at roughly $60 million. But that number kept escalating, primarily due to changes that occurred in the project's concept. In the end, the budget for what would now be a PAC, instead of a concert hall, swelled to $235 million.

The Goodman also carefully strategized before publicly announcing that the project would break ground in 1998 and be completed in 2001. Schulfer, with Daley's unwavering support, announced the Goodman's plans to build a new facility in downtown Chicago once the board had raised more than two thirds of the $21 million they had pledged to the project, and just after the city confirmed it would top off the capital campaign with an $18 million contribution in the form of TIF funds. The majority of the funding was now in place, and to the broader public it looked like the Goodman had all its ducks in a row. Either way (with or without public support) the project was going forward. And at this point any extra funding from the community would only help strengthen the Goodman's financial position.

The RPAC, by contrast, made its announcement about groundbreaking for its new building before the board had raised all of the money needed to pay for it. The Orchestra Association had already invested considerable time and money in planning the construction of a concert hall (and even worked with an architect to design the hall), but when the project was reimagined the budget increased significantly, and, even with the increased contribution from the state, the board still did not have all the money in hand to build the facility. At the time the public learned that the project was going to go forward, there was still significant skepticism that all the money needed could actually be raised. Furthermore, the community had the opportunity to follow in the public press all the ups and downs of the project, which, in turn, made it appear to be a precarious initiative. The RPAC's board finally made the announcement about groundbreaking for the project in hopes of getting additional donations, but fundraising again started to stagnate as the cost estimates continued to grow. Under these circumstances, the community could not yet trust that the Kimmel would actually get built nor how their money would end up being spent.

Much of the success the Goodman had in managing its building project is attributable to the extensive experience its two leading executives had gained as they led their organization. When the new Goodman Theater opened in 2000, these two key leaders had a combined 30 years running this organization, not to mention what they had learned prior to their joining the theater and becoming part of the larger theater industry. Arguably, it took these years to adequately understand what it takes to define the mission of an arts organization, how to go about effectively implementing that mission, and what potential role the theater could play in the future for developing American theater. Furthermore, like any partnership, Falls and Schulfer had already had the experience in managing the organization together, and therefore knew each other's strengths and weaknesses related to leading large endeavors. When they proposed the project, Schulfer and

Falls had a solid understanding of what it took to have a successful the-
ater company, and this informed how, among other issues, they responded
to multiple prominent architectural firms' bids to design the new theater,
remembered Schulfer:

> In terms of the nature of architect selected for example, we lobbied
> hard to the board to make sure that architects who were selected were
> familiar with theater construction and design . . . because we were
> very concerned based on our research and experience, that buildings
> that were designed by architects who did not have substantial experi-
> ence designing theater complexes ended up being catastrophes. And
> the board, to their enormous credit, supported us even though they
> took a lot of heat from architects who felt that they should have got-
> ten the commission even though they had limited experience designing
> theater complexes.

In contrast to the Goodman leadership's wide experience gained while
working for the organization (and doing that together), Kluger was a new-
comer when he unexpectedly took the reins as the Philadelphia Orchestra's
executive director at the age of 34. The newly formed RPAC hired as an
executive director a person who had little experience in arts management.
Looking back, even Kluger acknowledges that he did not have the expe-
rience required to lead one of the world's major orchestras, plus under-
take a major building project, but then said, "it was a career opportunity
of a lifetime" and "Who wouldn't have taken it?" Kluger did ultimately
accept the position, but with promises from the board that were not, in
the end, kept:

> You have to understand at this point I am at the orchestra, but serving
> as the general manager—the number two guy (in charge of the music
> side) having nothing to do with this project. The executive director,
> Steve Sell was really the "architect" so to speak . . . [the board] pro-
> moted me to be executive director at the age of 34, with the statement
> from the board chair: "Look we know you're young and little unex-
> perienced (sic). You run the orchestra, and we, the board, will run
> this concert hall project." And I said "okay." Well, six months after
> that, it was clear to me that the board was committed to the project. I
> really had to, from the leadership point of view, deal with the fact that
> we had a bank loan, we owned some land and we didn't have much
> and by the way of contributions and we had a community that was
> against it.

In many respects, it appears as if the Goodman and the Kimmel projects
followed similar trajectories. Both projects started with strong leaders pos-
sessed by a passion for their art form, which, in turn, helped generate the

idea for launching a major building project. The two organizations also explained their need for better facilities by citing the limitations their current facilities posed for their organization's ongoing operations, and, implicitly, their possibilities in the future. In addition, both organizations had been growing in size and stature prior to making the decision to build. When it came to these organizations' boards, both had trustees who were critical players in the process of moving these projects forward. Furthermore, both the Goodman and the Philadelphia Orchestra had the broader political support (and concomitant financial support) they needed in order to pursue the projects, and both leaders tried to ensure that what they envisioned was aligned with what the city's political leaders had in mind for improving their communities.

But as similar as the planning processes for developing these two new facilities might seem on the surface, there were also key differences, particularly in respect to how the their boards and executive leadership managed these projects. The Goodman's board ensured that the vision for the project remained consistent and clear, and that it strategically worked for Mayor Daley as well, as he communicated this vision to the broader public in Chicago. The Philadelphia Orchestra, by contrast, partnered with Mayor Rendell to communicate its vision for the Kimmel Center, but that vision was dramatically altered when funding and support for the project was not coming in as planned. A new organization was formed with a new board that effectively took the decision-making power for the building away from the orchestra's board, although the orchestra had representation on the new RPAC board. In addition, while the Goodman's board, after some trustees who were opposed to the project resigned, took time to restructure its membership before taking any major steps in the project's planning process, the orchestra's board continued to expend funds on the project despite having a deeply fractured board unable to see eye-to-eye in terms of why, at a basic level, the project was a good idea.

Finally, the Goodman benefited from the executive leadership duo that had intensive experience collaboratively managing the organization. The board also supported its leaders when they insisted the organization hire an architectural firm with experience in designing theaters, even though the design came with a social cost to the trustees. The board of the Philadelphia Orchestra hastily recruited Kluger into the organization's top role, even though he lacked the experience of leading a large organization. More importantly, though, while having promised their new director limited responsibility in managing the project (undoubtedly because the board realized Kluger's inexperience), the orchestra's board went back on their promise when the concert hall project started to spin out of the orchestra's control, and Kluger was left to figure out how to give the board the new facility it wanted while simultaneously trying to maintain the stability of his organization. These differences, and more, ultimately affected the outcome of each project.

DEMAND

Beyond each project leadership's managerial efforts (which as discussed above had large impacts on each project's success), there was also present a broader and arguably stronger force that contributed to the projects' final outcomes—the actual demand that did (or did not) exist for what the Goodman Theater and the Kimmel Center would be offering to the community. Unlike the issue of whether their leaders made sure to adhere to their original vision, or if the board decided to spend money before they had raised it, this actual demand was something well out of both organizations' control. Whether there was sufficient demand from the community to justify building a new Goodman Theater or a new Kimmel Center for the Performing Arts is still a question largely left unanswered, even a decade after each of these new facilities opened their doors. In fact, knowing whether any cultural building project has adequate demand in order to be successfully completed and then sustained over the longer term is something all arts organizations struggle with when they pursue these types of projects. As we argue in more detail in Chapter Six, it is impossible to make accurate predictions about the future for organizations like these because the factors that will determine their future are too complex and interrelated to be known with any degree of certainty.

Despite some arguments to the contrary, we actually know relatively little about what constitutes demand for the arts. There is, however, ample evidence that arts audiences, in the most traditional sense of the term (i.e., audiences who attend events in formal arts facilities), are on average wealthier and more educated than the average American.[13] Furthermore, we now have evidence that shows us that the three primary determinants of cultural facility building in U.S. MSAs between 1994 and 2008 were population change, the proportion of people with at least a college degree, and median household income.[14] With this information in hand, we can at least in a rudimentary way try to gauge a city's actual current level of demand for arts and culture by comparing its population change, education, and wealth levels with the average across all U.S. cities. This, in turn, raises the question of the precise degree to which a community's demographic profile might be correlated to a potential project's overall sustainability.

Before each organization decided to pursue a building project, there were demographic changes occurring in Chicago and Philadelphia that gave a glimpse of what demand for arts and cultural activities looked like and where it might be heading. For any organization making the decision to expand their offerings, and their expenses, these demographic trends are important to pay attention to. In the decade prior to the opening of the Goodman Theater the population of Chicago's metropolitan area grew by 11.2%, from approximately 8.2 to 9.1 million people. More importantly, that population was also progressively getting more educated and wealthier—two characteristics that likely reflect a population's greater propensity for attending arts

Table 1.1 Characteristics of Chicago, Philadelphia, and All U.S. MSAs

	Chicago MSA			Philadelphia MSA			Average All U.S. MSAs		
	1990	2000	Change	1990	2000	Change	1990	2000	Change
Population	8,182,076	9,098,316	11.2%	5,435,550	5,687,147	4.6%	991,520	1,133,565	16.2%
Percent of population 25 and over with at least a B.A.	25.5%	30.8%	5.3%	24.5%	29.4%	4.9%	21.4%	25.0%	3.6%
Median household income	$55,336*	$60,000	8.4%	$55,639*	$58,790	5.7%	$45,904*	$49,201	7.2%

Sources: U.S. Census Bureau, Census 2000 and 2010. Steven Ruggles, J. Trent Alexander, Katie Grenadek, Ronal Goeken, Matthew B. Schroeder, and Matthew Sobek. *Integrated Public Microdata Series: Version 5.0* [Machine-readable database]. Minneapolis: University of Minnesota, 2010.

Note: In 2000 USD.

events.[15] Between 1990 and 2000, the proportion of people over the age of 25 with a college degree in the Chicago MSA grew to 30.8%, higher than the national average of 25.0%. In 2000, median household income was more than $10,000 higher than that of all other U.S. cities.

By contrast, in Philadelphia, prior to the building of the Kimmel Center, the population had grown by only 4.6%. And even though the Philadelphia MSA's education and income levels were comparable to that of Chicago's, the "Windy City" showed far greater potential for growth in regard to median household income based on the rate at which its median level was already increasing.

Even though both organizations had needs that would be addressed by a new facility, and their existing facilities were not able to offer them the up-to-date technology, the space, and the functionality that each arts group required to continue excelling in their respective fields, the simple demographics of these cities hinted that the Chicago region, and not Philadelphia, could plausibly support an expanded operation. In Philadelphia, the city's demographic profile did not suggest that there was enough of a growing base of financial support for arts and cultural organizations. This became apparent many times during the Kimmel Center's fundraising campaign when the size and rate of donations stagnated, even as the center's budget continued to increase. In Chicago, when the Goodman asked for financial support from its community, it was forthcoming, showing that there was a real demand and tangible support for moving ahead with the building of this new theater.

* * *

The stories we read here about the Goodman Theater and the Kimmel Center projects are not unlike other building projects that were pursued during the most recent cultural building boom. As we saw with these projects, it was often the executive director, or key leader, of an existing institution who proposed the idea for a building project—such was the case in 95% of the projects we studied. Where a new facility was also coupled with the creation of a new organization, the person who proposed the project would typically be a civic leader, donor, local politician, or director of a resident company. In the former instance, the organization's leaders—as Schulfer, Sell, and Muti did—had the responsibility to persuade their boards that the project was indeed something the organization needed. If the board did decide to seriously consider their director's proposal, a round of resignations would often take place among trustees who either opposed the project or who were not willing to put in the time and effort required to seeing the project through. Eight-two percent of the organizations we studied experienced board turnover specifically due to resignations because of launching a building project. Some organizations (about 50%), like the Goodman, for example, responded to turnover by taking the opportunity to strategically rebuild their boards either by growing their board or carefully replacing the

ones who left so that collectively they would have the skills in place to successfully launch a building project. Others, like the Philadelphia Orchestra, proceeded quite hastily without addressing the doubts that were exposed within their boards by the resignations. Many decided to function with a relatively small board or planning group, because finding a large group of people to come to consensus about specific details of the project was often a difficult task. While the average board size of organizations was around 30 people, 80% of organizations utilized a specific planning group, or building board, which was often significantly smaller than the full board.

Both the Goodman and the Kimmel's boards attempted to be strategic as they tried to align their visions for a new facility with that of their city's mayors. In addition to the projects' initial purpose, which was to achieve these organizations' programming and development goals, the projects were now just as prominently tools the cities' mayors could use to strengthen their political platforms—namely, major contributors (hopefully) to economic development. Forty-seven percent of the projects we studied included economic development or community cultural enrichment as a primary motivator for building or renovating a new building; this was in addition to other internal organizational development goals. As the executive director of one very large PAC revealed to us: "I realized that hardly any other performing arts centers built with public funds had ever been built without an economic development component."

These more external visions were typically pursued by strong public spokespeople, such as a mayor, and were articulated well after the board had decided to build. External visions were generally communicated to the public to help build community support for the project; for example, with its vision to become part of the "Avenue of the Arts," the Philadelphia Orchestra secured a generous contribution to their concert hall project from the State of Pennsylvania. Organizations that cited economic development as a primary reason to build, in contrast to those that did not, were also more successful at obtaining local government contributions. On average, an organization that used economic development as a primary reason to build had 23% of its construction budget covered by local government funds, compared to 13% for organizations that did not use economic development as a key motivator. It makes sense, then, that Kluger decided to shift the project vision so that it was more aligned with Rendell's goal to spur economic development in downtown Philadelphia, because the result was a major contribution from the State of Pennsylvania.

But along with this change in vision came changes that affected the sustainability of the Kimmel project as a whole. The budget for the project continued to grow, and the RPAC could not keep pace with its fundraising. On average, projects built in the most recent building boom had budget increases of 62% from the time the initial budget was agreed upon by the board to the final cost of the project. For those projects that experienced significant vision changes throughout the course of planning or building, this figure was 72%.

There were other elements of the Kimmel project that may have led to its cost increases. For example, the major leadership transition that took place due to Muti's departure and the unfortunate death of the orchestra's executive director, Stephen Sell, placed a great deal of strain on project management, which, in turn, had an impact on the effectiveness of decision making. In the projects we studied, those that had to deal with major leadership changes either during the planning or building phase also had much higher cost escalations. The average cost escalation of a project without a major leadership change was about 42%—with a leadership change this figure is a stunning 118%.

Finally, Goodman's strategy of raising all of the funds for project construction helped the organization's financial performance following completion of the project. While many organizations that pursue building projects believe that taking on long-term debt is an absolute necessity, there were plenty of organizations we studied that were able to raise the full amount needed for construction (and maybe even more for operating and an endowment). Approximately 43% of all organizations had zero construction debt at the completion of their building project. Organizations with no construction debt were less likely to have operating deficits after the project was completed. And those that factored an endowment into their overall project fundraising efforts were even less likely to run a deficit.

By analyzing the development of the idea for the new Goodman Theater and the Kimmel Center for the Performing Arts, from first iteration to completion, and putting these two projects in context by comparing them to a representative sample of all cultural building projects pursued during the recent building boom, we see that there are common themes that emerge in both the planning and building phases of a new arts facility. There are certain building strategies that can have measurable positive effects on project, organizational, and community outcomes. The Goodman Theater's leadership seems to have done many of the right things when it came to building their new theater. They managed board relationships such that the board could effectively go about decision making for the project. They rigorously maintained a consistent vision throughout the entire project. Furthermore, they had the good fortune of having the same leaders both start and finish the project, and they raised all of the money for the project's construction before starting to build. It is not surprising, then, that after the new Goodman Theater opened, revenues and attendance grew, high-quality and varied programming continued, and the organization (with Schulfer and Falls still in charge) is thriving today.

By contrast, the Philadelphia Orchestra, in building the Kimmel Center, encountered various challenges that had large impacts on the project's outcome. The organization made major decisions about the project with a seriously divided board and without gaining full board consensus. It also had the great misfortune of losing its key leaders, and sources of project inspiration, before the project was completed. While the orchestra was able to effectively recruit a new leader, it did so under false pretenses by telling

Kluger that the concert hall would remain the board's responsibility. Without much choice, Kluger, with little experience leading initiatives of this magnitude, took the reins. To keep the project afloat, he and the board drastically changed the vision for the project, a change that led to their losing control of the project to a new organization set up to enable the new vision. In the process everyone got in seriously over their heads by allowing the budget to increase beyond the capacity of the organization to raise the funds necessary to fulfill the vision. As a result of all of these mishaps, the Kimmel Center since its opening has had multiple executive directors arrive and depart, its revenue has not kept pace with its rising expenses, its programming has been cut, and its primary tenant, the Philadelphia Orchestra, went into bankruptcy from which it has only recently emerged. How this will play out over the next few decades is unclear.

NOTES

1. This case study is partly based on our interview with Roche Schulfer, current executive director of the Goodman Theater.
2. Goodman Theatre website. "Our History." www.goodmantheatre.org/About/Our-History/.
3. Lyon, Jeff. "Saving the Loop. Garth Drabinsky's Plan to Restore the Oriental Theater Could be the Start of Something Big." *Chicago Tribune.* March 17, 1996.
4. This case study is partly based on our interview with Joseph Kluger, current principal at WolfBrown.
5. Anders, Robin. "The Philadelphia Sound: The Innovative and Iconic Philadelphia Orchestra Celebrates Its 112th Season." *USAirwaysmag.com.* June 2012.
6. Wakin, Daniel J. "Philadelphia Orchestra Offers Plan to Cut Debt." *The New York Times.* May 24, 2012.
7. Webster, Daniel. "Sounds of the Philadelphia Riccardo Muti Didn't Think an Orchestra Should Have a Characteristic Sound. So It Is a Little Ironic that Emi's Retrospective of the Conductor's Years Here Should be Called 'The Philadelphia Sound.'" *The Philadelphia Inquirer.* January 4, 1995.
8. "Stephen Sell, 47, Dies; An Orchestra Director." *The New York Times.* May 28, 1989.
9. Davis, Robert, founding member and fellow of the American Society of Theatre Consultants. Email message to author, July 25, 2012.
10. Yagoda, Ben. "Mayor on a Roll: Ed Rendell." *The New York Times Magazine.* May 22, 1994.
11. U.S. Bureau of the Census. Population Division. *Population of the 100 Largest Cities and Other Urban Places in the United States.* By Campbell, Gibson. Population Division Working Paper No. 27. Washington, D.C., 1998.
12. Hinz, Greg. "Why Is Chicago Always so Much More Violent?" *Crains Chicago Business.* July 8, 2013.
13. National Endowment for the Arts. *2008 Survey of Public Participation in the Arts.* Washington, D.C., 2009.
14. Woronkowicz, Joanna. "The Determinants of Cultural Building: Identifying the Demographic and Economic Factors Associated with Cultural Facility Investment in U.S. Metropolitan Statistical Areas between 1994 and 2008." *Cultural Trends* 22 (2013): 192–202.

15. There is ample evidence for education as a predictor of cultural attendance, including the Ford Foundation's 1974 report, *The Finances of the Performing Arts, Volume II: A Survey of the Characteristics and Attitudes for Theater, Opera, Symphony, and Ballet in 12 U.S. Cities;* S. Globerman's 1989 chapter, "What We Know and Don't Know about the Economics of Culture" in *Cultural Economics '88: A Canadian Perspective;* Heilbrun and Gray's 2001 book, *The Economics of Art and Culture* (2nd ed.); and the National Endowment for the Arts' 2004, 2000, 1998 reports, *2002 Survey of Public Participation in the Arts; Age and Arts Participation: 1982–1997,* and *Trends in Arts Participation: 1982–1987,* respectively. Bruce Seaman's 2006 chapter, "Empirical Studies of Demand for the Performing Arts," in the *Handbook of the Economics of Art and Culture, Volume I,* cites income as a positive predictor of cultural attendance.

2 The Rise of the Performing Arts Center

During the modern cultural building boom, the most prominent and costly type of cultural facility that appeared on the national landscape was the performing arts center (PAC). PACs were 50% of the total number of projects and they made up approximately 54% of the total cost of building cultural facilities between 1994 and 2008. Museums made up about 39% of the total number of projects and 38% of the total cost; theaters made up 11% of the total number and 8% of the total cost. The PACs that were built were multifunctional, often massive facilities that combined the production amenities of theaters, symphonic concert halls, and stages that were designed to accommodate everything from large choruses and classical musicians, ballet and modern dance companies, popular recording artists, full-scale Broadway musicals, and even magicians. They also incorporated user amenities like VIP and donors' lounges and flexible public spaces designed for conferences, private parties, weddings, bar mitzvahs, and other special events.

In general, PACs took longer to build and were more costly than museums and theaters. On average, a PAC project took a little over 10 years from the time the planning group started exploring the idea for the project to opening night. Museums, on average, took a little over nine years, and theaters took slightly over seven years. Budget escalations were also larger for PACs than for museums, but theaters had the largest of all. From the time the budget was decided upon by the board to the final cost, PACs, on average, increased their cost by 64%, compared to 46% and 88% for museums and theaters, respectively. While PACs and theaters tended mainly to increase costs due to additions of technological amenities, museums did so from architectural and design specification additions. Because technology steadily and relatively rapidly improves, often what PACs and theaters thought they needed was already out-of-date by the time the planning and construction process had run its course.

Many of the facilities built during the modern building boom were largely aspirational in character—they were built by those who had high hopes for the future of their cities and communities, as well as their organizations. They were designed to serve as symbols of confidence for how a city

and its community envisioned itself, and what vision it was projecting into the future. The multifunctional nature of PACs made them an ideal facility type for communities with little experience attending arts events and a spectrum of artistic interests that ranged from popular musical entertainment to more obscure genres like jazz. Just as America's oldest and most prestigious cultural institutions were built in major industrial cities at the turn of the twentieth century in order to compete with one another for cultural capital, cities across the United States that built PACs during the modern building boom embarked on these cultural facility projects because they felt they both deserved and were capable of offering cultural events that rivaled other cities in their region and across the country. A sizeable cohort of cities that were (and in some cases still are) largely unknown for their cultural offerings felt they needed an arts facility to legitimize their status on the national, and even international, stage. Civic leaders felt as if their city would be seen as "second class," and that they were not providing sufficient cultural leadership if they did not have their own cultural facility. Who would come to visit if there were no cultural amenities available? How could they attract new businesses, and the professionals who would staff these businesses, if they lacked what other cities had or were in the process of building?

In the narratives that follow, we highlight two medium-sized cities, both of which built large and expensive PACs. The motives behind these building projects were decidedly similar, inasmuch as they embodied what each city's civic leaders envisioned for their downtown districts. The first city—Kansas City, Missouri—constructed a $368 million PAC designed by Canadian/Israeli architect Moshe Safdie, which serves as the home to both the city's symphony and its opera. The idea for this performing arts center was born when, very near the end of her life, philanthropist Muriel Kauffman—one of Kansas City's strongest and most generous civic leaders—made it clear she wanted her family foundation to lead an effort to build a major new facility for the performing arts, and one that would match the ambitions of the city she had devoted so much time, energy, and money to over the decades.

Next, we will turn to Las Vegas, where a decade and a half of planning resulted in a monumental $480 million complex, replete with a 17-story bell tower, as well as an adjoining park designed for outdoor events. Following in a Las Vegas tradition of turning an inhospitable and unlikely terrain into an opulent and imaginative urban center, the new PAC was built upon a nearby brownfield (an abandoned Union Pacific rail yard, full of decades of dumped transmission fluid and diesel fuel) that needed to be scoured before building could begin. This new PAC was seen by the team that launched it as an anchor for urban transformation, and in particular as the key to restoring the frayed and slightly depressing area known as "Old Vegas." Both in Las Vegas and Kansas City, these PAC buildings were conceived and built relatively recently, so their effects on both the local performing arts organizations, as well as on the community at large, are still playing themselves out today.

KANSAS CITY, MISSOURI

Kansas City, Missouri, sits at the heart of the Midwest. Known for its legendary barbeque and the contributions of its many jazz musicians over the decades, it is one of the only major cities in the United States that spans the boundaries of two states (Missouri and Kansas). With a population of nearly 500,000 within the city limits, and over two million more in the MSA, it is a relatively large American city.[1]

Like so many other cities, Kansas City grew up around its transportation infrastructure. Located at the confluence of the Missouri and the Kansas Rivers, it was particularly convenient to get to for some of its earliest visitors. In the eighteenth century, early European explorers traversed these rivers in an effort to expand the hunting ground for the lucrative fur trade. After the Louisiana Purchase in 1803, Lewis and Clark, noting the strategic location, decided to build a fort in Kansas City. This marked the beginning of the westward expansion, with many transcontinental expeditions beginning in Kansas City's own Jackson County, and eventually for the city becoming the starting point for the Santa Fe, Oregon, and California trails. The city was also selected as home to the Hannibal/St. Joseph Railway Bridge (a key component in the growth strategy for industry in the Midwest). These developments, in turn, spurred enormous population growth in Kansas City in the early 1900s and beyond.[2]

It was connectivity, then, as defined initially by the transportation network that crisscrossed the city that made Kansas City a natural destination for nascent industries over the succeeding decades. Arguably, it is still this transportation network that helps make the city a hub for American entrepreneurship in the present.

It is striking how many major American corporations have located their headquarters in Kansas City, and even more surprising how many of these corporations' founders are actually from the city and how many of their families remain there to this day. Joyce C. Hall, founder of Hallmark Cards, moved his company to Kansas City shortly after its founding (his son, Donald J. Hall Sr. is now chairman of Hallmark Cards' board)[3]; the Kemper family, who are in the insurance and banking industry, also lives in Kansas City[4]; Russell Stover Candies was purchased by the homegrown Louis Ward, and both the company and its owner remain there to this day[5]; and the Blochs, who started H&R Block in 1955, were born in Kansas City, and Henry Bloch still calls the city his home.[6]

These leaders and their companies remain not only because of the convenience of being able to conduct business from Kansas City, but also because of their proximity to like-minded businesses and people. Recently, the city has seen a wave of new technology companies arrive, including one responsible for producing an exclusive new Google product.[7] In addition to its historic role in transportation, Kansas City is now defined by its technology network as well.

These corporations and their leaders contribute significantly to the health of the city not only because of the number of people they employ, but also through their leadership and support of a wide range of civic improvement projects. For example, Shirley Helzberg of Helzberg Diamonds is known for her extensive work on historic preservation in the community. She has restored many abandoned buildings around the city.[8] Larry Stewart, who founded Network Communications, was nicknamed Kansas City's "Secret Santa" after he (anonymously) distributed about $1.3 million to needy people and charitable organizations throughout the city.[9]

At the center of the philanthropic circle in Kansas City is the Kauffman family, whose history of generosity and leadership exemplifies the impact civic leaders have had on the city's transformation. Ewing Kauffman, who started Marion Laboratories (a highly successful pharmaceutical company), signaled his ongoing commitment to the city through his involvement in a wide range of philanthropic causes. He established the Kansas City Royals, and subsequently managed it using his own financial resources. Moreover, he arranged that it would be bequeathed to charity after his death. Kauffman also established a program whereby students who graduated from the Kansas City school system, avoided drugs and unplanned pregnancy, and pledged to be good citizens would receive scholarships to fund their college education. The program began at his alma mater and then expanded to other Kansas City schools.[10]

Ewing's wife, Muriel Kauffman, was equally engaged in a range of city initiatives. Together, Ewing and Muriel played a key role in the restoration of Union Station—seen by many residents as a catalyst to the city's subsequent growth. In the mid-1990s, a bi-state commission arranged to use public funds for the restoration of the old train station if both states could secure sufficient votes to pass the funding bill.[11] The votes were secured, but the remaining funds for the $250 million restoration of the building had not been raised. "I'll never forget it. It was the fundraising breakfast for Union Station, and in walked Mrs. Kauffman. She took out her checkbook, wrote a check for $25 million, and handed it to the commission," remembered Eric Youngberg (a long-time Kansas City resident who works for the nonprofit, NeighborWorks America).

Muriel Kauffman's extraordinary gesture, Youngberg believes, "transformed the community psyche . . . from seeing the collaboration of civic leaders and the restoration of Union Station—a building that had been neglected for decades—[to a] community [that] began to believe, 'Yes, we can do these things. We can make it work.'"

In 1993, Ewing Kauffman died of cancer. Shortly thereafter, Mrs. Kauffman died as well. But before she died, she told her daughter Julia Kauffman that she wanted Kansas City to have its own performing arts center. A long-time advocate and very generous supporter of the arts, Muriel Kauffman believed in the arts, supported them generously, and was convinced that Kansas City deserved a first-rate performance space in which to experience them. As a consequence,

her daughter Julia Kauffman ended up spearheading the largest capital campaign for the arts in Kansas City's history. The dazzling architectural gem, which now sits atop a hill in downtown Kansas City, and can be seen from miles away, is a legacy of the Kauffman's commitment to their city that is shared by all who live there today.

THE KAUFFMAN CENTER FOR THE PERFORMING ARTS

The Kauffman Center for the Performing Arts is located in the southwest quadrant of the city-center. It was designed by renowned architect Moshe Safdie and opened in 2011. This striking building immediately became a civic icon, whose form and scale, inside and outside, seize upon the viewer's senses in a way that sets it apart from the majority of new performing arts centers. Observers have struggled to describe it: some say it resembles two rising waves splashing onto the city park that surrounds it; others say it looks like an oddly shaped accordion, or perhaps a Slinky. Safdie, however, made it clear what lay behind his vision for this major new performing arts

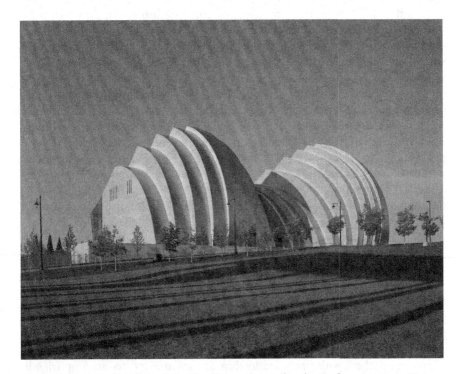

Figure 2.1 Exterior view of the Kauffman Center for the Performing Arts, Kansas City, Missouri.

Credit: Photo by Tim Hursley courtesy of Kauffman Center for the Performing Arts.

venue. The building, he explained, was designed to embody the very thing it was built for—music. For that reason, the southern wall displays an array of diagonal beams that look like the strings of an instrument, while the bulging metallic forms on the north side resemble a pair of bells.

The opening of the PAC created a stir within the Kansas City community. In addition to being an indelible reminder of the Kauffman family's deep commitment to their city, it has helped instill a broad-based feeling of civic pride. Arriving at the Kauffman Center on a cold, blustery morning in November, this became evident as we viewed people walking around the structure, looking up at its enormous walls and taking photographs. A small group of excited bridesmaids were being photographed in front of the Kauffman's stunning glass façade. Everyone we spoke to in the vicinity expressed the pride they felt that their city had been able to conceive of and then actually build an architectural *tour de force* like the Kauffman Center.

What distinguishes the Kauffman Center among the projects we studied is that it was built entirely with private funding. But, in fact, this it had in common with many of the city's civic improvement and cultural building projects. Other than the adjoining underground parking garage, which the city paid for, the entirety of the center's construction costs, plus $40 million for an endowment, came from individual donors and foundations. One aspect of the pride the community feels is having accomplished this enormous building on their own without having to depend upon public funding.

Since its doors opened, both the attendance figures and the Kauffman Center's general financial performance have been strong. In fact, attendance figures have surprised even the most optimistic members of the Kauffman Center's board and staff. When the doors first opened in 2011, over 55,000 people came to view the new facility—double what the center's management had forecast.[12] In its 2011 season, the Kansas City Symphony, one of the center's resident companies, sold on average 98.5% of all the available seats for their performances. When we attended the Kauffman on the opening night of the Lyric Opera's production of *Il Trovatore*, there was barely an empty seat in sight.

Instilling a sense of civic pride among members of the Kansas City community, attracting unprecedented levels of donor generosity, surpassing expectations in both earned revenue and attendance, successfully closing their $368 million campaign in February of 2013, and ending the fiscal year (and their second full season) with no deficit—these are all accomplishments the Kauffman Center's leaders have that help ensure the new facility's impact on the organization and its community.

How did the Kauffman's leadership group manage to accomplish all of this? In an interview with Jane Chu, the PAC's executive director since 2006, she pointed out a few important strategies that the center's leadership capitalized on during the project's planning and building process.

First, much of the PAC's and its resident companies' success in attracting audiences has to do with the extent to which the project's leaders were able to obtain community buy-in to the whole idea of the Kauffman Center and what it would do for Kansas City. Unlike many of the arts facility projects we studied, the Kauffman Center took full advantage of the availability of small donations (in addition to large ones). Some of these smaller gifts were in fact multiyear commitments that allowed people to pay in small increments over time. This strategy of encouraging small donations (even though this is labor intensive for a fundraising staff) was one of the ways in which the board was able to get a full spectrum of community members involved. "From the hair dresser to Kansas City's biggest philanthropists, everyone could be a part of this new organization," said Chu. In return, these donors could choose to add a child's handprint, age, and name to a commemorative wall on the inside of the building.

Chu said, "Our intent was to communicate to the community that we were building for the future, and one way we did that was to engage the future generations of Kansas City by giving them a place to put their mark." As a result, over a thousand donors each gave $1,000, many who would have not otherwise contributed. In other words, the Kauffman Center's approach was to make it easy for people to feel a part of the organization and feel like they had a stake in its success.

In terms of the governance structure of the Kauffman, the project leaders kept the board small—only seven people throughout the course of the project. By doing so, the organization was able to maintain nearly complete consistency in board leadership throughout the project and into its opening year. The "building board" continued on as the "operations board" after the facility opened, something that decidedly does not work well on some large cultural building projects, but in this case helped maintain a strong level of institutional memory among current board trustees.

Furthermore, the project utilized a unique governance structure that established a sense of clarity among leadership in terms of how decisions were made and carried out throughout the planning and building process. Early on, the Kauffman Center's leaders decided to form a special building committee *external* to the board that was composed of experts in various aspects of design and construction, but who were not trustees. By not calling it a "board committee," the leaders made it clear that the building committee was limited in their decision-making capacity. "They would bring recommendations to the board, and the board would say either 'yes' or 'no,' but we did not want them to be making final decisions," said Chu.

In addition, Ms. Chu spent a lot of time and effort on crafting an effective public relations strategy. First, she made sure there was only one person (herself) who would respond to the press; this helped ensure that the center was delivering a consistent message. Second, upon being hired, Chu brought an experienced political campaign manager on staff to help devise a comprehensive communications strategy. Third, before the building opened, she

hired a separate national public relations firm to get the word out beyond the Kansas City community. More than anything, however, Chu remembers that all of this took an enormous amount of work: "We all appeared at every event, wrote thousands of hand-written thank you notes . . . attending to the little details that go toward building relationships is so important."

A Community Fabric

There was also something less tangible that Chu believes contributes to successful facility projects, something that helped get the Kauffman Center built and the doors open. A particularly insightful leader (Ms. Chu has a Ph.D. in Philanthropic Studies), Chu understands how arts facilities are simply one part of a community's much larger infrastructure, and this understanding gave the facility project a strong edge. She articulated to us that cultural facilities cannot stand on their own; they will only flourish and be expected to produce the many things people expect of them if they are understood as one element within a broader community context. Without what Chu calls "the necessary fabric" in place, the outcome of building the PAC probably would have been a much different.

Chu firmly believes that in the late 1990s, when the planning for the facility started, the city was well poised for the development of a large-scale performing arts center. The demographic profile of the city at this time made it, in Chu's words, "P-A-C ready."

Before the planning and development of the Kauffman Center project took place, Kansas City was a city that was thriving. In the decade before the project broke ground, population levels in the Kansas City MSA were rising, education levels were high (and getting higher), and median household income levels were higher than the average median income levels for other cities in the United States.

Furthermore, the city had a relatively low stock of cultural offerings as compared to many other cities across the country. In 1990, on average, a U.S. MSA had 11.2 arts organizations for every 100,000 people; Kansas City only had 5.3.[13] On average, in 1990, a U.S. MSA had 4.8 arts and entertainment facilities for every 10,000 residents; Kansas City had 3.3.[14] This low stock of arts organizations, coupled with a growing demand from an increasingly educated and wealthy citizen base, indicated that Kansas City had less to offer its citizens in terms of its cultural supply than other cities.

Other than the distinctive alignment between the city's changing demographic profile and its lack of cultural supply, there were (and are) a variety of community characteristics specific to Kansas City that made it capable of supporting a resource-intensive PAC project like the Kauffman Center. Compared to the rest of the nation, Kansas City is home to a particularly strong and engaged foundation sector. In the year 2000, for example, the state of Missouri had more than 1,200 active foundations. They distributed $557 million that year alone, and of that total just six community

Table 2.1 Characteristics of Kansas City and All U.S. MSAs

	Kansas City MSA			Average of All U.S. MSAs		
	1990	2000	Change	1990	2000	Change
Population	1,636,527	1,836,038	12.2%	991,520	1,133,565	16.2%
Percent of population 25 and over with at least a B.A.	25.2%	30.3%	5.1%	21.4%	25.0%	3.6%
Median household income	$48,880*	$55,000	12.5%	$45,904*	$49,201	7.2%

Sources: U.S. Census Bureau, Census 2000 and 2010. Steven Ruggles, J. Trent Alexander, Katie Grenadek, Ronal Goeken, Matthew B. Schroeder, and Matthew Sobek. *Integrated Public Microdata Series: Version 5.0* [Machine-readable database]. Minneapolis: University of Minnesota, 2010.

Note: *In 2000 USD.

foundations gave almost 17%. By contrast, in Tennessee (a nearby state similar in size to Missouri), local foundations distributed only half of what Missouri's foundations did that same year.[15] Furthermore, the Greater Kansas City Community Foundation consistently gives more money than any other community foundation in the country—even more than the Chicago and New York Community Trusts, whose major cities are more than three and eight times Kansas City's size, respectively.[16]

In addition to the demonstrated capacity of the city's foundations, Kansas City's wealthiest residents give generously to the arts as well. According to the IRS, people who make over $250,000 allocate approximately 15% of their total charitable contributions to arts and culture. Compare this to the 2% given on average for persons with adjusted gross incomes below $200,000.[17] Kansas City's affluent residents giving 15% of their total charitable dollars constitutes a major commitment. And the more aggregate wealth there is, the more we can expect will go to arts and culture. In 2011, the state of Missouri ranked 35th in terms of the number of millionaires living there. While this ranking is not inherently impressive, the fact that three of the world's billionaires (Donald Hall of Hallmark Cards and Min Kao and Gary Burrell of Garmin, Inc.) also make their homes in Missouri likely has an impact on the support given by those committed to helping fund arts and culture in Kansas City.[18] Mr. Hall's family foundation, for example, is a generous contributor to the city's cultural sector.

There is also a distinct Kansas City ethos that helps strengthen and sustain cultural organizations like the Kauffman Center. First, many civic and corporate leaders actually live within the city itself (instead of in the

suburbs), and they therefore have a greater stake in what goes on there. For example, the current mayor of the city has plans to move into a new rental apartment complex in the very center of the downtown district. The connection between these civic leaders and their city helps create a particularly effective version of civic activism that manifests itself in broad support of civic improvement projects. Add to that the financial resources these leaders control, and it becomes easier to understand how capital projects are able to gain traction so quickly and effectively.

Finally, there are an array of local policies that help promote arts and culture. In 2007, for example, the city passed a tax-abatement provision for arts-related businesses in the Crossroads Arts District—a gallery district located directly adjacent to the Kauffman PAC. By subsidizing the leases of art galleries and other types of arts-related businesses, the city makes it comparatively easy for artist populations to live and work in Kansas City, thus helping create a creative presence downtown.[19] In addition, city restoration projects make use of a federal tax credit of 20% of rehabilitation costs on income-producing properties and an additional state tax credit of 25%.[20] Consequently, arts organizations, like the Kansas City Ballet that just renovated an abandoned power plant for $32 million, are able to create usable spaces and contribute to the artistic veneer of downtown.[21]

Perhaps most important, however, was that the will to build an iconic performing arts was present among Kansas City's civic and corporate leaders and its politicians from the outset. Those with the means to give and a consciousness of the importance of a project like this, both for the current residents of the city and for the city's longer term future, were willing to invest significant portions of their own fortunes in their city's future vitality. There is also likely some correlation between the scale of the citizenry's financial commitment to the city's cultural life year in and year out and the local government's support of policies that help promote the arts. As Chu told us, "Kansas City is an arts town." With the opening of the Kauffman Center, it is an arts town now more than ever.

* * *

We now turn to a city that is widely known for its range of entertainment offerings (the fine arts are only occasionally among these). Las Vegas is a globally recognized playground for the young and the old, the rich and the less rich, for single men and single women. With its over-the-top casinos, luxurious hotels, and fantastical stage shows, the city is a haven for those who want to let go and indulge in a venue far from their quotidian responsibilities. "What happens in Vegas, stays in Vegas," is a well-known tag line used by many who visit this metropolis in the middle of the Nevada desert.

Its reputation for being an iconic entertainment destination is exactly why, in the late 1990s, a group of prominent civic leaders decided Las Vegas needed a new performing arts center. At first glance, it would seem the city had enough entertainment to offer its citizens, but for the people

who lived in Las Vegas (as opposed to city's enormous tourist population) the type of entertainment Las Vegas made available was neither sufficient nor configured in a way that met the residents' needs and desires. Before the Smith Center for the Performing Arts was built, if you wanted to go to a show you and your guests had to walk long distances through a smoky casino; particularly with smaller children, this kind of situation was not ideal.

In the next story, we highlight exactly how and why the city of Las Vegas, guided by a group of influential and determined civic leaders, built a new performing arts center. Just like Las Vegas itself, building this ambitious new facility presented a huge risk for its proponents, especially as the construction phase took place, in part, during the Great Recession (an economic crisis that hit Las Vegas particularly hard). But just like those who built this gambling mecca in the first place, the city and its leaders decided to take that risk on a large scale—nearly a half a billion dollars in total. "Go big, or go home," is a maxim that suits the story of the Smith Center. We see how this monumental institution was built to serve the people who live and work in Las Vegas.

LAS VEGAS

Las Vegas is a relatively new city compared to others in the United States— it was established in 1905 and incorporated as a city in 1911. But even then, the city had its periodic economic woes. In 1917, the Las Vegas and Tonopah Railroad, a major line that connected the city to the goldmines in Goldfield, Nevada, went bankrupt, and a significant portion of the massive revenue it brought in shriveled and disappeared. As a result of this and other economic events, the city began to decline precipitously.[22]

Nevertheless, a gradual growth of industry began, as did the early stages of Las Vegas's tourism industry. In 1931, the building of the Hoover Dam caused the town's population to spike from about 5,000 to 25,000. The dam workers were primarily young, single, and male, and an ideal market for a gambling and entertainment industry. With gambling formally legalized in 1931, the city continued to capitalize on its opportunity to become the country's preeminent entertainment destination. In 1935, with the Hoover Dam completed, Southern Nevada Power began to provide electricity to the city, and the long period of expansion began. In the 1940s and 1950s, many of the city's most famous hotels and casinos were constructed, made possible, in part, by a new influx of workers who migrated to the area to take jobs at the Nevada Testing Site. The next few decades brought both rapid population growth and an explosion of development— from the mega-resorts that line the Strip to the single-family homes that spread out miles beyond the city and are the epitome of urban sprawl. Las Vegas was thriving.[23]

Table 2.2 Characteristics of Las Vegas and All U.S. MSAs

	Las Vegas MSA			Average All U.S. MSAs		
	1990	2000	Change	1990	2000	Change
Population	741,368	1,375,765	85.6%	991,520	1,133,565	16.2%
Percent of population 25 and over with at least a B.A.	14.4%	17.7%	3.3%	21.4%	25.0%	3.6%
Median household income	$47,431*	$51,200	8.0%	$45,904*	$49,201	7.2%

Sources: U.S. Census Bureau, Census 2000 and 2010. Steven Ruggles, J. Trent Alexander, Katie Grenadek, Ronal Goeken, Matthew B. Schroeder, and Matthew Sobek. Integrated Public Microdata Series: Version 5.0 [Machine-readable database]. Minneapolis: University of Minnesota, 2010.

Note: In 2000 USD.

The city's rapid population growth, matched by an expansion of its physical infrastructure, gave Las Vegas a boomtown reputation. In the decade during which the planning for the Smith Center took place, population in the Las Vegas MSA increased by 85.6%, making it one of the fastest-growing regions in the country. The city's demographic profile, however, remained relatively stable throughout this period. Historically, the proportion of residents with college degrees has been lower in Las Vegas than the average across all U.S. MSAs. Furthermore, between 1990 and 2000, Las Vegas saw a smaller increase in educational attainment than the average U.S. MSA.

To a large extent, however, the economics of Las Vegas are driven not by the city's resident population, but by its wealthiest strata. Las Vegas is home to four Fortune 500 companies and has a significant concentration of wealth concentrated among a group that works primarily for the hotel and casino industry.[24] While it is this industry and these people that contribute disproportionately to the city's economic success, they also remain especially vulnerable during times of economic distress. For example, when the economic recession of 2008 triggered major declines in tourism across the country as a whole, the financial impact on Las Vegas and its most powerful and affluent residents and companies was devastating, and the ripple effect on the city's economy can still be felt. On one central artery, Las Vegas Boulevard, one can see firsthand the striking evidence of economic carnage: cyclone fences surround lifeless construction sites with acre after acre of partially completed mega-hotels and casinos. Between 2007 and 2010 the city's unemployment rate increased from 5% to 15%.[25] And the foreclosure rate in the city continues to be one of the highest in the nation.[26] With

average hotel rates plunging from over $300 a night to well below $100 in a matter of a couple of months, the tourism industry—the lifeblood of Las Vegas—found itself in jeopardy. A number of other major hotels and casinos, like the $2.9 billion Fontainebleau hotel and resort, went bankrupt soon after they opened.[27]

THE SMITH CENTER FOR THE PERFORMING ARTS

A quick look at a map of Las Vegas reveals a city basically partitioned into four quadrants, divided by two major thoroughfares. They intersect in downtown Las Vegas, or "Old Vegas." In contrast to "The Strip"—the area of town containing an array of elaborate hotels and opulent casinos—Old Vegas is decidedly not glamorous; with older, seedy casinos, restaurants, and memorabilia stores. A walk through Old Vegas feels like an American popular culture historic theme park.

Nevertheless, the area around Old Vegas has recently seen rapid and startling changes. Once the location for a Union Railroad switching station, a large plot of land that sits on the western border of Old Vegas is now home to a new Children's Museum, a brain-health clinic, a five-million-square-foot merchandise mart (a behemoth that showcases home and hospitality furnishings), a few restaurants, and now the Smith Center for the Performing Arts (and its adjoining park). Civic leaders envision this area (popularly referred to as "Symphony Park") eventually becoming a 61-acre mixed-use urban community with four distinct "districts": a civic district (that includes the Smith Center and the park), a specialty district (that will include a wide range of hospitality, specialty retail, and a hotel/casino), a residential district (that will include a mix of high-rises, townhomes, live/work condominiums, and mid- and low-rise condominiums), and a medical office district (anchored by the brain-health clinic—a Frank Gehry–designed building erected in 2010).[28] More prominently, leaders hope that the area will help recast the image of Las Vegas from a town that caters only to its vast tourist market to one that focuses with equal energy on improving the quality of life for its own citizens. The Smith Center (TSC) for the Performing Arts, which opened in March of 2012, is a key component of that vision.

Seeing TSC for the first time likely replicates what happened to New Yorkers when they walked into the Metropolitan Museum of Art building for the first time in 1880 or San Franciscans with the War Memorial Opera House when it opened in 1932. Both the scale and the exterior and interior architecture and design features are incredibly imposing. With an art deco–inspired vernacular, architect David M. Schwarz stipulated that the exterior of the building be constructed almost entirely of Indiana limestone. The interior is clad with multiple varieties of imported Italian marble and custom-cast stainless steel railings and lighting fixtures.

Despite its singular architectural style and formidable scale (at least in relation to the rest of this relatively young city), the Smith Center exudes an air of confidence and permanency, as though those who conceived and built it are certain it will be flourishing a century from now. "Our intention was to build something that would last forever," said Dr. Keith Boman, a board member, a cardiologist, and one of the initial enthusiasts for the project.

Whereas much of the downtown casino interiors are clad with Styrofoam and plastic to achieve theatrical visual effects at an affordable price point, TSC spared no expense to give its viewers that feeling of gravitas its founders wanted them to have. Similar to the Hoover Dam, which was built during the Great Depression, TSC with all its accoutrements is meant to demonstrate to the people of Southern Nevada that they are capable of greatness.

Arguably, the most impressive element of the new facility is its 17-story, 170-foot, carillon bell tower—with 68,000 pounds worth of hand-cast bells—that extends upward into the Las Vegas sky and can be seen from miles away. The tower, with its 47 custom cast bronze bells, was designed with the intention of being the tallest standing structure in the new development. The Smith Center's leaders and its architect did not want the building

Figure 2.2 Exterior view of the Smith Center for the Performing Arts, Las Vegas, Nevada.

Credit: Photo by Geri Kodey courtesy of the Smith Center for the Performing Arts.

to be eclipsed as the area continues to grow and other structures appear on the skyline—they have been clear from the outset that no matter what is built around it in the future the Smith Center will be a visible and inspiring icon for the community. It is designed to pull people in and, with its multiple venues, to become a center of cultural activity for the community and a symbol of civic unity.

Every detail of the building, including the bell tower, the Venetian plasterwork that lines the lobby walls, the woven mohair seat covers in the main hall, and even the custom-designed refuse containers that mimic the outline of the bell tower, were carried out with the patron's experience in mind. The Smith Center, explains president and CEO Myron Martin, "was built to be the living room for Las Vegas."

As opposed to serving the people who visit Las Vegas as tourists, the vision for TSC was to build a new facility that could serve a small but distinct cohort of residents who have made Las Vegas their home and are committed to its future. And the hope is that this new cultural amenity will help attract others to come to this desert metropolis and do the same.

"We kept hearing from hoteliers, 'In order for us to attract the types of executives and creative thinkers we want, we have to have something like [the Smith Center] to provide a cultural infrastructure,'" said Martin. "These executives are telling us, 'I know what I'm going to do when I get to Las Vegas—I'm going to work 24–7—but what's my family going to do?'"

TSC was designed with the goal of not only making cultural activities available to residents, but to help generate civic pride. As Kim Sinatra, a member of TSC's board and general counsel for Wynn Resorts, explained, before the opening of TSC there was really nowhere else for community residents to go. The commercial districts were designed for tourists, not residents. And the casinos are not conducive to socializing with family and friends. "[TSC] is a place where you can dress up and wave across the grand lobby to your friends on a Saturday night," said Sinatra. And this is something very new in Las Vegas.

From looking at the timeline of the Smith Center's development, it is hard to understand how an arts facility, as enormous and opulent as it is, could actually get built and opened during the middle of the Great Recession. Unlike other cultural facilities constructed during this period— the majority of which saw the cost of building materials spike, donors drop out, or local governments that had promised financial support wilt under pressures from the needs of their municipalities and a simultaneous decrease in tax revenues—the Smith Center was built both on time and on budget. By the time the center broke ground in the spring of 2009, much of the fundraising for this $480 million structure had already been completed. But when it opened in March 2012, TSC had officially concluded its capital campaign, which included funds raised for construction, a substantial initial endowment, land, infrastructure, and operating costs through opening night.

Certainly a time to rejoice, TSC opened with a gala and performance as opulent as the facility itself. Hosted by Neil Patrick Harris and headlined by Jennifer Hudson, Carole King, Willie Nelson, and Joshua Bell, among others, the celebration was professionally produced and broadcast on PBS.[29] It was a fitting inaugural for a building that in many people's opinions beat the odds.

Clearly, being willing to take on a nearly half-billion dollar project in the midst of a very weak economy shows a robust appetite for risk. And it was not as if TSC's leaders did not understand the position they were placing themselves in. As Martin explained, "It was a leap of faith. But we knew we had to give it everything we had and, at the same time, try our best to limit the amount of risk we were taking."

Martin was right, and continues to be as he leads the center through its first years. Both the scale of the project and its location in a city with myriad other ways to spend leisure time made building the Smith Center a situation that those who were more risk-averse could not have comfortably lived with. This fact makes one wonder what would have happened if something on the scale of TSC had been proposed in another city. Was it the familiarity and comfort level with making bold, risky decisions (multibillion-dollar investments in hotels and casinos) in Las Vegas that made this kind of undertaking easier to pitch to foundations, individual donors, and the state and local government? Only time will reveal how sustainable this cultural facility is, but we can learn from the strategies TSC's leaders deployed during the process of planning and building, all of which will ultimately have an impact on the PAC's long-term viability.

Commitment of Leadership

Myron Martin's involvement with the center began in 1998 when TSC's leaders approached him and asked him to volunteer for their plan to build a new performing arts center in Las Vegas, and he consented. Not only does Martin have degrees in both music and business, but his long history in artistic management made him an ideal candidate for the position. In Las Vegas specifically, Martin had begun to make a name for himself for successful artistic programming efforts at the University of Nevada-Las Vegas Performing Arts Center. He also was familiar with the Las Vegas philanthropic community, having served as executive director of the Liberace Foundation. For the first few years, Martin volunteered as one of the center's only operations staff. His office was located in a rented office space just a short distance from where the Smith Center now stands. He and three other volunteers made it their task to help make this proposed cultural facility a reality.

Martin's long tenure with the project, starting with the planning, building, and then finally the opening and first months of a fully operational facility, is one key element in its success. He has perhaps the most comprehensive

institutional memory of anyone associated with this ambitious project, and probably more than any other CEO we have encountered in the cultural building projects we studied. On a tour of the Smith Center, he knew every detail about every nook and cranny in the facility. On a Saturday night when we visited, Martin and his vice president and COO, Paul Beard, stayed until the last show had ended and were up again early the next morning to prepare for the next show starting. These are positions that, at least in the first few years of operation, require onsite work both during the week and on weekends. Both Martin and Beard are clearly committed to the long-term success of TSC.

Paul Beard is a more recent arrival to the TSC's executive leadership cadre. He joined the center's staff well after Martin did and well into TSC's trajectory, but he is among the most experienced professionals in the business of bringing performing arts center facility projects on line. Before coming to Las Vegas, Beard opened both the Bass Performance Hall in Fort Worth and the Kravis Center for the Performing Arts in West Palm Beach. At TSC he was able to build on his previous experience, thus contributing significantly to the center's overall performance.

In collaboration with their board, Martin and Beard run TSC like a carefully calibrated business. For example, before it had anything else, the Smith Center wrote up a business plan, and to this day the center's leadership sticks to that plan. It includes clear revenue and expense goals based on *pro formas* that were drawn up well before the Smith Center's opening.

In 1999, when Martin and board chairman Don Snyder wrote the business plan that would lead the center through its development all the way to opening night, and then guide TSC's operations, they said that the PAC would be two things: "It would be a public/private sector partnership— 50/50—and it would serve the community."

The board and the executive staff stuck to that plan. Almost $200 million of the project cost was funded publicly: the city of Las Vegas provided land, environmental clean-up of the contaminated site, infrastructure, parking, and an additional lump sum of $69 million. In addition, the project utilized $121 million in the form of increased rental car taxes bonded by the city of Las Vegas, Clark County, and the Nevada legislature. The rest of the project was funded by foundations and individual donors, including $150 million in gifts from the Donald W. Reynolds Foundation.

Myron and Beard continue to aggressively target their revenue goals with the center's programming, which is largely geared toward serving the community. On the night we visited the Smith Center, we saw a performance of the Zion Youth Symphony and Chorus—a group composed of a large Mormon youth choir and musicians from the greater Las Vegas area. TSC also operates an ambitious arts education program in a purpose-built facility within the center. Additionally, the center maintains partnerships with the Clark County school district to provide arts education and teacher training, in addition to collaborating with both the Kennedy Center's "Partners

in Education" program and the Wolf Trap Institute for Early Learning Through the Arts.

The task of building staff capacity, particularly among leadership, was not an easy one. Not only did the PAC's early leaders have to determine how exactly the presence of TSC and its cultural offerings would actually motivate people to move to Las Vegas, they had to begin by persuading some key people from elsewhere to join their staff. When Martin proposed to the board his plan to recruit what he called "the dream team of arts management from around the country," he said, "people snickered. But I had this idea that I would get basically the best people I could get to move to Las Vegas and help lead this project with me. I thought of people like Paul [Beard], and Richard Johnson [the former CFO]."

In 2006, when Martin approached Beard and asked him if he would consider moving to Las Vegas, Beard demurred. For many of the same reasons corporations expressed having difficulty with recruiting talent, Beard was skeptical. But eventually he came on board. "Paul," said Martin, "was the solution to the problem we were trying to fix for the community of Las Vegas."

Both Beard and Martin live within close proximity to the center because they spend a large portion of their waking hours there. As Beard put it, "You don't run these buildings commuting. It's impossible." In fact, many of the executive leaders we spoke to who opened new facilities and started new organizations admitted to spending more time at work than they did at home, especially in the first three years (Jane Chu, the former CEO of the Kauffman Center, also lives near the PAC and had a bathroom and shower installed in her office so she would not be obliged to go home before evening performances. Chu told us, "[Opening a new PAC] is like raising an infant; for the first year, you're constantly at its side, making sure it's alright, making sure it's developing in the way it's supposed to. You ease up a bit in the second and third years, but basically, you don't really let go until it's time to go to preschool).

Beard and Martin exemplify the kind of intensity, focus, and passion that is essential to making a new arts facility a success, and these attributes are also found among TSC's board of trustees. Take, for example, Dr. Keith Boman, a lifetime Las Vegas resident who has continued to serve on TSC's board from the very beginning of the project and who, as a rule, attends one or more performances a week. A native of southern Nevada, he attended high school in Las Vegas and continues to serve on the board of numerous area nonprofit organizations. A strong arts advocate, he played a key role in the early stages of the Smith Center's development. He was part of the initial group of enthusiasts that came together in 1994 and decided the Las Vegas community needed a performing arts center. To honor his more than 18 years of effort in making the idea for the project a reality, the board named a cabaret-style theater for him: the Boman Pavilion.

The chairman of TSC's board, and Boman's colleague, Don Snyder, is similar in the strength and durability of his commitment to TSC. He, too,

was part of the initial group of civic leaders that came together in 1994 and launched the effort to build the Smith Center.

The commitment of TSC's leadership—including that of both executive leadership and the board of trustees—is remarkable both in terms of the number of years these individuals committed to the center (and continue to) and the tenaciousness with which they worked to make sure that the PAC actually got built and opened. They understood that fulfilling the original vision of building a new cultural destination for the city of Las Vegas would require the sustained commitment of a powerful cadre of civic, political, and philanthropic leaders.

For those willing to support this vision, TSC's leaders made sure to show how grateful they were. For example, the center includes on the third floor a very well-equipped Donor's Room that serves as a venue for trustees and major donors prior to the performance and then again during the intermissions. The architectural details of the space give credit (sometimes very subtly) to some of key TSC's supporters: from the bronze sculpture of an Arkansas Razorback boar (a favorite of the late Mary B. Smith, who was the wife of Fred Smith, for whom the Smith Center is named), to the irises that line the walls of the lounge (also a favorite of Mrs. Smith's), these and several other motifs appear as thank you notes to those who made the project possible. With constant reminders of how each of these key supporters contributed to making this grand vision for a performing arts center in Las Vegas a reality, they continue to stay engaged.

Overcoming Challenges

Like other performing arts center projects we studied, TSC engaged in a very long and arduous planning process. In fact, planning for the facility took five times longer than construction itself—about 17 years! Planning began in earnest in 1994 when Steve and Elaine Wynn (of Wynn Resorts) organized a group of 60 or so civic leaders that included Don Snyder, Keith Boman, John Goolsby (former head of the Howard Hughes Corporation), Nancy Houssels (cofounder of the Nevada Ballet Theater), and Scott Mac-Taggart (an attorney) and met with them at the Golden Nugget Hotel and Casino in Old Vegas for a community "call-to-action" meeting. Two years later, the group established the Las Vegas Performing Arts Foundation, which would become the 501(c)(3) that operates TSC. The next decade would be filled with nonstop planning, political maneuvering, and fundraising by TSC's leadership team, driven by a total commitment to the vision of a new performing arts center for the citizens of Las Vegas.

The first major hurdle TSC's leaders had to overcome was demonstrating to the Las Vegas community that the idea of building a performing arts center within the city limits was a viable one. In 1999, when the Smith Center was still only an idea, there was another group in the valley that was pushing for a performing arts center to be built in the suburban enclave of Summerlin.

Both PACs had strong advocates; for example, those in favor of a down-town PAC project believed that putting a cultural facility in an economically distressed area could spur development. In contrast, those in favor of a Summerlin PAC thought the facility would be accessible to a broader audience than if a PAC were built downtown and would come closer to justifying the substantial investment that would be required. The Summerlin group also planned to use only privately donated funds, whereas the downtown PAC's supporters adamantly argued that the project needed to be a public–private venture. Both groups went up before the Clark County Commission, but in the end it was the downtown PAC project that was given the green light by the local government.[30]

The next major milestone was getting the county to agree to the proposed downtown location. Early in the process, TSC's leadership hoped that the center would be built on the vacant Union Pacific rail yard adjacent to many county government buildings. But the local government wanted to reserve that site for additional government-owned and operated buildings. It took four years for TSC's leaders to secure this parcel of land, but finally the city council agreed to donate part of the vacant 61 acres to the performing arts organization. The city now designated a significant swath of this property to the Smith Center team so that it could build a "world-class performing arts center" for Las Vegas residents.[31]

Now that the idea was fleshed out and the land secured, TSC's leadership turned to fundraising. The first big hurdle was surmounted in 2003 when the Nevada legislature gave preliminary approval for a dedicated car rental tax that would be used to fund the construction of a PAC. Getting final approval proved, however, to be a serious struggle. The center received significant pushback to the idea of a rental car tax (especially from the car rental industry). Bernie Kaufman, then acting president of the Nevada Car Rental Association, was quoted as saying, "The more taxes they add to our industry, the more it is going to hurt our business."[32] Given the central importance of the tourist industry, these arguments were taken seriously, but with two years of effort they got the county, city, and state to approve the new tax.

Even as they were getting the publicly funded portion of the project sorted out, TSC leadership was simultaneously working on generating substantial private donations. The initial "quiet" phase of the fundraising campaign officially began in 2005. In March of that year, the Donald W. Reynolds Foundation announced they would gift $50 million to TSC's endowment. At that time, the Reynolds Foundation's contribution represented the largest single charitable gift ever received by an organization in Nevada. But that was soon to be trumped. In 2007, the foundation announced an additional gift of $100 million for a main hall and education center, again the largest single charitable donation in the state's history. Combined with the public funding portion of the project, the center's private contributions allowed leadership to deliver on their promise that the project would be a public–private partnership, split 50/50.

Achieving Its Vision

For TSC's leadership, the realization of their initial vision was partly achieved when the doors opened on March 10, 2012. However, their plan to "serve the community" with this dramatic new cultural facility is still playing itself out today with the variety of programming the center offers (very distinct from what the Strip offers) each season to a wide spectrum of the community.

When visiting the Smith Center on a weekend in November, we saw first-hand the diversity of audiences the programming caters to. On the first night we attended a performance of Brazilian/Funk music by Sergio Mendes and Candy Dulfer in the main hall; Sam Harris, a Broadway performer, performed in the Boman Pavilion cabaret space on the second night; and on the third night, there was a performance of the Zion's Youth Symphony and Chorus. Mendes and Dulfer played to a full house of energized Latin music fans, many of color, and a group of hundreds of schoolchildren; the performance by Harris was mainly attended by middle-aged and older couples looking for an entertaining weekend night out; and the audience on the third night consisted of families bonded by community and religion. In its entirety, the weekend audience we saw was an illustration of audience diversity: young and old, black and white, male and female—overwhelmingly composed of residents, and thus a fulfillment of the initial vision TSC's leaders had for a performing arts center for those who made their home in the city and suburbs of Las Vegas.

Interestingly, a new small subpopulation of TSC attendees has emerged as well—one not initially anticipated at the outset of the project. The unique cohort of professionals who not only makes Las Vegas their home but who also work in entertainment establishments located on the Strip have utilized TSC for its cultural offerings and for its employment opportunities. Dancers, costumers, musicians, producers, set designers, sound technicians, and circus performers—these are all the people who both live and work in Las Vegas, and also seek entertainment options beyond their occupational obligations. This resident population also offers the Smith Center some of the best technical talent in the world, which they make use of in the production of the center's own performances. It is too soon to tell the impact that this segment of the Las Vegas population will have on the center's operations, but for a PAC in its initial fragile stage of development even a small impact can be helpful.

If you consider the audience it draws, the people it employs, and the leaders who run it, the Smith Center for the Performing Arts appears to be well on its way to achieving its mission of becoming "the living room for Las Vegas." Even if they have not yet been to the PAC, Las Vegans know about the center and are proud of it. On separate occasions during our visit, both a taxi cab driver and a waitress asked us if we had been to the Smith Center, and both were very excited about its presence and were anxious to know what we thought.

The question, then, is whether the residents of Las Vegas will embrace the center and support it at a level that will sustain it for the long term; TSC needs an enormous revenue base in order to maintain its opulent and impressive facility. Will the Las Vegas community commit to this new kind of performance venue? And will that commitment, as it grows and solidifies over time, carry the center through another major economic crisis should that occur? Vision, tenacity, and a powerful belief in the importance of the mission of the new PAC and its role for the future of Las Vegas—maybe these will be enough to help the Smith Center, its management, and the community hit the jackpot.

* * *

There are a number of similarities between the Kauffman Center and the Smith Center that helped lead to their early stage success. Both projects maintained consistency of vision from the time the idea for the facility was hatched to the project's completion. It was Muriel Kauffman who first articulated her vision for the city she was so devoted to and had done so much to help build. In turn, her daughter Julia made the realization of her mother's vision possible. From the beginning, the Kauffman Center would serve the community of Kansas City, but would also be a home for two of Kansas City's major arts groups—the symphony and the opera. Today, the Kauffman achieves this vision by balancing its programming between an extensive presenting series and its resident companies' performances.

In Las Vegas, it was a relatively small but very powerful group of civic leaders that pushed their vision for a PAC that would be a 50/50 public–private partnership. Using all the tools and connections at hand, they managed to get both the public sector and the private sector on board relatively early, which then gave the project momentum. By articulating their vision clearly in a business plan from the outset, TSC's leadership created a way to provide regular reminders of what exactly they had set out to build. And, most importantly, they stuck to it.

Successfully implementing a vision requires constant monitoring and managing throughout the planning and development stages of a cultural building project. Attention to both the details, and to the plan as a whole, has to be constant. The price of not doing this is that a sequence of incremental changes may unfold that will fundamentally alter the initial vision. These projects can, and sometimes do, change dramatically from the moment the project is conceived to its opening years later. This, in turn, can significantly impact both the timeline to completion and the ability to stay on budget. Particularly when major vision changes take place during the construction phase, this can add both time and money to the project. Those projects that had major vision changes take place had, on average, six month longer construction timelines (and cost escalations that were 43% higher) than those that did not. The Kauffman Center and Smith Center projects, which came in on time and on budget, give further credence to the idea that marked

clarity and a strong commitment to the vision throughout a project's process of unfolding results in smaller budget increases and more effective timeline adherence.

In addition to preventing unplanned scope increase, committing to a vision over the long term can also help a project attract external private support with donors that have been following the project. As one director of a theater put it, "If there is clarity of vision, then there's a consistency of message, and then it's easy to sell the idea. If you don't have that, then there's going to be a lot of talking and a lot of frustration"—and an increase in the possibility that the project could go off the rails.

But with any cultural building project, vision alone is not sufficient. It is the skill, judgment, and focused dedication of a project leadership team that ultimately sees a project through to a successful end. Kansas City and Las Vegas' leaders had all of these. Each organization had an executive leadership team with the extensive experience and demonstrated track records (that, in turn, inspired confidence from donors, foundations, and government officials). They had the ability to competently and strategically keep these projects on track. Coupled with their commitment to the final outcome, the organizations themselves, and their own work, these people remained on board as the central drivers of these organizations' operations after the facility project was completed. Add to that the focus, devotion, and thoughtful and responsible managerial style of their boards that they bring to the task of building a long-term and viable organization (i.e., raising an endowment). With all of this, these two projects found the leadership formula they needed to build and maintain a new facility.

Assembling the right group of people to manage a cultural building project requires hand-picking skilled people with the necessary knowledge and experience at the very outset. As one PAC leader we spoke to put it, "Be sure to put together a professional, competent team early on to manage and oversee what is a very complicated process in terms of design, planning, cost control, construction and so forth."

With TSC, Martin made it his goal to recruit what he called "the dream team of arts management." The small, but extremely effective board assembled to take charge of building the Kauffman Center, in turn, selected Jane Chu, a remarkably able and talented individual who, in addition to opening a multimillion-dollar PAC, completing the capital campaign, and ending her second year in the black, also managed to finish her dissertation, and obtain her Ph.D. during the process. It is hard to overestimate the importance of strong, decisive, experienced leadership. The cost of not having this in place can result in very unwelcome outcomes.

It is arguably these assets (i.e., clear vision and the knowledge and expertise of project leadership) that enabled the Kauffman Center and TSC not only to be completed, but also to be able to do that during the worst economic downturn the United States has experienced since the Great Depression. Without these committed and skilled leaders, there would be no way

each project could raise the amount of private and public funds that they did, given the precipitous drop in contributions experienced by all arts organizations starting in late 2007.[33]

When placed in the context of their communities, the Kauffman Center and the Smith Center have very different outlooks for their long-term sustainability. Before the Kauffman Center, Kansas City had a demographic profile that was increasingly shifting toward one aligned with cultural participation. In the decade before this new facility opened, not only was the city growing in terms of its overall population, but the portion of that population known for supporting and attending the arts was consistently getting larger as well. In fact, Kansas City's education and median household income levels were higher than the average MSA and were growing more rapidly as well. Therefore, not only did Kansas City seem well poised to build the PAC based on its long and extensive history of supporting civic improvement projects, but its demographic profile hinted at the development of a community equipped to support a cultural institution over the long term.

The city of Las Vegas, by contrast, has only just begun its foray into large-scale capital improvement projects whose primary purpose is to serve the local community—this being the very reason that civic leaders thought a project such as the Smith Center was necessary in the first place. In addition to little historical precedent for supporting and attending the arts in Las Vegas, the region's demographic profile is one that does not suggest demand for the arts was present on a large scale. While population in the Las Vegas MSA exploded previous to building TSC, the city as a whole still maintained a level of education that was lower than the national average. Moreover, Las Vegas' education level was not growing steadily enough in the decade before TSC to suggest the long-term demand and ability to support major culture venues. Las Vegas was booming when the major investments in TSC were made, but by the time the PAC was finished, that had profoundly changed. Since 2000, the population of the Las Vegas MSA has grown at about half the rate than the previous decade, whereas the population of the Kansas City MSA has continued to steadily climb.[34]

Therefore, as with so many cultural facility projects we studied, the community in Las Vegas decided to take a huge risk by investing in a "If you build it, they will come" project—as opposed to the strategy of waiting until they come before you undertake to build something of this scale and complexity. Obviously, there are skeptics about the effects building cultural facilities can have on blighted areas. As one museum director we spoke to put it, "We're just way too optimistic about what new buildings, especially those built by famous architects can do. A city is not going to change just because you have another interesting piece of architecture." On the other hand, there are many, like TSC's leaders, who believe in the power of the arts to revitalize regions. Otherwise, they would not have invested as much time, effort, and money as they did to build TSC. Only time will tell how

successful their efforts will be, not only on the organization, but also on the economic development of Old Las Vegas.

NOTES

1. This case study is partly based on interviews we conducted with Jane Chu, former executive director of the Kauffman Center for the Performing Arts, and Eric Youngberg, senior management consultant at NeighborWorks America.
2. Montgomery, Rick, and Shirl Kasper. *Kansas City: An American Story.* Kansas City, MO: The Kansas City Star Co., 1999.
3. Hallmark Corporate website. "Hallmark History and Timeline." http://corporate.hallmark.com/Company/Company-History.
4. Carty, Sharon Silke. "All in the Family: Missouri Cousins run 2 Top-rated Banks." *USA Today.* May 27, 2010.
5. Russell Stover website. "About Russell Stover Candies." www.russellstover.com/jump.jsp?itemType=CATEGORY&itemID=657.
6. H&R Block website. "Company." www.hrblock.com/company/.
7. Knapp, Alex. "Kansas City Is Boosting Its Tech Startups with Launch KC." *Forbes.* October 4, 2012.
8. Spencer, Laura. "Do Cities Need Old Buildings, Even if They're not Historic?" *Kansas City Public Media.* February 8, 2013.
9. "Illness Unmasks Generous Secret Santa." *The Associated Press.* November 16, 2006.
10. Ewing Marion Kauffman Foundation website. "Our Founder Ewing Kauffman." www.kauffman.org/who-we-are/our-founder-ewing-kauffman.
11. Union Station Kansas City website. "Timeline." www.unionstation.org/timeline.
12 Hall, Holly. "Donors from All Walks of Life Made Mo. Arts Center Possible." *The Chronicle of Philanthropy.* October 14, 2012.
13. National Center for Charitable Statistics. Urban Institute. Washington, D.C.
14. U.S. Census Bureau. County Business Patterns Data.
15. The Foundation Center website. "Aggregate Financial Data by State—2000."
16. The Foundation Center website. "25 Largest Community Foundations by Total Giving."
17. Congressional Budget Office. *Publication No. 4030, Options for Changing the Tax Treatment of Charitable Giving.* Washington, D.C., 2011.
18. Phoenix Marketing International.
19. "Crossroads Artists Win Tax Abatements." *Kansas City Business Journal.* October 26, 2007.
20. Kansas City Historical Society website. "Tax Credit Basics." www.kshs.org/p/tax-credit-basics/14673.
21. Collison, Kevin. "Ballet Home Gets Historic Preservation Honor." *The Kansas City Star.* October 30, 2012.
22. This case study is partly based on our interviews with the Smith Center's staff and board trustees, including Myron Martin (president and CEO), Paul Beard (vice president and chief operating officer), Dr. Keith Boman (vice chairman of the board of trustees), and Kim Sinatra (secretary of the board of trustees).
23. City of Las Vegas website. "History." www.lasvegasnevada.gov/factsstatistics/history.htm.
24. CNN Money website. "Fortune 500."
25. U.S. Bureau of Labor Statistics.

26. Smith, Hubble. "Local Evictions Dropping, but Las Vegas Still Leads Nation." *Las Vegas Review-Journal.* November 18, 2012.
27. Green, Steve. "Court Sides with Contractors in $100 Million Dispute over Fontainebleau Bankruptcy." *Las Vegas Sun.* July 28, 2011.
28. City of Las Vegas website. "Symphony Park." www.lasvegasnevada.gov/ Government/7598.htm.
29. "From Dust to Dreams: Opening Night at the Smith Center for the Performing Arts." DVD. Public Broadcasting Service, 2012.
30. Moller, Jane. "Rival Groups Present Plans for Arts Center." *Las Vegas Review-Journal.* October 29, 1999.
31. Squires, Michael. "Las Vegas Sets Aside Part of Parcel for the Arts." *Las Vegas Review-Journal.* May 22, 2003.
32. Geary, Frank. "Rental Car Tax Linked to Facility." *Las Vegas Review-Journal.* September 22, 2003.
33. *Giving USA 2013: The Annual Report on Philanthropy for the Year 2012 Data Tables.* Chicago: Giving USA Foundation, 2013.
34. U.S. Census Bureau. Population Estimates.

3 The Southern Boom

In contrast to the late nineteenth and early twentieth centuries, when we saw cultural facility building take place primarily in the nation's great industrial cities of the Northeast and Midwest like New York, Boston, Chicago, and Cleveland, the recent building boom was centered (at least statistically) in the South. The total cost of cultural building was much higher in the southern region than any other region in the United States between 1994 and 2008. It made up 32% of the total cost of all regions as compared to 25% in the Midwest, 20% in the Northeast, and 23% in the West.[1] From Texas to Florida, Virginia to Kentucky, cities were building cultural facilities like never before. These were PACs and museums, both privately and publicly supported. Some were planned as anchors for economic development; others were built to provide homes to existing arts organizations or to pay tribute to local civic leaders. All of them were built in the context of the southern region's rapidly changing demographics.

Taken together, the southern region became more dense, more educated, and wealthier faster than any other region in the country in the decade prior to the modern building boom. Between 1990 and 2000, population grew by approximately 17% in the southern region of the United States, compared to 8% in the Midwest and 6% in the Northeast. While population also grew in the western region (by 20%), the percentage of educated people that comprised the southern region's population increased at a faster rate than in other regions. The percentage of the population with at least a college degree grew by 44% in the southern region between 1990 and 2000, compared to 40%, 37%, and 29% for the West, Midwest, and Northeast regions, respectively.[2] Furthermore, per capita GDP increased faster in the southern region than in other regions.[3]

Additionally, the southern region had fewer cultural facilities to start with than any other region. The Northeast and the West had the largest number of cultural facilities (about 10 per 100,000 people), the Midwest and the South the least (about 5 and 4 per 100,000 people, respectively).[4] So at the beginning of the decade, there were about twice as many cultural facilities per capita in the Northeast and the West than there were in the Midwest and the South. This pattern holds for theaters and performing

arts venues, but less so for museums, although it is important to note that the South still has the lowest number of museums per capita of any region. This suggests that if the South wanted to "catch up" to other regions in terms of the number of cultural facilities it already had, it would have to build more. It is likely then that population growth, education, and wealth increases had much to do with high levels of cultural building investment in the South.

But demographics only provide part of the picture. The South, during the period before the modern building boom, was trying to retool and redefine itself. Wanting to distance itself from its reputation as a region rife with social and political conflicts, it has tried to position itself as an up-and-coming region with economic opportunity and an appreciation for cultural amenities. Cities in this region were using cultural facility projects as tools to transform their civic images from what they had been for decades prior. No more would the South be known as a region characterized by the prominence of racial inequality and a slow and easy pace of life. By building a cultural facility, city leaders in this region would prove to the rest of the country that their cities were now on the move economically and, combined with lower taxes and modest labor costs, they could compete culturally with cities in other regions as well. In the new prototypical southern city, one could now come and find a good job and a high quality of life at a lower cost, including a growing array of cultural amenities (and an easier climate than offered in the North, at least).

* * *

We now turn our attention to two South Florida cultural facilities, one in Miami and the other in Miami Beach, that illustrate some of the challenges of building PACs in a rapidly changing area. In later chapters, we consider other southern facilities that were part of this boom.

Largely a public works project, the Adrienne Arsht Center for the Performing Arts was built in 2006 for a staggering $478 million. It was initially envisioned (and planned) as a home to five major resident performing arts companies and as something that would help spur economic development in downtown Miami. But in the course of planning and building it, the strategic vision for the center dramatically changed and, as a result, the PAC continues to struggle with remaining relevant to the rapidly expanding and diverse population of Miami.

The New World Symphony decided to build its own concert hall (designed by Frank Gehry) five years after the opening of the Arsht Center. Following the leadership of the organization's artistic director Michael Tilson Thomas (MTT), plans were laid for a purpose-built facility directly across the street from its existing facility, and just 3.6 miles away from the Arsht Center, in what is now the flourishing and popular Miami Beach neighborhood that lies just a few blocks from the ocean. The organization has emerged as a pacesetter in the performing arts field, recognized for its skill at developing

new audiences, many of whom had little experience with the performing arts prior to the opening of the organization's state-of-the-art facility

MIAMI

It was not until 1896 that Miami was officially incorporated as a city. Miami Beach was created in 1913.[5] When compared with Kansas City (1853), Chicago (1837),[6] and Philadelphia (1701),[7] it is clear that Miami, like Las Vegas, is a relatively young city. Not only is the city relatively new, but due to its role as a major destination for Latin American immigrants a large percentage of Miami's population is composed of first- and second-generation residents. Thus in terms of its population's permanence and stability, the city is still in its developmental stage.

For many decades, the majority of Miami's Latino population had migrated from Cuba. More recently that has changed, and the region now includes a large population of immigrants from both South and Central America. The first wave of Cuban migration to Miami took place in the 1960s after Fidel Castro came to power. In 1980, the Mariel Boatlift facilitated the next mass exodus, with more than 150,000 Cubans arriving on Miami's shores.[8] And despite policy measures taken by the Clinton administration in the mid-1990s to ease the rate of migration among Cuban refugees, at least 20,000 new immigrants arrived in the United States every year, primarily to the Miami region.[9]

In the last 20 years, the Latin American population in Miami has steadily increased. Not only has the population expanded, but also because the city has gained a global reputation for being inclusive of its immigrants and welcoming to others, many have chosen to make Miami their home, even those from within the United States. As of 2010, the city of Miami's population was 70% Hispanic/Latino[10]—an increase of 52 percentage points since 1960. In addition to Cubans, the city also has a large population of Haitians, Venezuelans, Argentinians, Columbians, and various other Latin American populations. There are also distinct European communities in Miami, such as Portuguese, German, Italian, Middle Eastern, Chinese, and Greek.

While there are distinct cohorts of Miami's immigrant population that brought with them substantial wealth, the majority of these refugees came to the United States with relatively little capital, other than their own skills. There is, as a result, little history of a strong philanthropic community in the Miami region, particularly in relation to the arts. Those that do contribute to the city's cultural institutions typically only live in Miami part of the year, when they use the city as a winter escape from their northern homes. For example, many of Miami's wealthiest who serve on the boards the city's cultural organization boards have permanent homes in cities like Cleveland, Chicago, and Cincinnati—cities where the tradition of contributing to the arts is deeply rooted and has lasted for multiple generations. "Snow birds,"

Table 3.1 Cultural Characteristics of Miami and All U.S. MSAs

	Miami, FL MSA		Average All U.S. MSAs	
	1993	2000	1993	2000
Cultural organizations per 100,000 people	4.6	6.3	11.2	14.9
Cultural facilities per 10,000 people	1.9	1.9	4.8	3.8

Sources: National Center for Charitable Statistics; U.S. Census Bureau, County Business Patterns.

as they are sometimes referred to, have their philanthropic focus more in their cities of origin than in their winter retreats, which creates a challenging fundraising problem in Miami.

Prior to the first decade of the twenty-first century, Miami had relatively few cultural organizations and facilities. Well below the national average, the Miami MSA in 1993 had 4.6 arts organizations for every 100,000 people and in 2000 had 6.3. In both 1993 and 2000 the Miami MSA had 1.9 cultural facilities for every 10,000 people.

Because the city of Miami is largely inhabited by early immigrants and part-time residents, its cultural building initiatives have an ongoing challenge generating private support. As such, these cultural facility initiatives have required some form of public investment in order to materialize. In the last decade, many of Miami's most prominent civic leaders, including its political leaders, have made great efforts to expand the city's cultural offerings. In 2004, Miami-Dade County passed the Building Better Communities Bond Program, which, to date, is the largest capital construction bond program in the county's history. The program includes over $450 million for countywide cultural facilities development.[11] Between 1994 and 2008 alone, the Miami MSA had approximately 21 cultural building projects totaling at least $663 million in raw construction costs (not including the cost of fitting out each of these facilities). More recent and accurate estimates that include costs in addition to bricks and mortar value Miami's cultural building projects at more than $1 billion.[12] These projects include an approximately $17 million expansion at the Miami Children's Museum[13]; construction at a number of private museums, including the Bass Museum of Art and the Norton Art Museum; largely publicly funded institutions like the Perez Art Museum Miami at approximately $220 million[14]; a new $7.4 million headquarters for the Miami City Ballet[15]; and more than one major performing arts center. The new Patricia Frost Museum of Science (previously the Miami Museum of Science) is a $275 million facility funded by $165 million in city bonds and is slated to open in the spring of 2015.[16] The city also invested $50 million into the renovation and restoration of seven theaters and community centers.

THE ADRIENNE ARSHT CENTER FOR THE
PERFORMING ARTS: MIAMI, FLORIDA

In 2006, Miami's downtown became home to a new performing arts center, something the city could not have imagined happening a decade before. The PAC cost about $478 million to build—a cost that was $200 million more than was stated in the original budget. The timeline for the project was also substantially delayed multiple times throughout the construction process. In a gesture of appreciation to the Carnival Cruise Line for its $20 million gift to the project, the PAC opened as the Carnival Center for the Performing Arts. But less than two years after opening, the PAC was renamed the Adrienne Arsht Center for the Performing Arts to credit the eponymous donor who rescued the organization from financial catastrophe: in just its first year of operating the center ran a $2.6 million deficit.[17]

Like so many PACs we studied built during the modern building boom, the Arsht Center experienced severe financial difficulties once it opened. Many Miami residents believed that the center was too ambitious and too large a project to begin with. In 2007, a *New York Times* article reported that many community residents thought the project was a serious overreach (it even earned the nickname the "Carnivorous Center for the Performing Arts").[18] Alan Farago, one of Miami's prominent civic leaders, was quoted as saying the PAC project was "a total misappropriation of money." Edward Villella, executive director of the Miami City Ballet and one of the Arsht Center's resident companies said the center was ". . . too ambitious and premature for the city, and the community would have been better off building a more modest complex that could be expanded with time as the city's cultural life matured."

The PAC itself is a behemoth. Comprised of two separate facilities and connected by a pedestrian bridge, the center has three performance spaces—a 2,400-seat opera house, a 2,200-seat concert hall, and a 200-seat black box theater. The interior lobbies scale up multiple stories and are surrounded by additional event space. Even walking at a brisk pace, it can easily take 15 minutes to make one's way around the building's exterior.

Motivation to Build

In the early 1980s, several Florida communities had started the initial planning stages of new performing arts centers. The David A. Straz Jr. Center for the Performing Arts (initially the Tampa Bay Performing Arts Center) opened in Tampa Bay in 1987. Fort Lauderdale opened the $54 million Broward Center for the Performing Arts in 1991, made possible by a partnership between public and private entities. And in 1992, the Raymond F. Kravis Center for the Performing Arts opened in West Palm Beach at a cost of $55 million, fully funded by private donors.

Alongside these regional PAC planning efforts, officials in Miami were also in the early stages of thinking about building a new performing arts

Figure 3.1 Exterior view of the Adrienne Arsht Center for the Performing Arts, Miami, Florida.

Credit: Photo by Jeff Goldberg/Esto. Courtesy of Pelli Clarke Pelli Architects; Wikipedia Commons; College of Fine and Applied Arts.

center in the heart of downtown Miami that would be built through a public–private partnership (the majority of which would be public). There were two primary motivations for building. First, the PAC's leaders imagined it as a much-needed home for five resident performing arts organizations: the Florida Grand Opera (a resident company at the Broward Center), the Miami City Ballet (a resident company at the Kravis Center and the Broward Center), the Florida Philharmonic, the Concert Association of Florida (a resident company at the Broward Center), and the New World Symphony.

Both the serious financial difficulties some of these groups were experiencing and the relatively limited programming they were offering prior to building the new PAC were blamed on the fact that the companies lacked a suitable space for performance, thus their growth was being hindered. Two of the resident companies—the Florida Philharmonic and the Concert Association of Florida—had chronic financial problems. The latter ran a $2.5 million deficit on a $4 million budget prior to the PAC being built. Even so, both companies had ambitious plans for using the new performance center. The Florida Philharmonic initially projected using it 110 days per year as a dedicated symphony hall, even though they had never done anywhere near that many performances in a season. This was their basis for requesting that a purpose-driven hall be built in the first place.

The Concert Association envisioned playing in the PAC about 20 days per year. The Florida Grand Opera—a strong and financially solvent organization—projected about five operas per year split between the Miami PAC and the Broward PAC. The Miami City Ballet and the New World Symphony projected about four weeks per year and four to five dates per year, respectively. Combined, it was envisioned that the resident companies would provide the majority of the PAC's programming and fill the majority of the center's annual calendar. Curiously, the PAC's leadership anticipated only hiring about 35 staff to operate the facility, with the majority of those hires being devoted to maintenance of the facility as opposed to its programming. Moreover, the annual budget for the PAC was only projected to be about $8 million.

This enormous new performing arts center, with a very small staff, was envisioned as bringing life to the economically distressed area of downtown Miami. In fact, locating the PAC in an area in need of revitalization was a strategy the center's leaders deployed in order to acquire significant public funding for the project. It was argued by many of the PAC's initial supporters that Miami, in the 1990s, was changing from being a seasonal tourist destination to a year-round center for commerce, trade, and tourism. As such, just like other global business centers, the city needed cultural amenities to add to the community's expanding civic infrastructure. This reasoning helped persuade Miami's Chamber of Commerce and its Convention and Visitor's Bureau that this new performing arts facility was a good idea for Miami.

Governance

In order to appropriately assign responsibility for building and operating the PAC, leadership devised a complex governance structure that included a partnership between one public organization and two private nonprofit organizations. To give the resident companies primary control over scheduling as well as the organization's policies, the Performing Arts Center Trust was established. In addition, the Performing Arts Center Foundation was established to control fundraising for construction and the endowment. The trust and the foundation maintained their own separate staffs until 2004 when staffs were combined (the boards remain separate). Furthermore, Miami-Dade County and its political representatives for the project would be responsible for providing 85% of the design-construction funds and 35% of the operating budget. All three groups and all of their members had to work together to get the structure built and to plan for operations and for paying down any subsequent debt.

The trust's key responsibility was to manage and operate the new center. Many of the decisions made by the trust emerged from a smaller management committee composed of three members representing the resident companies, plus three members that were *not* associated with the companies.

This three-to-three design was a way to ensure that the resident companies could not be overruled by the others. Other members of the trust included representatives of Miami-Dade County, the cities of Miami and Miami Beach, the Dade County School Board, and two ethnically specific cultural organizations. Additionally, all business of the trust operated under the Florida Sunshine statute—a law governing public meetings that ensures the public's right of access to all deliberations.

The foundation's responsibility was to raise private funding for the center, which was initially planned to be 18% of the PAC's total construction costs, plus a $20 million endowment. Again, three members representing the resident companies would serve on the foundation's board in order to protect the interests of the five resident companies. Additionally, the board of the foundation would appoint 50% of the managing committee of the trust. The foundation did not operate under the Sunshine law and could therefore operate with some degree of privacy.

The idea was that these three entities—the trust, the foundation, and the county—would be highly collaborative and also highly reliant on one another. The trust had a contract with the county to manage the facility and provide debt payments to the county after the center opened. Since the trust did not raise its own money, it had a contract with the foundation whereby this organization would transfer the funds the trust needed to pay its debt on construction and endowment.

There were also additional governmental groups that were involved in the center's construction (and operations) that both the trust and the foundation collaborated with. In addition to Miami-Dade County, which was run by 13 commissioners, the county's managers and their staffs, and the mayor, there were more than a dozen other committees involved. Both the City of Miami (five commissioners, a mayor, and a manager) and Miami Beach (six commissioners, a mayor, and a manager) helped both plan and fund the project. The Omni Community Redevelopment Commission was responsible for the utilization of TIF funding for the PAC project (and other community development projects). And finally, the State of Florida, the Florida Department of Transportation, the Miami Downtown Development Authority, and various county departments and political leaders in the county's 35 incorporated cities had some degree of involvement in the development of the PAC.

Ballooning Scope

As leadership was beginning to sketch out the PAC's programming, they were simultaneously attempting to manage what had become an increasingly complicated design and construction process—a process that was contributing to a ballooning project budget. In 1995, the center was projected to cost approximately $118 million—already double what other Florida-area PAC's had cost to build. Once leaders started to incorporate the elements

that were articulated as priorities of the center's resident companies, and to more clearly understand the scope and the details of the architect's design, the budget steadily grew over the next two years to $184 million (1997), then to between $213 and $233 million in 1999, $266 million in 2000, and $279 million in 2001—the year construction formally began.

The confusion and the problems that emerged from plans that architect Cesar Pelli drafted resulted from the inexperience of the construction partnership that was awarded the project: Performing Arts Center Builders (PACB). This group included only one partner who had any prior experience in constructing performance spaces. Even so, they were paid millions of dollars by the county department responsible for overseeing construction. This was the Performing Arts Center Management Office, established exclusively to help carry out the PAC project, which included, among a number of other tasks, studying Pelli's drawings and verifying the cost estimates and the proposed construction schedule over a six-month period. In 2001, in consultation with Pelli's firm, PACB confirmed that, in their view, the project could be completed at a cost of $261 million and that it would take three years to build.

Over the next three years, the issues between all those involved in the construction process became so tangled and labyrinthine that it became evident that neither the anticipated budget nor the construction schedule goals were even remotely realistic. Because the two local construction architects who were hired to collaborate with Pelli were producing poor-quality working drawings, Pelli's firm assumed the construction architects' responsibility. Yet Pelli's firm neither had the expertise nor the resources to assume such a role. The mechanism by which the contractors and architects were to communicate (using a formal Request for Information [RFI] protocol whereby the architect must respond in writing to a contractor-issued RFI) proved both cumbersome and inefficient. As a result, the contractors blamed the architects for not providing them with information, and the architects blamed the contractor for purposefully slowing down the construction timeline. Finally, within nine months of construction, a subcontractor discovered a major flaw in the steelwork design that would frame out the buildings. As a result, Pelli and PACB were drawn into an extensive redesign effort, which further distracted them from their work, slowed down the construction process, and accelerated the cost overruns.

By the fall of 2003, the difficulties came to a head. The architects and the builders were blaming one another and threatening to sue, while the PAC's leaders and the resident companies demonstrated that they had no control over the process and were only left to lobby for changes. The time had arrived where there had to be a radical restructuring of the entire construction process, in order that the PAC would have at least a reasonable chance of being completed. Leadership brought in Ron Austin of Vital Management Solutions to lead a $50 million restructuring effort in summer of 2004. Austin took over the construction management in August 2005 and, after

another $50 million in costs for acceleration,[19] the project was completed in 2006 at a final tab of $478 million. Of that cost, about $368 million went toward construction, $62 million went toward capital costs (e.g., design fees, furnishings, etc.), $46 million went toward owner development costs (e.g., permitting, insurance, environmental testing), and $2.3 million went toward land acquisition. Approximately $120 million was raised from private sources (including a $30 million donation from Adrienne Arsht that went toward the center's operations in 2007 and resulted in the renaming of the center).

Mission Shift

Responding to the resident companies' emphatic requests for dedicated performance space based on the companies' initial estimates for programming, the PAC's leadership went ahead and designed a facility that would be largely purpose-built. The idea was that the Miami PAC would closely resemble, in design and function, institutions like Lincoln Center in New York and the Kennedy Center in Washington, D.C. There would be two large halls primarily for classical use—including a horseshoe-shaped opera and ballet house and a symphony hall—and then a black box theater with seating capacity of 250, which would be designated for use by the "community."

As the day for groundbreaking approached and the design was becoming finalized, it was becoming clear that initial projections for the resident companies' needs (in terms of days booked in the facility) were significantly overestimated. One of the resident companies, the Florida Philharmonic went bankrupt and closed in 2003. At the same time, other companies started to get more realistic about their ambitious programming goals. However, adjustments to the program and the PAC's mission were not made until a year after construction had already started. A new plan was not delivered to the PAC's leaders until the spring of 2003.

Now that the Arsht Center is up and running, approximately 30% of programming comes from the resident companies and a little over 50% is presenting by outside companies, in addition to what comes from the center itself and external programming partnerships with the Cleveland Orchestra and Live Nation. Nevertheless the resident companies continue to have primary control over the center's management and its policies in a manner disproportionate to their use and their own fiduciary liability. The shift in the proportionality of programming from what was initially anticipated to what was actually possible also came with an enormous increase in the PAC's operating staff and its budget: the PAC now requires a permanent staff of about 175 and currently has an annual budget of $45 million.

With the new programming plan came the opportunity for the PAC to target its services to Miami's increasingly diverse audiences. But this new, more populist focus creates tension with the original conception that was

characterized by a more traditional and elitist focus of the resident companies' donors and supporters. The Arsht Center's programming calendar illustrates the way in which the PAC swings between trying to serve the wider community and at the same time give attention to the resident companies' supporters and their programmatic preferences. Not only is the cost of attending many events prohibitive for the many residents of Miami (attending an event can run anywhere from $24 to $254 per ticket, plus the $15 required fee to park in a nearby lot since the Arsht Center did not construct its own parking facility), but there are actually very few events that take place outside the walls of the opera house and concert hall for those seeking a slightly different kind of performance experience. Increasing the accessibility of programs could help make first-time arts attenders (of which there is a large pool of in Miami) more comfortable since the PAC's opulent lobbies and crowds of upscale patrons can be intimidating to those trying out the new facility for the first time.

Finally, despite the project leaders' vision that the PAC would help revitalize downtown Miami, the area surrounding the PAC remains quite desolate, with only a scattering of pedestrians to be seen in the area. On the south end of the facility there is a major Miami freeway. On the east and west are vacant sites and a few parking lots. North of the facility is downtown Miami, a district that is still far from revitalized.

Today, the Arsht Center's financial situation has improved. In 2008 and 2009, the organization had surpluses of $8.5 million and $2.4 million, respectively, but deficits of between $600,000 and $700,000 in 2010 and 2011. Annual operating costs were $46 million in 2011, but increases in program revenue have helped to offset costs. In 2010, the PAC brought in $20 million in earned revenue alone. This figure increased to $26 million in 2011. Nevertheless, contributions primarily come from government sources (approximately 65% of total contributions), so it is safe to say that without significant ongoing support from taxpayers the Arsht Center could not survive.

* * *

The New World Symphony (NWS) announced in the early 2000s that it would build its own dedicated concert hall in the heart of Miami Beach. While the organization would still utilize the new Arsht Center's space several times a year, its leadership had always known that it needed to update its current facility to continue to serve the educational mission of NWS. As opposed to the traditional design and function of the Arsht Center's two performance spaces, the NWS's new facility would be a flexible and multiuse space designed to serve the organization's mission—"to prepare highly-gifted graduates of distinguished music programs for leadership roles in orchestras and ensembles around the world." With the facility's architect—Frank Gehry—the NWS made it their goal to create a facility that would openly welcome the South Florida community.

Notwithstanding the well-publicized construction and budgetary issues that plagued the Arsht Center project, the New World Symphony was able to convince both the City of Miami Beach and Miami-Dade County to help support this project. Understandably reluctant at first, the city and county were ultimately persuaded by the NWS's vision for the new facility and its innovative plans for integrating its program into the entire South Florida community.

Not only did the organization display skill and efficiency in managing this large and ambitious building project from the early planning stages forward to construction and opening night, but it also continues to be on the leading edge in efforts to develop new audiences. With its innovative techniques and introduction of new modes of arts participation, South Florida audiences, young and old, of all races and ethnicities, can and do enjoy the New World Center. In the next story, we see just how the New World Symphony was able to realize its vision.

THE NEW WORLD CENTER: MIAMI BEACH

Just about four miles from the Arsht Center across Biscayne Bay, the other major performing arts facility—a concert hall—the New World Center (NWC), can be found in the midst of this vibrant, heavily populated neighborhood of Miami Beach, full of restaurants, retail shops, hotels, and apartment buildings.

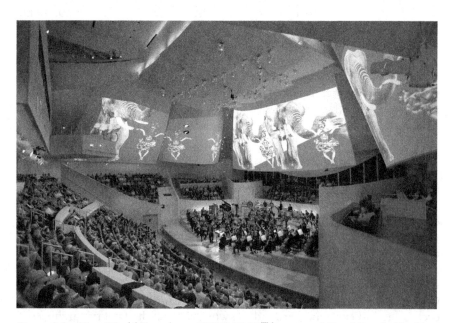

Figure 3.2 New World Symphony WALLCAST™ concert, Miami Beach, Florida.

Credit: Photo by Rui Dias-Aidos courtesy of New World Symphony.

Designed by Frank Gehry, the façade of the building is almost entirely transparent, allowing pedestrians to see in and audiences to get a glimpse through the front doors of the event they are about to see. Howard Herring, president and CEO of the New World Symphony (the organization for which the facility was built) said of the decision to have a glass façade: "MTT [Michael Tilson Thomas] asked Frank Gehry to design our front door as an invitation. We want everyone in Miami to feel welcome as they cross our threshold."[20]

Except for a few curves here and there reminiscent of some of Gehry's signature structures like the Experience Music Project in Seattle or the Pritzker Pavilion in Millennium Park in Chicago, the NWC is not readily identifiable as a Gehry design. Instead, it brings to mind structures that have simple, clean lines—ones designed by architects like David Chipperfield (see the Figge Art Museum in Davenport, Iowa). With the NWC, Gehry chose to give his signature design motifs to the facility's interior, like the large geometric masses seen as you enter the door that in fact contain rehearsal rooms and stairwells.

The NWC opened in January 2011, about five years after the Arsht Center. Yet, the planning for the NWC largely coincided with the planning and the building of the Arsht Center. During the late 1990s, when the New World Symphony was performing in the Lincoln Theater—a converted 1930s art deco–style cinema—the symphony was feeling cramped. The practice rooms' ceilings were too low for standing violinists to fully extend their bows, and the acoustics were substandard. The organization's leadership decided that this was the time to begin exploring the possibility of renovating this space or possibly building an entirely new one.

At first, the executive staff and trustees looked into expanding the Lincoln Theater. But after realizing that the cost of repurposing the space would be almost as much as a new building, they set their sights instead on taking over two open surface parking lots located directly across the street from the Lincoln that were owned by the city. The city's initial response to the symphony's proposal to take over these lots was encouraging. "They said, 'We hear you. We'll work with you, but before we move forward we're going to commission a master plan just to make sure that we use these lots to best advantage,'" remembered David Phillips, the symphony's senior vice president and CFO. It was this plan that also introduced the idea of including a park and parking garage to sit on either side of the facility, making the project much bigger than initially envisioned.

Almost immediately, the NWS started working with the city to arrange a ground lease for the land. Within a couple of years, as the plan began to look like it might actually be viable, MTT, the New World Symphony's founder and artistic director, proposed that Frank Gehry be approached to design the facility. "At first, the board was reluctant because Bilbao had just opened, and the Disney Center in L.A. was having all sorts of problems, and, I mean, we just didn't have that kind of money," said Phillips. But MTT, a lifelong friend of Gehry's, knew that "Gehry was our guy."

Gehry started working on the project in 2003; it broke ground in 2008 and was completed in 2011. The years leading up to the opening of this new performing arts facility were spent planning every detail, large and small, from where percussionists would rehearse relative to the stage so that they could easily carry their instruments back and forth, to the precise location of the rehearsal rooms, such that pedestrians could walk by and see the musicians at work. For more than six years, this group, composed of staff and trustees, met every two weeks for an hour to an hour and a half at a time to make literally thousands of decisions about the project and how it would unfold. These meetings addressed every facet of the project, from the building's interior design and its budget to bidding for contractors and actual construction. In addition, dozens of consultants were involved. More than 20% of the total project budget alone was spent on soft costs like consultant fees, which was seen as an investment that would inform the experimental aspects of the program design and address the challenges of construction.

With a $7.5 million annual operating budget prior to the new facility, NWS had relied on income from an endowment 10 times that size to fund approximately half of the organization's operations. In addition to its campaign to cover actual construction costs (which included donations of $15 million from the City of Miami Beach, $25 million from Miami-Dade County, and the remainder from private donors, including one anonymous $90 million donation), the symphony also had goals for increasing its endowment, which was absolutely necessary if they were going to be able to cover the costs of a much different and much larger facility.

"We calculated that we had to raise about $50 to $75 million before we opened in order to continue funding half of our new budget with our endowment," said Phillips. "We hit the $30 million mark, but then the recession hit and the campaign plateaued. So instead of ending up with $150 million in our endowment, we're at about $90 million, which has put pressure on our annual campaign in order [to balance] our [annual] budget, [which has] nearly doubled."

Two years after the project's completion, Phillips reports that the organization is, "refocusing on endowment fundraising so we can get back to the proper financial balance point."

Up until this time, NWS has benefited from all the publicity the new building has received, both domestically and around the world. As a result, both local and national funders have helped support the organization's new infrastructure and their signature educational mission. Since the facility has opened, the organization has continued to focus on achieving annual balanced operating budgets partly through increases in annual giving, an expanded endowment, and the larger income stream the new building has helped create as a result of increased attendance. All of these things are seen as critical to the long-term viability of this ambitious organization and its new Gehry-designed building.

An Educational Institution

There is currently no other program in the nation like NWS. Entirely related to education, the mission of NWS is to, "prepare highly-gifted graduates of distinguished music programs for leadership roles in orchestras and ensembles around the world." "Fellows" spend three years with the symphony, led by MTT, and receive training in other areas "vital to developing careers as a professional musician in this day-and-age," says Ayden Adler, NWS dean and senior vice president.

"There is a need for young musicians, who are entering an industry such as the classical music industry, that is experiencing so many challenges, and facing questions about sustainability, to be prepared to serve [in] a variety of roles," believes Adler. "Be it as musician, administrator, or community advocate, or some combination of all three, our fellows go out into the professional world ready to do it all."

NWS graduates, over 900 to date, appear in symphonies across the country. There are 25 graduates in the Kansas City Symphony, including one who works as an administrator. Ten graduates play in the San Francisco Symphony. Others perform with the Boston Symphony, Philadelphia Orchestra, St. Louis Symphony, and a long list of others. Staff members frequently hear stories about the versatility their graduates show in their jobs: "We hear from executive directors that our fellows are the first ones who put down their instruments after a show and go out into the lobby to mingle with the audience. It's because they're taught here that the arts experience is about engaging with your audience, which doesn't only happen on stage," says president and CEO, Howard Herring. Some graduates have even started their own nonprofits.

With the establishment of NWS in 1987, MTT's vision to recruit the best young musicians from conservatories across the country and to provide them with housing, stipends, and training in order to prepare for the life of being a musician has now became a reality. Since then, 87 fellows each year experience what it is like to live and breathe the playing of their instrument, and they also learn what it means to work within an organization that must balance revenue and expenses and maintain prominence within a community. Fellows experience what it is like to be a professional musician in every sense of the word: from the responsibilities they have in entertaining and educating audiences, to the ways in which they assist in fundraising by attending donor events. In their recollections about the decision-making process for the new facility, staff members we spoke with framed their description in terms of how the new facility could help deliver on the organization's mission. For example, when asked about the process of deciding to create a flexible concert space (i.e., retractable seats, an adjustable tiered stage), Phillips's response was, "Our goal was not to be necessarily flexible; instead the educational performance program was driving the design."

In other words, the mission of NWS, articulated in MTT's initial vision, remained at the forefront throughout the entire process of building the New World Center. The new building serves the mission. In working with Gehry and with all the consultants, the leadership group focused on creating a space that would be a laboratory for the fellows and one that would provide an opportunity to experience what being a musician, in every sense of the word, is really about.

The Facility as Laboratory

The New World Symphony fellows make use of the wide range of resources at their disposal—practice rooms, studios, and rehearsal halls scattered throughout the facility—during their three-year tenure. Each room in the building is wired for Internet connectivity and appropriate lighting and audio/visual equipment. Fellows can take or teach music lessons remotely, learn the intricacies of recording, and prepare for auditions with video feedback. Nonmusician fellows (i.e., the library and audio-engineering fellows) also have their own customized facilities. All these educational amenities offer NWS fellows a premiere training experience in which preparation takes precedence over the final product, and personal reflection is more important than weekly performances.

"Process over product" was also a prominent theme during the planning phase of the facility. Project leadership spent three full years integrating mission and vision with the articulation of a functional program of an educational laboratory before starting discussions with architects and acousticians. They used this time to build consensus among stakeholders, including their trustees and local politicians. They understood that it takes a significant investment of time to build trust between the organization and its community. Developing community relationships continued during the architectural design phase as the team experimented with different ideas as part of the effort to help realize the potential of the organization's highly innovative new facility.

The leadership group would often spend time examining architectural models Gehry and his team built to experiment with alternative versions of the design. "It allowed us to envision the look and function much more than if we were just looking at sketches," remembers Phillips, a key member of the group. For Gehry, the design itself was also experimental; the project ultimately took on a much different shape than some of the signature buildings he had worked on in the past, and this, in turn, helped expand his portfolio and educate potential future clients about both his flexibility and creativity.

The systems for the most innovative programs of the facility required extensive modeling. For example, creation of the WALLCAST™ concert system for displaying symphonic performances in high-definition sight and sound for audiences in the adjacent park presented significant

challenges. NWS had tried outdoor simulcasting before, but on a much smaller scale. In the end, the sound system employs 167 separate speakers, each carefully aimed at specific sections of the viewing area. Four 35,000-lumen projectors (the most powerful available) are synchronized across 7,000 square feet of white wall, providing a vivid, convincing image for the WALLCAST™ concert audience, a group that is consistently at or above 2,000 people.

The process of projecting the organization's revenues and expenses by building accurate *pro forma* budgets began in 2006, five years prior to the center's opening. With the exception of insurance costs, which are very difficult to predict in this hurricane-prone region, the planning team was able to estimate the center's operating expenses with remarkable precision. And justification for each expense line became more accurate throughout both the design and construction process. The staff of NWS held meetings with utilities providers and based the new facility's estimates on usage estimates for facilities of varying sizes and ages. They also used other techniques, including undertaking a "365-degree sun study," which helped inform the estimated cost of air conditioning. The staff of NWS was diligent in their efforts to gather all the necessary data needed to create precise estimates because they understood the possible negative consequences for financial stability and fundraising credibility.

Finally, the New World Symphony's singular approach to audience development is combining the architectural flexibility of the facility with clever content, marketing, and audience surveys work in innovative ways in order to expand the size and demographic mix of its audience. On the weekend we visited the NWC, there were two very different programs presented to two distinctly targeted audiences. The first event—*Pulse 2.0: Late Night at the New World Symphony*—featured a collaboration between the symphony and a local DJ. With the audience seats retracted, the performance hall had a club-like atmosphere. An audience of 20- and 30-somethings were mingling, drinking cocktails, dancing, and listening to the music. The performance started at 9:45 p.m. and ended at 1:30 in the morning. Two days later, the second offering included an instrument "petting zoo" and an educational performance (complete with projected visuals and animations, even some created by the children attending the concert) about famous composers and musical pieces. Several of the symphony's fellows took part by contextualizing the music to a large audience of children and families. For both these programs, there was a wide and diverse range of attendees, of which many were Hispanic.

In addition, it was clear at both these events that while some audience members had ample experience attending arts events, others had almost none. During *Pulse*, some people would turn their attention to the orchestra while it played, while others would continue to talk. The former group likely was used to refraining from noise when musicians perform—acquired behavior from past concert experiences—while the latter brought another set

of expectations. "Both groups are important," said NWS president, Howard Herring. "Those who instinctively direct their attention to the orchestra performances are following the old cultural norms and getting the full impact of the playing but in a setting that is tailored to their lifestyle. The other group is probably finding their way to orchestral music for the first time. Through *Pulse*, we are introducing them to the music, the players, and the performance space. We find extraordinary opportunity in both groups."

It is difficult to know what percentage of these new attendees come back, or even become regulars—more data are being collected by the NWC so that can be determined. What we do know is that the NWS included two notable design features in the facility to make it more welcoming, more flexible in the kinds of events that can be hosted, and more intimate—the concert hall with its many possible configurations and the outdoor projection system (the WALLCAST™ concerts). Both are helping develop the audience of the future for NWS. The concert hall, for example, expands and contracts depending on the program. For events such as *Pulse 2.0*, audiences can stand on the concert hall floor (comparable to a mosh pit), while for others like the family-oriented event we attended, people can sit in traditional rows of seats. But even when this happens, many other nontraditional aspects of the concert hall's design make attending an event at the center feel like something unique and special. For example, there is seating behind the stage, which makes you

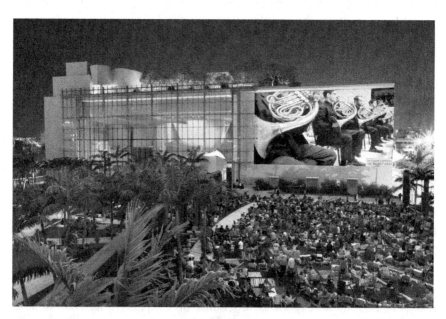

Figure 3.3　Stravinsky's Circus Polka at the New World Center—digital animation by Emily Henricks, Miami Beach, Florida.

Credit: Photo by Rui Dias-Aidos courtesy of New World Symphony.

feel like you are part of the performance that is taking place. Even lighting control centers and sound booths are located within the audience space, as opposed to above the top row of seats like in most concert halls. This allows for a feeling of involvement and participation in the actual performance. And there is the capacity to project stunning visual images on the walls inside the concert hall that complement the performances.

Miami's diverse communities are openly encouraged to attend the symphony's "performances in the park" outside of the NWC. Bruce Clinton, the board trustee and donor who was largely behind the park idea, and his wife are avid users of the space: "It's a lot easier and more enjoyable for us to set up some chairs and watch the performance outdoors than file into the concert hall and have to sit still in a seat for two hours. The park provides a level of accessibility for us that we never imagined. It also allows us to spend time with friends and family in a more relaxed setting than what it would be indoors. "

The New World Symphony encourages building relationships that contribute to the overall sustainability of the organization. The success of these relationships between the organization and its staff, for example, has helped retain many key staff members since before the facility project started. President and CEO, Howard Herring, has been with the organization since 2002; senior vice president and CFO, David Phillips, has been with the symphony since 1990; Doug Merilatt, the symphony's senior vice president for artistic planning and programs, has been at the symphony since 1995; Victoria Rogers, executive vice president, has worked there since 2005; and, of course, Michael Tilson Thomas, the organization's founder and artistic director, has been there since the beginning. The lack of turnover at the organization is largely due to its strength of the founder's vision, which has helped them maintain a culture of engagement among and between each one of the organization's constituencies. For example, Herring decided to locate his office downstairs *within* the fellows' rehearsal space to help foster a sense of organizational inclusiveness. He shares MTT's belief that these types of "small things" help "make each person in the organization feel like they're connected to decision making." Even the decision-making team for the symphony's building project included several staff members from various departments (unlike so many projects we studied, which only included executive leadership and board trustees).

It is no surprise, then, that the New World Symphony has also become a leader in the arts and culture sector in developing relationships with its audiences, given its approach to engaging its staff and fellows. With the hopes of creating sustained demand for what the organization offers long into the future, the symphony experiments with a mix of programming and innovative techniques in performance to help make the community of Miami feel welcome. For the symphony, a new facility was a tool it could use to continue engaging with its audiences and help create a cultural community in South Florida.

* * *

These two projects, when juxtaposed, illustrate the importance of having a clear picture of what you envision before starting a cultural building project. Additionally, the stories show what can happen when the initial vision for a project dramatically changes and, by contrast, how a steady and consistent vision helps ensure greater organizational success. The Arsht Center's initial vision (along with its name) changed when its leaders realized that the five original resident companies would not be able to sustain the center with their collective programming. Unfortunately, by the time they realized this, those working on this new PAC had not only already approved a purpose-built design meant to serve the original plan, but also a budget and a timetable to match. When the plans changed (which they did in a very substantial way), the PAC's leaders were left scrambling to find an alternate programming plan—one that ultimately did not align with the capabilities of the new facility, which by this time was already on its way to completion. The result? A hugely expensive purpose-built facility with a multimillion-dollar budget, but without the programming to fill it and not being able to serve the audiences it was designed to attract. And since the original governing structure did not change along with the guiding vision of this new PAC, the organization struggles to this day with an awkward and inefficient management structure.

In contrast to the Arsht Center's experience, the New World Symphony, with its new 740-seat concert hall, continues to follow its carefully conceived and articulated founding vision. Planned from the beginning more as an educational institution than a concert hall, the New World Center provides its fellows an ideal space in which to learn, to practice, to perform, and to interact with their colleagues and teachers. The facility also provides these gifted musicians with what can best be described as a "laboratory" for learning about and engaging in the wide range of activities and competencies now expected of a professional musician. For three full years, fellows get to experience firsthand what it takes for a symphony to attract and retain audiences. As such, NWS fellows learn how challenging it can be for a twenty-first-century orchestra to survive, let alone thrive, but more importantly, they have the opportunity to learn from some of the foremost leaders in audience development. In other words, they see that an orchestra, to be sustainable, must constantly be experimenting, pushing the boundaries of traditional symphonic performance and finding ways to draw in and keep new audiences—something the New World Symphony does very well.

But even for a project like the Arsht Center that ended up becoming something very different from the initial conception, it is difficult to comprehend how a facility project could end up with a budget double its original size and take twice as long to complete as originally planned. Why did no one step in and rein in both the budget and the construction timetable before it got so out of control? It would be reasonable to think that the local government in Miami-Dade County that was supposed to be protecting taxpayers' interests could have done something to get the process under

control. The fact that the Arsht Center, in addition to so many other resident performing arts centers we studied, turned out to be as fraught an organization as it turned out to be, suggests that these types of resident "umbrella" arts organizations contain many inherent risks, and thus should only be pursued with great caution and circumspection.

Looking back at the different types of cultural facilities communities built over the past two decades—museums, theaters, and nonresident and resident performing arts centers—it is the last of these that experienced the most difficulties with building and then with sustaining their new facilities. We define nonresident PACs as those that are primarily in the business of "presenting" outside performers and companies. This means that these PACs have their own staff that decides what to put on stage—everything from Broadway musicals and other touring arts groups to popular concerts and sometimes even local organizations that rent the facilities for a night or two. A nonresident PAC usually has no long-term obligation to provide one group more calendar space than another; it is all about who pays the rental fee and books their dates the earliest.

Resident performing arts centers are organizations whose primary mission it is to serve a limited group of local companies. Unlike nonresident PACs, these organizations have an obligation to one, two, or more arts organizations—giving them time to perform, furnishing technical assistance, helping with marketing, and sometimes even providing fundraising advice. Resident companies still maintain their independence by being their own organizations (for example, they have their own executive staff and board and have separate 501(c)(3) status), but they often exercise (either directly or indirectly) significant influence over the PAC organization in terms of its management and its policies. Typically, a resident PAC organization will include representatives of its resident companies on its board of trustees. It is also not unusual for a resident PAC organization to provide office space to their resident companies, partner with them for both marketing and fundraising initiatives, and frequently host special events together. Most importantly, and also perhaps the most risky characteristic we found, the resident PAC organization relies heavily on revenue from the resident companies to pay its bills.

While, in theory, space and resource sharing among a group of organizations seems obvious, we found that in practice it is the opposite.[21] One benefit resident performing arts centers have been thought to have is an economy of scale in terms of what these facilities provide for their users. Instead of each arts group having to maintain their own space and equipment, they can share these costs among a group of organizations. The issue, however, is that sharing space reduces the incentive each organization has to sustain it, which sometimes translates into situations where the organization responsible for keeping up the facility is under great financial pressure to sustain organizations that are financially weak or frail. There are countless examples of resident performing arts centers that have struggled with being

sustainable after opening a new facility because of the financial fragility of one or more resident companies. The Kimmel Center for the Performing Arts, our case study from Chapter Two, is one such example. Built for the Philadelphia Orchestra and several other smaller companies, the Kimmel relied on the orchestra to pay the rent. Unfortunately, the rental fee put such financial pressure on the orchestra that it helped precipitate a crisis that resulted in this venerable corps of musicians becoming the first major orchestra in the United States to file for Chapter 11 bankruptcy. As they did, they left the Kimmel with a large sum of backdated unpaid rent payments.

In the sample of cultural building projects we studied, resident performing arts centers had the most troubled records. On average, they took longer to build (3.5 years as opposed to 2.2 years for all other types of facilities), were more expensive (approximately $137 million as compared to $49 million for museums, theaters, and nonresident PACs), and experienced more difficulties, including more lawsuits, more board and staff turnover, and more timeline delays than other kinds of facilities. They also had the largest budget increases of any type of project; on average, a resident PAC's budget increased by 92%. Reflecting back on the process of building a resident PAC, one CEO told us, "It's harder than you think." Another told us, "You need nerves of steel."

Along with the realization that the Arsht Center's resident companies would not be able to fill the PAC's programming calendar came the concurrent realization that the center would not be able to generate sufficient revenue to stay in the black. Now, not only was a resident company—the Florida Concert Association—no longer a resident of the Arsht and thus no longer a major source of income, it also became clear that the other residents' programming and revenue projections were entirely too ambitious. The PAC was left with no choice but to fundamentally alter its mission and goals and figure out how to get into the business of presenting and be successful at it. But because the PAC's leaders' initial plans for designing the center were to produce a purpose-built space specifically for the five resident companies, the facility they ended up building was not really appropriate for their new vision of being primarily a presenting organization. It also was evident that it had become much too expensive for what the community could sustain. It turned out that early on in the process the PAC's leaders allowed the five companies too much influence over the design of the new facility and ended up with a building that is extraordinarily difficult to sustain without significant public support.

The Arsht Center's story is not an unusual one. For a variety of reasons, the leaders of a new facility project can end up making the mistake of investing money, or at least too much money, in a building and an operating model that is, in the end, neither plausible nor viable. A civic leader or individual donor's commitment to a particular cultural organization or his or her desire to give an organization what he or she believes it deserves, becomes a passion given concrete form through a cultural building project. A business model defined

by a codependence between one or more organizations, some of which have markedly less incentive than others to sustain the collective entity that was created to help bind them, is simply too risky for performing arts organizations. For such a collaborative model to work, each of the parties involved must have the same level of incentive—or care as much as the others do about the financial health of the entire collaboration and all the parties involved. As long as a resident company's primary goal is to pay its bills and not be in some way dependent on the PAC for its own financial performance, the resident performing arts center model is not a feasible one for the longer term.

On the other hand, when an arts organization operates independently—when the organization is responsible for its own financial performance, which includes supporting its own facility—it is much more likely to be successful. The New World Symphony made the decision to build its own facility and assume the responsibility for maintaining it. Often it was these types of organizations that were more likely to succeed. This type of business model (i.e., the facility is built by the arts organization *for* the arts organization, not for a group of different organizations) is most prominent among producing theaters. Consequently, in the sample of projects we studied, producing theaters were by far the most successful types of cultural building projects we studied as well in terms of turnover in leadership; shorter, more efficient timelines; and altogether fewer of the kinds of things that contribute to difficult building projects.[22]

Organizations that take on the responsibility of planning and building their own facility and then independently assume the burden of operating it have incentives to sustain the facility because of the obvious ways their own organizational health is tied to the facility's economic health. For example, if the Goodman Theater or the New World Symphony were no longer able to operate their facilities, the artistic organizations themselves would also be struggling. When maintaining a facility is considered just one (admittedly key) part of an organization's responsibility for the total spectrum of operations (inclusive of marketing, fundraising, programming, and so on), a cultural building project is far more likely to be successful. Moreover, it is these organizations that are also more likely to seriously consider whether a facility project is a plausible idea to begin with, since they are the ones that will directly suffer the consequences if the project fails.

NOTES

1. U.S. regions are defined by the Census Bureau and are available at www.census.gov/geo/maps-data/maps/pdfs/reference/us_regdiv.pdf.
2. U.S. Census Bureau, Population Division.
3. Department of Commerce, Bureau of Economic Analysis.
4. U.S. Census Bureau, County Business Patterns.
5. Official website of the City of Miami Beach. "History of Miami Beach." http://web.miamibeachfl.gov/visitors/scroll.aspx?id=14232.

6. Encyclopedia of Chicago website. "Act of Incorporation for the City of Chicago, 1837." www.encyclopedia.chicagohistory.org/pages/11480.html.
7. U.S. History.org website. "Philadelphia Timeline, 1700s." www.ushistory.org/philadelphia/timeline/1700.htm.
8. United States Coast Guard website. "U.S. Coast Guard Operations During the 1980s Cuban Exodus." www.uscg.mil/history/articles/USCG_Mariel_History_1980.asp.
9. Salas-del Valle, Hans de. "Cuban Migration to South Florida: Impact and Implications." *Cuba Transition Project Issue 114*. Institute for Cuban and Cuban-American Studies, University of Miami, 2009.
10. U.S. Census Bureau, Population Division.
11. Miami-Dade County Cultural Affairs website. "Building Better Communities Bond Program." www.miamidadearts.org/facilities/general-obligation-bond-gob-projects-facilities-progress.
12. Ibid., "Arts and Economic Prosperity IV." www.miamidadearts.org/ImpactStudy/2012/2012_FLImpactStudy.pdf.
13. Iuspa, Paola. "Children's Museum Due to Begin Construction on Watson Island in 5 Months." *Miami Today*. August, 2, 2001.
14. Sampson, Hannah. "Perez Art Museum Miami Construction Nearing Finish Line." *Miami Herald*. August 27, 2013.
15. Miami City Ballet website. "About Us." http://miamicityballet.org/about.
16. Sampson, Hannah. "Perez Art Museum Miami Construction Nearing Finish Line." *Miami Herald*. August 27, 2013.
17. This case study is partly based on our interview with Michael Hardy, former CEO of the Adrienne Arsht Center for the Performing Arts.
18. Semple, Kirk. "Fits, Starts and Painful Bumps for Carnival Center in Miami." *The New York Times*. December 29, 2007.
19. *Acceleration* is a term used in construction contracts that essentially means there has been a delay in the construction project, and, rather than complete the project on an extended timeline, the contractor will complete the project in a shorter amount of time.
20. This case study is partly based on our interviews with New World Symphony staff, including Howard Herring (president and CEO), Victoria Rogers (executive vice president), Ayden Adler (senior vice president and dean), Douglas Merilatt (senior vice president for artistic planning and programs), Craig Hall (vice president for communications), and David J. Phillips (senior vice president and chief financial officer). We also interviewed Bruce E. Clinton, NWS board trustee.
21. Mark Stern and Susan Seifert recommend sharing space and resources among nonprofit art and cultural organization, and emphasize that focusing more "the venues themselves [as opposed to organizations] may become the source of stability for the cultural world." See Stern and Seifert's 2012 report *"Natural" Cultural Districts: A Three-City Study*, available at the Social Impact of the Arts Project website.
22. Woronkowicz, Joanna. "The Feasibility of Cultural Building Projects." Working Paper. Cultural Policy Center, University of Chicago, 2012.

4 Not Just Big Cities

Cities of all sizes built cultural facilities throughout the modern building boom. Between 1994 and 2008, smaller MSAs, defined as those with fewer than 500,000 people in the year 2000, ranked second in terms of total funds spent on cultural construction by MSAs of all sizes. Between these years, MSAs with over two million in population spent close to $10 billion on constructing cultural facilities. MSAs with fewer than 500,000 people invested approximately $2.3 billion in total across these 15 years. MSAs with between 500,000 and one million people, and one million and two million people invested $1.4 billion and $2.2 billion, respectively.

Smaller cities were somewhat more inclined to invest into PACs than larger cities were, and we saw greater investment in producing theaters in larger cities than we did in smaller ones. Sixty percent of the total cost of cultural facility building in MSAs with fewer than 500,000 in population was devoted to PAC building, compared to 52% in cities with greater than two million in population. Fifty-eight percent of the total number of projects were PACs in smaller cities, and 48% in larger cities. Only 5% of the total cost of all cultural facility building in smaller cities was for theaters—this figure is 10% in larger cities. As for number of projects, 7% were theaters in small cities, and 14% were theaters in large cities.

Not surprisingly, the relative cost of cultural building, when compared to an MSA's population, was, on average, far greater in small MSAs than in larger ones. Eight out of 10 MSAs, ranked in order of total per capita spending on cultural building between 1994 and 2008, had fewer than 500,000 people. And it was not just one major building project that contributed to the high per capita cost in these small MSAs; each one of these had more than one major project as well.

Similar to what we saw take place with building cultural facilities in the southern region of the country, many of the smaller cities that built new cultural infrastructure throughout the modern building boom were building for the first time. Indeed, many of the smaller cities were also located in the southern region of the country. Among the projects that were built, in smaller cities, 46% were new organizations. This is in contrast to larger cities, where only 26% were new—most projects were renovations and

additions for existing organizations. While these cities would have movie theaters, a town hall, or school auditoriums that might be used for performances, they had no major building purpose-built for the arts. Frequently, these cities would see a neighboring city build a new cultural facility—as the city of Paducah, Kentucky, did after observing the nearby city of Owensboro build a PAC—and this motivated them to initiate an effort to build one of their own. But many smaller cities that built were not accustomed to having cultural amenities, and thus often not fully prepared for all that was involved in raising the money to build and support one over the longer term. But civic leaders in many of these smaller cities believed that investing in culture could help raise their city's status as a tourist destination, make it attractive to companies looking to move, and ultimately place their city on the national stage.

* * *

We start this chapter with the story of the Durham Performing Arts Center (DPAC) in Durham, North Carolina. Completed in 2008, primarily to serve as a Broadway touring house, the plans for this PAC did not include partnering and working with local arts organizations. Despite opposition from both arts organizations and community residents to the idea for this PAC, the new facility has managed to exceed expectations, both in terms of earned revenue in the form of ticket sales and in the transformation of the downtown. Many in Durham attribute this to DPAC's arrival on the scene.

Next we travel to the heart of the Midwest—Omaha, Nebraska—where civic leaders renovated a grand but seriously neglected early twentieth-century vaudeville theater and then turned to the task of building a major new concert hall. In the early 2000s, the Omaha Performing Arts Society (OPAS) became the manager of these two new facilities. Both building projects unfolded relatively smoothly, coming in on time and on budget, and the fundraising campaign that made them possible was successful as well. Nevertheless, the organization continues to try to stabilize its finances, even though it is limited in terms of the kind of programming it can present to the community.

DURHAM, NORTH CAROLINA

Durham, North Carolina, is part of what is known as "The Research Triangle"; if you took a pencil and drew a line between the state's two largest universities—North Carolina State University at Raleigh and the University of North Carolina at Chapel Hill—and the state's most prestigious school, Duke University, you would see a rather lopsided-looking triangle, hence the moniker. Inside this triangle are also four cities that make up two distinct MSAs. In 2010, the Durham-Chapel Hill MSA had a population of 504,357, and the Raleigh-Cary MSA had a population of 1,130,490.[1]

Table 4.1 Characteristics of Durham and All U.S. MSAs

	Durham MSA			Average All U.S. MSAs		
	1990	2000	Change	1990	2000	Change
Population[a]	344,644	426,493	23.8%	991,520	1,133,565	16.2%
Percent of population 25 and over with at least a B.A.[b]	37.4%	41.3%	3.9%	21.4%	25.0%	3.6%
Median household income[b]	$54,150*	$58,000	7.1%	$45,904*	$49,201	7.2%

Sources: U.S. Census Bureau, Census 2000 and 2010. Steven Ruggles, J. Trent Alexander, Katie Grenadek, Ronal Goeken, Matthew B. Schroeder, and Matthew Sobek. *Integrated Public Microdata Series: Version 5.0* [Machine-readable database]. Minneapolis: University of Minnesota, 2010.

Notes: * In 2000 USD; [a] Figures are for the Durham-Chapel Hill MSA; [b] Figures are for the Raleigh-Cary MSA.

Rooted in the success of the tobacco industry and the prominence of the Duke family, the population in downtown Durham has consistently grown. Between 1990 and 2000, downtown Durham's population grew by 37%, and the Raleigh-Durham-Chapel Hill MSA's population increased by 36.9%. The Raleigh-Durham-Chapel Hill MSA included a large proportion of highly educated people, due to its proximity to the universities and the Research Triangle Park, a high-tech research park. The median household income of the Raleigh-Durham-Chapel Hill MSA was also high compared to the rest of the country.

With Durham's growth has come the creation of multiple cultural institutions in the area as well. Since 1978, Duke University has hosted the American Dance Festival (ADF)—a school and performance company for some of the world's most talented modern dancers. At the other end of town, the Carolina Theater has operated in Durham since 1926 and has since then undergone a major renovation. In 2005, Duke University built on its campus the Rafael Vinoly–designed Nasher Museum of Art for an estimated $24 million. Finally, DPAC was built in 2008 in order to be able to offer Broadway musicals for the greater community of Durham and to give additional space for ADF to perform.

DURHAM PERFORMING ARTS CENTER

The Durham Performing Arts Center (DPAC) opened on November 30, 2008. It was designed by local developer/architect Phil Szostak and cost around $47 million to build. Seventy percent of the project's funds were drawn from public sources.[2]

Figure 4.1 Exterior view of the Durham Performing Arts Center, Durham, North Carolina.

Credit: Courtesy of Durham Performing Arts Center.

Despite its relatively small price tag (relative to other PACs we studied), the PAC reportedly has had a large impact, both on the performing arts industry and on the city of Durham itself. In 2014, the concert industry magazine *Poll-star* ranked DPAC number 4 on its list of the 100 top-selling theaters in the world[3]; in the year prior, the PAC ranked number 5. In 2013, the PAC made a $3.3 million profit.[4] Furthermore, since the city of Durham maintains an agreement with the PAC's facility manager—PFM Nederlander—to receive 40% of DPAC's profit,[5] approximately $1.3 million from the operations of DPAC went into the city's budget in 2012.

Many in the Durham community are thrilled with the impact they believe the PAC has had on the surrounding urban area. By and large, DPAC was envisioned as an economic engine for the Durham downtown—"a BIG engine," as Szostak described it. Since DPAC opened, the downtown population has grown by more than 10,000 people. In addition, there are now dozens of new businesses, particularly restaurants. In reporting his observations of the downtown area since the completion of DPAC, Bill Kalkhof, former president of Downtown Durham, Inc. (an economic development committee), said not only is the downtown now a "mecca of restaurants," but these restaurants have grown to the extent that they now have two

seatings on show nights—both before and after the shows. What results is a significantly greater volume of economic activity than would be the case if DPAC did not exist.

Opposition to the Project

Those who are less enthusiastic about DPAC feel that way mainly because it has very little connection to Durham's other local arts organizations. Currently, the only relationship the organization has with local arts organizations is when it occasionally rents space to them (assuming the organization can afford it and can find an opening on the facility's very packed calendar). The decision not to partner with local arts organizations was made by DPAC's leaders early on in the planning process. "This was not a, 'Let's give the Durham Symphony a home'" kind of project, said Szostak. "Rather, this was much, much bigger than that. This was business. This was meant to make money."

Because those who were pushing to build DPAC took this position, the project was initially opposed by one of the community's oldest arts organizations— the Carolina Theater. When the theater's former executive director, Connie Campanaro, became aware that city leaders were seriously entertaining the idea of building a new cultural facility project, she made her opposition known. She was concerned that the presence of a large new arts facility would have negative consequences on the Carolina Theater's revenue. To overcome this opposition, Kalkhof and DPAC's other leaders engaged in "a lot of behind-the-scenes lobbying." When asked how his team was able to get Campanaro to back down, Kalkhof indicated that it became political: "In the end, we had more influence with the theater's board than she did."

As much as they could, however, DPAC's leaders tried to cooperate with the Carolina Theater by finding ways to prevent this new organization from cannibalizing the older theater's ticket revenues. For example, the two organizations came up with a written agreement that stipulated specific limitations on DPAC's programming. The agreement stated that DPAC's offerings had to differ from the theater so that it attracts particular audiences. As an additional goodwill gesture, DPAC's leaders agreed that a percentage of its public funding, which was to come from the city, would be used to pay for a limited renovation of the Carolina Theater's existing (and aging) facilities.

Five-years later, many would argue that the Carolina Theater's operations have not only *not* experienced detrimental impacts from DPAC's presence downtown, it has actually benefited. In 2012, the Carolina Theater had its best year in recent years in terms of revenue and ranked 88th in the world for theater attendance at live events in the first half of the year.[6] The strategy of responding to the Carolina Theater's opposition, versus ignoring it, was in Szostak's opinion, a key to the Center's success: "If anybody had an objection, there was an answer to it. That's one of the things that made this project work."

There were others to answer to as well. In addition to the Carolina Theater, many other local area nonprofits expressed concerns about the new cultural facility project and the impact it would have on their organization's operations. For example, many feared that the PAC's campaign to sell naming rights would divert local philanthropic contributions, thus threaten other organizations' fundraising efforts. As a response to these organizations' anxieties, DPAC's leaders came up with other ways to collaborate. An agreement between DPAC and some area nonprofits requires donors who have previously contributed to another nonprofit, but wish to purchase naming rights, must contribute to that nonprofit first. In addition, DPAC shares 10% of every naming right contribution it receives with other nonprofits, and the center is restricted from hosting fundraising events, all in an effort to share resources.

There was another community group that initially opposed the creation of DPAC but now considers the project to be a resounding success: the Durham Convention and Visitors Bureau (DCVB). The primary responsibility of DCVB is to reinvest a "visitor-paid" room occupancy and tourism development tax into marketing and promotion initiatives. At the time of planning the performing arts center project, Kalkhof, who sat on the DCVB, proposed increasing the tax by 1% to generate $22 million for the center's construction. At first, the rest of DCVB was against Kalkhof's proposal because, "They simply didn't think that the city of Durham needed any more infrastructure," said Kalkhof.

Rather than trying to persuade the DCVB, Kalkhof and another one of DPAC's supporters, Mike Hill (who at the time was the vice president and general counsel of Capitol Broadcasting) lobbied the state legislature to try to get the tax increase passed. The legislature agreed to pass the tax, as long as its revenues would be shared among the city's other cultural organizations. Once the DCVB learned of the legislature's intent to pass the tax increase, it stopped opposing the project.

But perhaps the toughest pushback to the project came from the greater Durham community in response to DPAC's leaders' success at convincing the city council to refrain from sending the project out for a public referendum. If the project went out for public vote, there would need to be majority approval for the city council to issue bonds to finance the PAC's construction. Without the use of the city's bonding capacity, DPAC's leaders knew that the project simply would not be possible. However, they also knew that a bond referendum among the Durham citizenry would never pass. While Kalkhof and his team (which at this point included Durham's mayor, Bill Bell) were able to convince the city council to approve the use of bonds without putting it up for vote, their success came with a major cost. Kalkhof remembered this time well: "Both personally and professionally, it was a tough time for me. I was getting hate phone calls to my house."

But DPAC's leaders knew that this was what it would take to get the facility built. "If I learned anything from this project," said Szostak, "I'd say you need thick skin to take the arrows, because trust me, there'll be a lot of them."

Mitigating Risk

For the city to support the new PAC project, it had to be sure that it was minimizing the risk (to the extent possible) it was imposing on the city's budget in the coming years. When Alan DeLisle, at the time Durham's assistant city manager for economic and workforce development, first arrived in Durham in 2002, he was reluctant to support the idea to build. "As much as I wanted to think it, I realized that this thing was not going to be the slam dunk that I thought it would be coming into it," said DeLisle.

DeLisle, whose job it was to serve as the project's manager by keeping a close eye on the actual construction of the facility, also focused his efforts on ascertaining that the project was something the city could support. Therefore, one of the first things he did after arriving in Durham was put together a steering committee composed of people both for and against the project. He tasked the committee with figuring out what a new PAC would *really* mean for the city of Durham.

First, the committee commissioned Duncan Webb, a consultant specializing in the performing arts, and on infrastructure projects in particular, to conduct a feasibility study that could prove there was a local market for what the new center would offer. The study's conclusions showed that there was a market for a new performing arts center in the greater Durham area. In addition, it stated that without a new PAC people would continue to spend their entertainment dollars elsewhere and the city and its businesses would lose out on revenue. The committee also commissioned an economic impact study to estimate the benefits a PAC could bring to Durham's downtown. Again, the study's conclusions gave DeLisle and the committee the evidence they needed to believe that that a new PAC was a good idea. "At that point," DeLisle said, "I knew that building a performing arts center made a lot of sense for the economy. I was convinced it was going to be successful."

Encouraged by the mayor, DeLisle also ran dozens of worst-case scenarios to assess the extent to which the PAC could potentially negatively affect the city's budget. "I thought of every downside possible, and then when I thought I had looked at everything, Mayor Bill Bell would think of more."

DPAC's leaders also practiced strategic decision making in order to minimize the risk the project's outcomes posed for the community. For example, by choosing an architect who would also be the developer, the city helped maximize the chances that the project would stay on budget. Since the same person who was designing the facility was also a key investor, he had an incentive to keep costs down. As result, Szostak only included amenities in the proposed structure that he believed it truly needed in order to function well, or that significantly added to the patron experience of attending an event. He also focused on systematic cost-cutting when the opportunity presented itself; throughout the course of the project's design phase, he managed to decrease the square footage of the facility by 50%. Because Szostak

believed the project was a very solid business decision, in addition to any additional benefits it might bring, he was willing to take on the burden of putting a great deal of effort in during the life of the project, even though he did not turn a profit for the first three years.

This strategy of leveraging the investments made by various project stakeholders was one that DPAC's leaders used repeatedly. They even had the public works consultant they contracted with invest a small sum in the project. In doing so, they ensured that the consultant had something to lose if the project failed, and gave him every reason to try to make the project a success.

Finally, in order to help offset future maintenance and capital improvement costs, DPAC's leaders came up with a strategy to cover all of the facility's maintenance costs. A portion of every ticket sold now goes toward a general maintenance and improvement fund the city can utilize to update and maintain the facility. Therefore, city leaders never have to worry costly renovations or maintenance will affect the city budget in the future.

"It's All about the Operator"

The group who guided this project through its various stages believes that much of DPAC's success as a building project, as an arts organization, and as a city initiative, is because of the relationship with the facility's operator—PFM Nederlander. Part of the five-year agreement the city of Durham established with Nederlander requires the operator to turn a profit. In the case of a shortfall, Nederlander is obligated to cover the difference. In the first five years after opening, DPAC's profit has consistently grown. In 2013, DPAC was negotiating a revised contract with its operator, still based on a model of profit-sharing.[7]

The decision to hire a third-party operator instead of building staff organizational capacity to carry out the presenting function was made early on by DPAC's leaders. Because of the city's past positive experience using a third-party operator to manage the Durham Bulls Athletic Park (the city renovated the "DAP" using city-obligated bonds in 2009), the leadership group decided they would employ the same strategy for DPAC. They also did not believe that the Durham community had the necessary expertise to manage a performing arts center. In other words, they doubted that the PAC's staff capacity could even be built.

When the idea for a new performing arts center in downtown Durham was first floated, city leaders had another operator in mind. In scouting out a location in North Carolina for a new 5,000-seat concert venue, Clear Channel Entertainment initiated meetings with Szostak and other civic leaders about building something in Durham. But the partnership quickly fell apart and the city started to pursue a new vision, one that they thought was in much better alignment with their community's needs.

The new performance facility was basically now envisioned as a Broadway touring house, so the city needed a new operator skilled at presenting

Broadway productions. Because of its experience managing theaters in major Broadway markets like New York, Chicago, and London, leadership decided to partner with PFM Nederlander. The partnership they developed with Nederlander also helped assure them of the feasibility of the project. "If PFM Nederlander thinks they're going to make money, then there's a good chance that's what's going to happen because they wouldn't want to operate the facility otherwise," said Kalkhof.

The leadership team believed that Nederlander knew the market better than they did, hence the project would be successful. Szostak explained, "There's a strategy to where Broadway locates. Nederlander knew where we fit into the national model of where Broadway theaters should be and could be."

It turns out, however, that Nederlander was wrong about just *who* the market for DPAC is. The market is significantly larger than either the project's leaders or the professional operator expected; it extends more than 100 miles out, as far as Richmond to the north and Wilmington to the south. Despite the fact that Durham's two neighboring cities—Raleigh and Charlotte—have performing arts centers of their own (the Progress Energy Center for the Performing Arts and the Blumenthal Performing Arts Center, respectively), an estimated 40% of DPAC's audiences come from Wake County (the county in which Raleigh lies). As much as 30% to 35% percent of DPAC's audiences come from within the city of Durham. There is also a small contingent of DPAC's audiences—an estimated 4%—that come from neighboring Greensboro, which is now pursuing its own cultural building initiative—GPAC.

* * *

It is hard to get more quintessentially Midwestern than Omaha, Nebraska. Located on the border of Nebraska and Iowa, the city of Omaha has historically been defined by its railroads and livestock industry, not by its cultural amenities. Yet, due to the sustained efforts of some generous local philanthropists, this perspective has recently begun to change.

Part of Omaha's uniqueness, and its cultural development, rests upon the fortune of one man—Warren Buffett—who through his investment acumen and his entrepreneurial gifts has *indirectly* helped make it possible to fund arts and culture. While Buffett—the billionaire who founded Berkshire Hathaway—does not directly contribute to the city's arts and culture initiatives, many of the early investors who shared in the good fortune of the company he founded use their fortunes to contribute to Omaha's cultural landscape. For example, in the early 2000s, two downtown cultural facilities reaped the benefits of Omaha's entrepreneurial success when the organizations responsible for the facility's operation completed a $105 million capital campaign.

The funds, which came from approximately 70 major gifts, went toward a restoration of the historic Orpheum Theater (once home to vaudeville and now home to Broadway touring companies) and the construction of a

new 2,000-seat, two-stage concert hall—the Holland Performing Arts Center. Just how these two major facility projects were completed in a town not known for the arts provides an inspiring story about how communities can capitalize on the distinctive characteristics that make their towns function as well as they do.

OMAHA, NEBRASKA

As late as the mid-1960s, Omaha was, in the words of philanthropist Richard Holland, just "a cow town." Home to the Omaha Stockyards, one of the largest in North America for over a century, it also was home to some of the largest meatpacking corporations in the country. At one time, in and around the late 1950s, it was estimated that Omaha's livestock and meatpacking industries employed fully 50% of the population of Omaha. In 1999, the *Nebraska Farmer* magazine reported that the industry was, "the backbone of Omaha's economy ever since the first steer trotted into its pen in 1884." Much of the success of Omaha and its livestock and meatpacking industries were due to its location along a number of prominent railroads. At the height of the meatpacking industry's prosperity, 20 states used Omaha's numerous railroads to transport their livestock there.[8]

It was around the 1960s that Omaha's livestock industry began to disappear. Both the market and the industry were changing, and slaughterhouses were being moved out to rural locations to be closer to the cattle feedlots. In the early 1980s, after the Union Stockyards were sold, they started to fall into disrepair. By 1996, the city of Omaha had taken over the property to transform it into an office park, and in 1999 the stockyards officially closed.[9]

Like all the cities we studied, Omaha's demographics directly mirrored the ebbs and flows of its strongest industries. Downtown Omaha's population grew consistently from about 1900 to 1970, but took a major dip between 1970 and 1980 when the livestock industry began to migrate outside of the city. However, population began to grow again shortly after and has continued to grow ever since. Population in the Omaha-Council Bluffs MSA has also consistently grown since the mid-twentieth century, but less so between 1970 and 1990. Since about 1990, though, the MSA has begun to see population increases comparable to when the livestock industry experienced its initial economic success. Between 1990 and 2000, population in the Omaha-Council Bluffs MSA grew by 24.1%. Along with this growth, the population became increasingly educated and wealthy as well.

Omaha's "cow town heritage," according to Dick Holland—who, in his 90s, is one of the city's most influential philanthropists—has always infiltrated the city's view on funding the arts. "For a long time, in Omaha, you couldn't get any public money for the arts," said Holland. "A lot of people

Table 4.2 Characteristics of Omaha and All U.S. MSAs

	Omaha MSA			Average All U.S. MSAs		
	1990	2000	Change	1990	2000	Change
Population	685,797	767,041	11.8%	991,520	1,133,565	16.2%
Percent of population 25 and over with at least a B.A.	26.3%	32.0%	5.7%	21.4%	25.0%	3.6%
Median household income	$47,780*	$55,000	15.1%	$45,904*	$49,201	7.2%

Sources: U.S. Census Bureau, Census 2000 and 2010. Steven Ruggles, J. Trent Alexander, Katie Grenadek, Ronal Goeken, Matthew B. Schroeder, and Matthew Sobek. *Integrated Public Microdata Series: Version 5.0* [Machine-readable database]. Minneapolis: University of Minnesota, 2010.

Note: In 2000 USD.

thought, if you wanted that sort of thing, you should have to cough up the money to pay for it."

The city has had other cultural facilities, but the burden of building these facilities was historically taken on by the private sector. In 1895, a group of private investors built the Creighton Orpheum Theater, which became part of the Orpheum circuit—a chain of vaudeville and movie theaters in the early twentieth century.[10] In 1904, a private stock company built the original Omaha Auditorium for an estimated $300,000. But the campaign to pay for it stalled at about $180,000, leaving a sizeable debt. The City of Omaha took over the auditorium in 1915, even though its private investors still owed the campaign shortfall. Just after World War II, the city helped build the Civic Auditorium (which superseded the Omaha Auditorium and led to its demolition in 1963).[11] The Civic Auditorium is now to be closed in 2014.[12]

Even now, the private sector in Omaha remains extremely strong. A city with just under 500,000, this former livestock processing center is now home to five Fortune 500 companies, four Fortune 1000 headquarters, and a number of other successful entrepreneurial enterprises that have put down roots in Omaha. Among those companies are Mutual of Omaha, ConAgra Foods (a major food producer), Union Pacific Corporation, the Kiewit Corporation (one of the world's largest construction firms) and, of course, Berkshire Hathaway—arguably Omaha's largest and most influential company.

Led by billionaire Warren Buffett (who still resides in the same house he purchased for $31,500 in 1958[13]), early investments in Berkshire Hathaway helped transform the financial lives of a handful of Omaha's residents. Indirectly, through their contributions, the success of these residents also continues to have a large impact on many of the city's civic improvement

projects; it is estimated that about 25% to 30% of civic projects are funded through returns on residents' Berkshire Hathaway investments.

The corporation's early investors, many of whom were also friends and associates of Mr. Buffett, had no expectation they would become multimillionaires. As John Gottschalk, former CEO of the *Omaha World-Herald*, civic leader, and philanthropist, described it, "Berkshire Hathaway has a lot of owners in this town, many of whom started with five thousand bucks and wound up with two or three million. I'm talking about a professor, an adman, and people who still haven't been identified. Fortunately for Omaha, a lot of them still live here and love their community."

The presence of wealth and the commitment and loyalty shown by Omaha's most fortunate toward their community has helped create a formula for successful civic improvement projects. Yet, since much of this wealth came from relatively recent investments, the people who acquired it were not entirely comfortable distributing it. It was not an absence of generosity; they just had not grown up with sufficient excess wealth to be able to regularly make this kind of contribution toward public amenities, and, in particular, arts and culture, so it was not completely familiar territory. By helping to make possible these projects, which constituted the "civic fabric of the community" (as Gottschalk put it) some of Omaha's wealthiest residents required coaching in how best to leverage their charitable investments. To accomplish this, a group known as Heritage Services emerged to help Omaha's new philanthropists manage their commitments and contributions.

Heritage Services serves, at least in part, as the Omaha philanthropist's information and advisory service for large-scale charitable giving. On Heritage's board sits an array of Omaha's most powerful corporate and civic leaders: Walter Scott, Jr., chairman emeritus of Level 6 Communications; John Gottschalk, former publisher and CEO of the *Omaha World Herald*; Kenneth Stinson, chairman emeritus of Kiewit Sons' Inc.; Bruce Lauritzen, chairman of First National Bank; and Richard Bell, former chairman and CEO of HDR, Inc. Developed as part of a capital campaign in 1989 for the Joslyn Art Museum and Durham Western Heritage Museum (now known as the Durham Museum), Heritage Services has raised over $435 million for various Omaha community initiatives. These have included the Strategic Air and Space Museum (a $34.6 million campaign), the CenturyLink Center and Arena (a $50.5 million campaign), the Central High Football Stadium (an $8.7 million campaign), and, in 2001, the OPAS's renovation to the Orpheum Theater and construction of a major new performing arts center (a $107 million campaign).

Led by Sue Morris, since 1996, Heritage's strengths lie not only in its demonstrated ability to raise substantial amounts of money from those it advises, but also in its expertise at managing both the planning and the development of complex capital projects. From conducting feasibility studies to arranging financing and managing the construction process, Heritage and its board provide comprehensive oversight. This is one of the reasons

that the OPAS project, and so many other projects Heritage has managed, has been so successful. According to John Gottschalk, who serves as vice chairman of the firm's board and who chaired the OPAS board during its building project: "Heritage takes the project, they raise the money, build it, and hand the client the key. They won't fuss around with committees and change orders, and they won't waste anyone's time. As a result, the projects they manage will always be done on schedule and on budget."

THE OPAS PROJECT

The Omaha Performing Arts Society (OPAS) manages two performance spaces in Omaha: the Orpheum Theater and the Holland Performing Arts Center. The Orpheum Theater is owned by the City of Omaha and was renovated in 2002 at a cost of $10 million. The Holland is owned by OPAS and opened in October of 2005 and altogether cost about $97 million to build; 85% of that came from private donations. The Holland PAC includes three separate performance spaces: the Peter Kiewit Concert Hall, which seats 2,000 people; the Suzanne and Walter Scott Recital Hall, which seats 400 people; and the semi-enclosed courtyard, located in the center of the structure, surrounded by walls on all four sides, that holds

Figure 4.2 Interior view of the Kiewit Concert Hall at the Holland Performing Arts Center, Omaha, Nebraska.

Credit: Photo by James Colburn courtesy of Omaha Performing Arts Society.

about 1,000 people. The concert hall, however, is the PAC's most esteemed performance space. It was built by Kiewit Construction and collaboratively designed by the New York City firm, Polshek Partnerships, acousticians Kirkegaard & Associates, theater consultants Fisher Dachs, and Omaha's own HDR—one of the nation's largest architecture, engineering, consulting, and construction firms that is also employee-owned. They produced a stylish minimalist structure that reflects the down-to-earth personality of Omaha.

The Omaha Symphony is one of the primary tenants of the Holland Center. A long-standing Omaha institution, the symphony was established in 1921, but periodically experienced financial difficulties throughout the twentieth century. It halted operations altogether during portions of the Great Depression and World War II.[14] While functioning without interruption under multiple music directors since 1947, the orchestra has never been able to attain the stature of other large-scale symphonies in urban centers across the United States. In the 1990s, the symphony went through a particularly difficult series of starts and stops involving various endowment and capital campaign efforts and was never really able to gain the momentum it needed to reach its goals. Many long-time supporters of the organization would argue that the symphony's difficulties are at least in part due to not ever having had an adequate space in which to perform.

For many years, the Omaha Symphony was sharing the stage of the Orpheum Theater with a number of other local arts groups, including the Omaha Opera and several Broadway touring groups. This arrangement was trying as it gave the symphony only enough calendar space to perform, at most, 20 weekends a year. Additionally, the Orpheum did not have the physical infrastructure and technological capacity that a full orchestra needed in order to perform. A proscenium theater from the beginning, the Orpheum was most suited for theatrical presentations. Just as serious was the fact that the theater's acoustics did not lend themselves to symphonic performances. And finally, the theater had fallen into a state of acute disrepair as a result of neglect by the city, which had for several decades owned and maintained it. Gottschalk described the Orpheum before its renovation: "We would have Itzkak Perlman perform there with a porta-potty backstage. We would have Henry Fonda visiting his hometown and using a basement as a green room. At intermission, there would be a line of 50 women waiting to use the bathroom."

Richard Holland, a long-time supporter of the symphony, is credited for floating the idea of undertaking a major renovation of the Orpheum, and then the building of an entirely new concert hall so that the symphony would finally have an appropriate place to perform. In the early 2000s, Holland approached Sue Morris at Heritage Services with the possibility. As a result, Morris called a meeting with her board chair—Walter Scott—and Richard Holland and his wife Mary, to take them on a tour of the dilapidated facility. At the end of the tour, Walter Scott, who Morris described as, not "really going to many arts events," expressed his dismay with the

current state of the theater. Morris remembered him describing the facility as, "embarrassing." And this was going to be the turning point in the effort to revamp the performing arts facility situation in Omaha.

Before Heritage could even officially take on the project of restoration, the issue of who would own and manage the Orpheum needed to be sorted out. Those who were heading up this effort, which included Gottschalk, Morris, Scott, and Holland, all agreed that the only possibility of successfully renovating the facility would be if a new governance structure were put in place, one that could assure them that the facility would be maintained over the longer term. At that time, it still had not been decided that a new PAC would be built, but Gottschalk, Scott, Morris, and Holland knew that without first renovating Omaha's existing cultural facilities they would not have a chance of convincing donors to support a new one. Gottschalk used what he called his "five-answer test" to convince the mayor and the city council that it was in their best interest to relinquish ownership and management of the Orpheum and turn it over to a new entity:

I chatted with each member of our city council and I asked him:

1. Is the Orpheum totally unsatisfactory to serve our city?
2. Should something be done to resolve this?
3. Do you have the money to do it?
4. Do you want somebody else to do it?
5. Are you willing to change the theater's governance structure?

Gottschalk was looking for four yes votes and one no vote from each council member and the mayor, and that is what he received. As a result of his efforts, the city of Omaha agreed upon a memorandum of understanding (MOU) whereby a new governing group would pay the city $1 every year for a hundred years to manage the facility, and also pay for the facility's renovation. Additionally, the MOU stated that the city would provide the land and infrastructure for a new performing arts facility, which it would benefit from because of a "seat-tax" placed on admissions. As a result, the OPAS was established in June of 2000 to be the steward and manager of the Orpheum Theater. The organization also decided to build a new performance hall, towards which Richard Holland and his wife would donate a substantial (and undisclosed) amount to. Gottschalk was chosen to be the OPAS's board chairman—a role he continues to serve 13 years later. Richard Holland serves as his vice chairman counterpart.

Fundraising

To bring in the $107 million Heritage managed to raise for the OPAS project, Morris used a familiar fundraising approach that has proven successful in many of the other projects Heritage has managed. As she does with

all projects, Morris first focused on securing several initial very large gifts. After the lead gift, she was able to use it as leverage for attracting smaller gifts (under $5 million). For the OPAS project, five donations totaled about $70 million, one of which was a gift from the city of Omaha in the amount of $10 million to be used for land and infrastructure.

Second, Morris focused almost exclusively on gifts in excess of $100,000. With a staff of six, she believes chasing after small gifts is an inefficient use of time, and specifically that the cost of trying to procure the gift often ends up being greater than the net benefit that would come from receiving it. Therefore, from the outset, Heritage identified would-be donors as those who could give more than $100,000. Donors are still able to contribute less than $100,000, but they do so because they (not Heritage) initiate it. Not only did a very small proportion of donors contribute less than this amount to the OPAS project, but among those who did, most of them just sent in a check without being solicited.

Third, Heritage customarily completes the majority of fundraising for a project in a relatively short time, during what they call the "predesign phase." Morris and her team starts off every facility project by deciding what types of amenities the project will include and what its priorities are by making a point of visiting other facilities. For the OPAS project, for example, Morris and her team visited Benaroya Hall in Seattle, Bass Concert Hall in Fort Worth, Texas, and the Musikverein in Vienna. The predesign phase is when Heritage begins to get a handle on what the project will cost, set goals for fundraising, and be able to accurately assess the feasibility of the project as envisioned by those who want to see it happen: "It's possible that, during the predesign phase, we'll have to scale back the project by 20% or 25% because we just don't think the money is there." Over the course of a year, which is how long the OPAS predesign phase lasted, Heritage had identified all potential donors and had already raised the initial $70 million for the project.

OPAS in 2013

In the end, Heritage was able to exceed its goal of raising $102 million by $5 million for the OPAS project. The Orpheum renovation transformed the old vaudeville theater, and OPAS can now offer a wide variety of productions, including five or more touring Broadway productions a year, major dance companies, popular entertainers, and local graduations and dance recitals. In addition, the Orpheum continues to host Opera Omaha with its three productions per year. As originally planned, the Holland Performing Arts Center is also the primary home for the Omaha Symphony. Additionally, OPAS presents touring artists and ensembles, including jazz, speakers, world music, and entertainers, as well as local arts groups looking for a top-notch performance space. Almost daily, the Holland PAC offers new programs.

The city of Omaha and its residents have also been pleasantly surprised by the economic performance of the OPAS. To help demonstrate the group's economic impact, in 2012 the organization commissioned two economists from the University of Nebraska to conduct an economic impact study of the facilities and their programs on the metropolitan area. It showed that in 2011 the performing arts group generated $31.6 million in economic activity in Douglas County and the equivalent of approximately 400 jobs. From 2006 to 2011, the economic impact from the OPAS totaled $128.5 million in salaries, restaurant meals, hotel stays, and other goods and services, not to mention about $1.54 million in state and local taxes.[15] The OPAS continues to cite these results as they advocate for more community support.

While the development of the facilities was not specifically intended to serve as an anchor for downtown redevelopment, many believe the OPAS project contributed significantly to the city of Omaha's rapidly developing infrastructure. Downtown development began in the early 1990s when ConAgra relocated their corporate headquarters to Old Market—an area of downtown with a growing stock of restaurants, art galleries, and upscale shopping. And since that time, the city has begun to experience increases in its population—throughout the 1990s downtown Omaha's grew consistently—6% from just 1999 to 2000 alone. After 2000, and around the time the renovation of the Orpheum and construction of the Holland Center started, development in downtown continued apace, primarily around the western edge of the Missouri River that flows right through downtown.

Since its inception, OPAS, a nonprofit organization, has managed to be sustainable as well. The organization's ticket revenue has continued to grow since the Holland Center opened; its budget has gone from $5 million in 2005 to more than $16 million in 2010. And unlike so many of the performing arts organizations we studied, the percentage OPAS earns from ticket revenue is greater than what it earns in contributions; approximately 80% of the organization's revenue comes from programming receipts and 20% from contributions. The Orpheum Theater has also contributed to OPAS's success; in 2011, the theater ranked as the best in Midwest ticket sales according to *Venues Today*, an industry publication. This same year, the theater ranked 16th in ticket sales worldwide according to *Pollstar*. Similarly, the Holland Center ranked in the top 10 nationally in ticket sales in 2011.[16]

Notwithstanding the success of OPAS and its new facilities and the impact it has had on the community of Omaha, the organization's president, Joan Squires, acknowledges that there were initial programming challenges that originate in the fact that Omaha is a smaller community. In a city of less than 500,000, one in which many of the community's residents did not have the opportunity to attend touring performing arts events (especially on a regular basis), the presence of an arts and cultural "scene" is still something they are getting accustomed to. The organization

is very successful in selling its Broadway performances—there are currently about 7,000 subscribers for the Broadway Series. In 2007, for example, the organization was selling out five-week runs in its 2,600-seat theater for musicals like *The Lion King*.

But, when it comes to the programming other than Broadway, OPAS has been somewhat cautious. To balance OPAS's budget (expenses sum to about $16 million annually), Squires had to focus on a high proportion of programming in the initial years that would attract large audiences (and hence, large revenues). For Squires, this usually means programming more popular works, and fewer modern and unfamiliar things—more familiar artists, dance companies, and entertainers, and fewer touring chamber orchestras, for example.

Nevertheless, Squires believes that as OPAS continues to evolve, so will its programming. To Squires and her board, this means becoming a more sustainable organization, and that, in turn, means they need to raise an endowment. Unfortunately, the sum that Heritage Services was able to raise for the facilities project did not include an endowment. One is definitely needed in order to support the organization's operations during the coming decades. Eight years after the project's completion, the board has set its sights on raising the funds to establish such an endowment, and in 2012 the board members had already started work on a campaign for this purpose in 2013. "Expect big things" was what the organization's board chair, John Gottschalk, told us. It is not that the idea had not come up before; it was just necessary to take the facilities projects one at a time. And now they are ready. In 2012, Squires was quoted in the press as saying the organization intends to raise "money for an endowment [that will] go towards long-term financial support for the Holland Performing Arts Center . . . This is the next stage in our evolution . . . We have two world-class venues, and we want to ensure that they are here for future generations." [17]

<center>* * *</center>

In these narratives, we have seen how two relatively small cities—Durham and Omaha—went through the steps involved in building a cultural facility. In both cities, passionate project leaders had a strong and durable drive to build. In Durham, DPAC's leaders were guided by a vision of transforming their downtown, which appears to have happened since the opening of the facility. This passion for downtown Durham's transformation was readily apparent among all of the project's leaders, especially when they were faced with opposition to the project from community residents and organizations: under no circumstances were DPAC's leaders going to be dissuaded from believing this project was a good idea.

In Omaha, the passion to renovate the Orpheum Theater and build the Holland Performing Arts Center was shared among a small but powerful

group of donors and civic leaders and an incredibly skilled fundraising firm. In a city not known for the arts, this group of leaders succeeded in not only completing two construction projects, but also raising more donations in their capital campaign than had ever been raised in the history of the city.

As it turns out, it is rare for a cultural building project to be completed in the absence of the enthusiasm we saw that ignited and then helped drive both these cities' projects. Because the passion to build is usually so intense, it is also quite rare to see a project not completed. Out of all of the projects we studied, not one was dissolved after the issuing of the building permit. There are instances of projects being dissolved, but because the process of dissolution is so complicated, they are a rare occurrence. For example, just $300,000 away from breaking ground and after over 10 years of planning and fundraising, the Arts Center of North Texas began the process of dissolution after a major city funder backed out. The process of dissolving this PAC project involves not only returning the land that was donated for the project and returning private donations, but also figuring out how the remaining public funds will be allocated among multiple government parties. Suffice it to say, a large portion of these funds cannot be returned because they have already been spent.[18]

But the situation in north Texas is rare, not only because the process of dissolving a project typically means agreeing to forgo the money already spent, but also because a strong and powerful group of leaders' passion to build a new cultural facility is extremely difficult to curb. As one arts consultant with a large portfolio of capital facility work told us, "Building a cultural facility is like being in a bobsled race: the only time to reconsider is before you begin, because once the gate goes down, it's almost impossible to put on the brakes."

This passion that drives the sled down the slope also helps energize fundraising goals and inspires leaders to figure out complicated financing arrangements. Both projects we read about in this chapter experienced unprecedented success when it came to figuring out how the facility was going to be paid for, and this is partly due to the passion its leaders had to build. Leaders in Durham were able to get a $33.7 million city bond initiative passed without a voter referendum. Additionally, they were able to garner the support of Duke University to the tune of $7.5 million. The OPAS project leaders in Omaha surpassed their initial $102 million capital campaign goal by $5 million. The project was even able to get the city, which had a history for being unsupportive of arts initiatives, to contribute $10 million.

The passion to build, and to raise all of the funds required for construction and initial operations, is a prerequisite for any successful cultural building project. And being able to raise all the money to pay for a cultural facility project (as opposed to relying on loans) has a large impact on an

organization's sustainability. Among projects we studied, projects with larger amounts of construction debt also had larger and more frequent operating deficits once they were completed.

But, as we saw in Omaha, a successful building project initiative is not all that is required to ensure a feasible organization. Despite having a relatively smooth planning and construction process, as compared to many projects we studied, OPAS continues to struggle with the task of balancing its books. To do so, this organization had to learn to become more flexible with its plans for programming the facilities. While initially the organization's leaders envisioned introducing cutting-edge programming to its community, in order to stay in the black it had to shift to offering more popular programs. DPAC, by contrast, was planned all along to have more of a populist appeal by partnering with Broadway operator, PFM Nederlander, and consequently has reaped large profits.

In being flexible with programming, OPAS is not alone. It is not uncommon that plans for artistic programming, which are largely dependent on revenue projections before a project is complete, must change for an organization to pay its bills. Often, project leaders have goals for offering more narrowly focused programming before facility construction is complete. But when the realities of budgeting become apparent once the project is completed and the doors open and revenue expectations do not pan out, it becomes clear that programming must be aimed at a wide range of audiences. Fully half (54%) of the projects we studied had lower revenues than projected once the facility opened and started operating, and 59% had higher expenses than projected. So, not only do project leaders need to remain conservative with their operating projections, but they should also remain realistic concerning the audiences they believe the facility's programming will attract, particularly after the novelty of a new facility has passed.

The two projects in this chapter not only illustrate how passion among those who plan and lead these ventures is vital to their successful completion, but also how facilities in smaller cities with smaller markets need to be prepared to offer a range of programming that includes popular work. There is a tendency among project leaders to feel as if their greatest accomplishment is opening the new facility's doors. But as we saw in Omaha, often organizations need their leaders most after the construction has come to an end. It is always more difficult attract audiences in smaller locales. Nonetheless, with attendance in the arts declining nationally year by year, particularly attendance at formal arts events, it is difficult for all organizations in large and small cities to generate demand. DPAC chose to partly side step this difficulty by focusing on popular programming from the outset. But for OPAS, the reality of building and operating its facilities means not only being willing to remain flexible with its artistic programming and also serve audiences that may be experiencing attending a cultural facility for the first time.

NOTES

1. Before June 6, 2003, the Office of Management and Budget included Durham as part of the Raleigh-Durham-Chapel Hill MSA. The MSA was then redefined into two separate MSAS—the Raleigh-Cary MSA and the Durham-Chapel Hill MSA, primarily due to population growth that took place in the city of Cary.
2. This case study is partly based on our interviews with Phil Szostak (principal at Szostak Design), Bill Kalkhof (former executive director of Downtown Durham, Inc.), Alan DeLisle (executive director of the Louisville Downtown Development Corporation), and Mayor William V. "Bill" Bell (mayor of Durham).
3. DPAC website. "DPAC Finishes 2012 with #5 National Ranking." www. dpacnc.com/news/detail/dpac-finishes-2013-with-4-national-ranking.
4. *Durham Performing Arts L.L.C. Financial Statements for the Fiscal Years Ended June 30, 2013 and June 2012.* http://durhamnc.gov/ich/cmo/Documents/dpac_fin_statement_12-13.pdf.
5. Gronberg, Ray. "Council Scrutinizes Proposed Change to DPAC Profit-Sharing." *The Herald Sun.* April 18, 2013.
6. Carolina Theater website. "Press Release: Carolina Ranks among Top 100 Worldwide Theatres for First Time in Its History." www.carolinatheatre.org/press-releases/carolina-ranks-among-top-100-worldwide-theatres-first-time-its-history.
7. Gronberg, Ray. "Council Scrutinizes Proposed Change to DPAC Profit-Sharing." *The Herald Sun.* April 18, 2013.
8. This case study is partly based on our interviews with Richard Holland (Omaha philanthropist), John Gottschalk (former CEO of the *Omaha World-Herald*), Susan Morris (president of Heritage Services), and Joan Squires (president of Omaha Performing Arts Society).
9. Nolte, B.T. "Stockyards to Leave South Omaha after 115 Years." *Nebraska Farmer.* January 15, 1999.
10. Omaha Performing Arts website. "History." www.omahaperformingarts.org/orpheum/history/.
11. Omaha Public Library website. "Early Omaha: Gateway to the West." http://digital.omahapubliclibrary.org/earlyomaha/.
12. Perez, Jr., Juan. "City Exploring Options for Omaha Civic Auditorium's Disposal." *Omaha World-Herald.* November, 24, 2012.
13. "Warren Buffett, Billionaire, Still Lives in Modest Omaha Home which Cost $31,500 in 1958." *Huffington Post.* January 18, 2013.
14. Omaha Symphony website. "The Omaha Symphony History." www.omahasymphony.org/history.asp.
15. Jordan, Steve. "Arts Group Is Performing Well for Omaha's Economy." *Omaha World-Herald.* February 17, 2012.
16. Omaha Performing Arts Society website. "Press Release: Orpheum Theater and Holland Center Recognized for Ticket Sales." August, 3, 2011.
17. Jordan, Steve. "Arts Group Boosts Omaha Economy." *Omaha World-Herald.* February 17, 2012.
18. Watkins, Matthew. "Cities Agree on Plan to Dissolve Arts Center of North Texas." *Dallas News.* October 14, 2012.

5 Museums

The astonishing array of museums, large and small, that one finds in cities and towns across the United States serve their communities well, but in ways quite different from those of performing arts facilities. What makes them sustainable differs as well. While both museums and performing arts facilities are created to engage, educate, and bring pleasure to their audiences, museums generally assume a greater responsibility for the preservation of past cultural creations than PACs and theaters do. This responsibility makes the process of building a new structure or renovating an existing one especially challenging, and raises issues different from those confronting theaters and PACS. Obviously, with more than 17,000 museums in the United States[1]—from tiny municipal art galleries and historical museums to major cultural institutions like the Art Institute of Chicago and the Metropolitan Museum of Art—there are profound differences in the ways museums assume and carry out their mission. But some clear and instructive patterns do in fact emerge.

In this chapter, we explore what distinguishes museums from other kinds of cultural buildings and what makes it possible to build a museum facility that is sustainable. By analyzing a variety of cases, using the large body of data we collected on museum building projects completed during the modern building boom, we now have a better understanding of how a well-thought-out museum facility can enhance the ability to deliver on mission and ensure adequate alignment with a community's actual interests. We also see how an experienced and passionate group of trustees and staff can, if they work strategically, place an organization on firm financial footing for the longer term; and conversely, we see how if they fail to do this, an organization can end up in significant distress, if not serious jeopardy. We begin by looking at how four museums—the Nelson-Atkins Museum of Art in Kansas City, Missouri; the Mobile Museum of Art in Mobile, Alabama; the Figge Art Museum in Davenport, Iowa; and the Ohr-O'Keefe Museum of Art in Biloxi, Mississippi—planned their projects, converted their plans into a reality, and, once completed, explored the possibilities and options for longer term sustainability. Although all of these museums are art museums

(not history, science, or natural history museums, for example), we have also incorporated insights we learned from the other museums, not all of which were art museums, for which we gathered and analyzed data.

WHAT IS SPECIAL ABOUT MUSEUMS?

Museums have a complex and demanding mandate. Since the late eighteenth and early nineteenth centuries, they have been the designated repositories and archives of cultural artifacts in the United States. In this capacity, they are expected to adhere to strong protocols in order that the objects housed and displayed within their confines remain intact and available to future generations. While museums need to be welcoming and accessible to visitors, their crucial and distinct role as cultural "safe houses" also requires them to be as secure as feasibly possible. This not only creates a substantial long-term expense as part of a museum's operations, but also adds a host of administrative and legal complexities, sometimes very expensive ones. Take, for example, the bitter and prolonged legal disputes concerning the provenance of art works looted by the Nazis in World War II that have unfolded at a number of museums since the end of the war. Because many of these works have been safely kept in dedicated art storage facilities, and not displayed, even their existence has remained virtually unknown—that is, until efforts to unearth the art evolved into bitter disputes over ownership.

It is a museum's staff that is tasked with cataloging, assembling, and conserving a museum's collections. Specifically, these tasks include acquiring (and periodically deaccessioning) art or trading individual art works in order to refine a museum's collections. In addition, the staff curates incoming and outgoing works, and by doing so, gives meaning to the items in a museum, both individually and collectively. This set of tasks is critical to a museum's larger mission of educating its audiences. By arranging objects in context, museum curators attempt to explain the significance of the art while simultaneously trying to attract and engage as large an audience as possible. For a museum's staff to accomplish all of these tasks, the executive staff, in collaboration with its board of trustees, must ensure that the organization has adequate financial resources. This generally means making sure that a museum has enough money to pay salaries, plus basic expenses like heating and cooling, humidity control, and elaborate security systems, plus enormous insurance premiums for the collections themselves. And they have to provide funds that are available to continue building their collections.

Notwithstanding the economic recession that began in 2008, which made it challenging for virtually all arts organizations to stay in the black, museums, in general, have had an extremely difficult time earning sufficient revenue to cover expenses. First, a museum draws in its audience primarily with its collections, its programming, and the occasional special or

"blockbuster" exhibit. As opposed to performing arts organizations that can and generally do charge larger sums "at the gate," there is a much lower cap on what a museum can charge for entry. The "recommended" entry fee for the Metropolitan Museum of art is $25,[2] for example, which remains one of the costliest entry fees to a museum in the nation. Many museums also include gift stores and restaurants (it turns out, however, that restaurants and cafes rarely function as profit centers in museums because of the inherent difficulties and complexity of merging food service with a museum's mission). Hence, many museum restaurants have not survived, and the spaces they occupied have been repurposed.

Also, in contrast to performing arts facilities, most museums are somewhat limited in their capacity to rent out space for special events such as parties and conferences. Performing arts facilities typically include designated space for these types of functions, and are thus more easily able to create an income stream to support general operations. These types of flexible spaces are often configurable for different sized groups and kinds of activities. Being able to rent out space to community groups can also help an organization integrate itself into the community and thereby assist in building support from the community over the longer term. By contrast, museums typically have collections to protect, expensive security systems to maintain, and enormous insurance costs to cover, thus fewer opportunities to rent out their space, filled as they are with valuable and fragile works of art.

Therefore, if a museum is going to depend on earned revenue from ticket sales and member fees to constitute a significant and reliable income source, it must also ensure that its patrons attend on a fairly regular basis. Not surprisingly, however, attracting repeat visitors poses a significant challenge for many museums, because in order to do so a museum has to provide new programming on a regular basis. And mounting exhibitions is both labor intensive and costly. In addition, most museums have very real space limitations; they are confined to a specific square footage, and this hinders them from presenting a wide selection of programming, which could also help to get people to come back. And finally, there is an increasingly prevalent sentiment that museums are community resources and should be freely available to the public, and so there is sometimes resentment that there are entry fees (and often very substantial ones).

Because of the difficulties museums have earning revenue, they are very dependent upon contributions, which enable them to operate in the black. Compared to performing arts organizations (i.e., PACs and theaters), the average ratio of earned revenue to contributions among the museums we studied between the years 2000 and 2009 was 0.23. The average ratio for PACs and theaters for these same years was 1.31. Thus, even in our sample, it is clear that museums typically earn much less from programs than they do from contributions. Therefore, in addition to filling the gap between ticket sales and expenses, contributions (i.e., public and private) also make it

possible for museums to add special features that can help attract audiences, such as new acquisitions, endowed curatorial positions, educational programs, and, of course, the construction of a new or significantly enhanced museum building.

WHY DO MUSEUMS BUILD?

Museums build for a variety of reasons. Some build because their facilities have simply grown old and have become outdated, or because existing spaces have become inadequate for the curatorial and preservation staff, or because the size of their collections has exceeded existing storage space. Some build to house new collections, like the San Francisco Museum of Modern Art, which embarked on a building project because of a recent gift of a vast and very important contemporary art collection. Other museums build to provide upgraded housing for existing collections. And still others build because their communities have grown substantially and there is increased attendance or museum leaders have a new vision of the role the museum can play in its community.

The Nelson-Atkins Museum of Art in Kansas City, Missouri, illustrates the first reason for building—the museum had outgrown its existing structure and desperately needed to modernize its facilities.[3] The creation of the Nelson-Atkins Museum was largely serendipitous: the result of an implausible alliance that took place after the death of its two major donors (who did not know one another)—Mary Atkins and William Rockhill Nelson. And even more implausible, this opulent and spacious museum opened its doors in the middle of the Great Depression. In 1911, when Mary Atkins—a former schoolteacher and widow of a successful real estate entrepreneur—died, she left a large sum for the creation of an art museum. When Nelson, founder of the *Kansas City Star*, died in 1915, he stipulated that his estate be used to purchase art for the public's enjoyment. It was the decision of both estates' trustees to combine the two benefactors' wishes and create the Nelson-Atkins Museum of Art.[4]

The original building, which cost approximately $2.75 million (just over $50 million in 2014 dollars) to construct, comprised more than 200,000 square feet and was almost twice as large as was needed to house the existing collection. Those who built it intended the museum to grow into its space over the decades, and they worked behind the scenes to catalyze that growth by putting in place an ambitious collections strategy. In terms of what the museum looked like and what it offered to the public, it was clearly designed to be a cultural landmark for generations to come. Its monumental scale and imposing neoclassical architecture was meant to symbolize confidence, tangible achievement, stability, and permanence in a Midwestern city. In the decades prior to the museum's establishment, Kansas City was rapidly growing as a key manufacturing center both in size and strength.

The museum was then, and undeniably still is, representative of how leaders in Kansas City think about the future of their city.

Almost 75 years later, the Nelson-Atkins Museum—one of the most respected museums and encyclopedic collections in the United States—underwent its first major building project. The project included a comprehensive renovation of the museum's existing structure, plus the addition of the Bloch Building, and cost approximately $200 million to build. Among staff and the museum's supporters, there was wide consensus that the current facility was old, out-of-date, and increasingly inadequate to the demands of a major nationally recognized museum. There was a long list of infrastructure problems for this aging but beloved facility: inadequate storage space for the collection, insufficient exhibition space, substandard conservation facilities, outdated HVAC and electrical systems, and a shortage of office space, among a long list of other needs. There was a threshold moment, as the museum's chief operating officer, Karen Christiansen, described it, when the staff realized that "to not grow is to stand still." This was the catalyst to launching a major building project. Sited on a verdant 22-acre campus, it required a major construction project to successfully address its physical problems and to provide Kansas City with a first-rate museum that civic leaders believed it deserved.

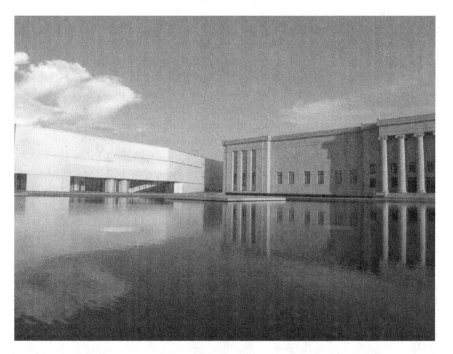

Figure 5.1　Exterior view of the Bloch Building at the Nelson-Atkins Museum of Art, Kansas City, Missouri.

Credit: Photo by Beth Byers courtesy of Nelson-Atkins Museum of Art.

By contrast, part of the stimulus for expanding the Mobile Museum of Art in Alabama emerged in response to the launch of an ambitious city plan to build an urban cultural hub that would embody and reflect the growth and development of Mobile at the turn of the twenty-first century.[5] In the mid-1990s, Mobile's civic leaders decided to embark on a major cultural building project: a comprehensive overhaul of the city's outgrown and aging museum. A $15 million project, which involved trebling the square footage of the museum's existing facility (originally constructed in the 1960s), was only one component of a broad and ambitious effort by Mayor Michael Dow and the city council to transform Mobile into a city that could offer the kind of amenities that would elevate them to the same tier as Charlotte, Raleigh-Durham, Birmingham, and other prosperous southern metropolitan centers. To do this, the city launched the "String of Pearls" initiative wherein an array of new facility projects were planned, hundreds of historic downtown buildings and homes would undergo restoration, and zoning and permit revisions would be fast-tracked.[6] The goal of the initiative was to help facilitate a downtown transformation by making it much more attractive and easy for new businesses, particularly those that might relocate from other parts of the country. In the 1990s, economic vitality is what civic leaders thought was missing in Mobile, and the city's campaign was designed to bring it back.

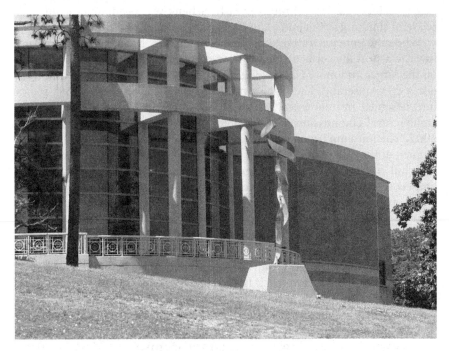

Figure 5.2 Exterior view of the Mobile Museum of Art, Mobile, Alabama.

Credit: Courtesy of Mobile Museum of Art.

The idea to include the renovation and expansion of the Mobile Museum of Art as part of the city's broader effort to revitalize Mobile was that of the museum's previous director, Joe Schenk, along with the museum's head curator, Paul Richelson. After closer scrutiny of the project's potential expenses, they concluded that it would cost the museum substantially less to construct a new building than to renovate the current facility's 32,000 square feet of existing space. Furthermore, they knew that the museum was well beyond capacity in terms of space, so they needed a plan that would increase that substantially. A new facility could also provide the museum with a better-equipped space to help manage the collection, and to enable the staff to offer programming that more closely fit the needs and preferences of the community.

At the time Schenk began his tenure as director in 1988, the museum's facilities were already out-of-date and its collections were in disarray. When the original museum opened in 1963, it began acquiring art—and a lot of it—at a very rapid pace, applying little discrimination in terms of selection, and with no particular plan for developing the collections. Simply expanding was the main priority for the museum at that point. Schenk's first task, then, was to carefully examine and assess the museum's collection, and then to develop a strategic plan for refining it, which included an acquisitions fund. He also wanted to get the museum accredited, which he finally was able to achieve in 1995. Simultaneously, Schenk was beginning the internal phase of thinking about and planning for a renovated and expanded facility.

While the impetus for building the new Figge Art Museum in Davenport, Iowa, was (on the surface at least) similar to that in Mobile; the Figge took on the larger and more challenging mission of being a regional, rather than just a city museum.[7] The Figge Art Museum—a striking, modernist structure designed by renowned British architect David Chipperfield (his first architectural commission in the United States)—opened in late summer of 2005. The museum began as the Davenport Municipal Art Gallery (the first municipal art gallery in the United States), which opened in 1928 at the top of a hill overlooking the downtown. Originally, the Davenport Museum housed a significant and substantial collection of art donated by Charles Ficke, a Swiss immigrant banker, and over time the museum's collection grew to approximately 4,000 pieces.

The idea to build a new museum started as a project of and for the city of Davenport, but later evolved into a project envisioned as serving the entire Quad Cities region (now a group of five municipalities including Davenport and Bettendorf, Iowa; and Rock Island, Moline, and East Moline, Illinois). Traditionally (and much to the frustration of local foundations and philanthropists) each of the Quad Cities tended to duplicate organizations, and their bricks-and-mortar incarnations—one for each of the municipalities. For example, for this metropolitan region of approximately 383,000, there are nine public libraries scattered throughout the area. Therefore, what would ultimately become the Figge Art Museum represented an important

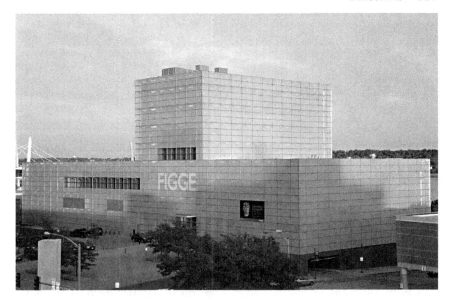

Figure 5.3 Exterior view of the Figge Art Museum, Davenport, Iowa.

Credit: Photo by Andrew Wallace; © Figge Art Museum 2014.

departure from the tradition of these contiguous cities initiating, building, and then trying to support their own separate cultural institutions. The leaders behind the Figge took a regional view, seeing that the project could both benefit and be supported by the entire metropolitan community. They also knew that, realistically, they could not pull the museum project off without the financial involvement of the entire region.

The Ohr-O'Keefe Museum in Biloxi, Mississippi, had an altogether different origin and mission for building its new set of facilities.[8] They were built to house a collection of pottery that had been poorly housed for decades. The Ohr-O'Keefe Museum, in the words of its former director, Denny Mecham, is "a small, regional museum with a high profile." A cluster of five moderate-sized buildings designed by architect Frank Gehry, the museum sits just a 100 yards in from the beachfront and the coastal highway in Biloxi, Mississippi.

The idea for the museum had been spawned by a local philanthropist, Jeremiah O'Keefe, (at that point in his 80s), who wanted this project to mark a major turning point for Biloxi. A former fighter pilot, one-time mayor of Biloxi, and one of the city's few liberal Democrats, O'Keefe was determined to have the museum make a unique architectural statement on the coast, and, hopefully, over time, contribute to improving the region's oft referred to reputation as the "Redneck Riviera."

O'Keefe and Gehry—who had become friends well before working together on this museum project—were particularly excited that a key focus

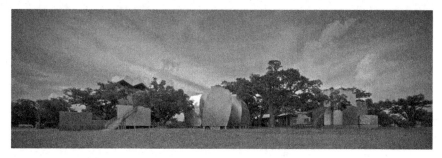

Figure 5.4 Exterior view of the Ohr O'Keefe Museum of Art, Biloxi, Mississippi.

Credit: Photo by Billy Dugger (2014) courtesy of the Ohr O'Keefe Museum of Art.

of the museum was to provide an appropriate home for the work of the eccentric "mad potter" of Biloxi, George E. Ohr, who died in 1918.[9] Ohr was a gifted, prolific, self-promoting, and tireless ceramicist whose work is only now coming to be recognized as a significant contribution to the modernist art movement in America. During his lifetime, Ohr's work became increasingly popular among collectors. He became someone with whom the community was familiar and ultimately very proud of as his fame developed. By taking on this museum building project, O'Keefe wanted to give the potter, his art, and his reputation its due in a venue as interesting and provocative as Ohr's ceramics. From O'Keefe's point of view, the artist's work had been displayed for far too long on the second floor of an older building in the middle of town, up one flight of stairs from Biloxi's ground floor public library. With the help of Gehry, one of the world's renowned architects (and a personal friend), O'Keefe (also a bit of a wild card in his community because of his Democratic politics and his wealth) was determined to shake things up a bit in this quiet Mississippi seaside town.

TRANSLATING VISION INTO REALITY

Despite different motivations for embarking on a major building project, all of these organizations, plus many others across the country, faced the daunting task of raising the funds necessary to build, and then to sustain over the long term the operating costs of their new building. Each faced different circumstances arising from the distinctive traditions of their communities, and from the different goals they set for themselves.

The Nelson-Atkins Museum had the most orderly and straightforward experience. It is the museum's former director, Marc F. Wilson, who is largely credited with the success of the Nelson-Atkins Museum's building project. He saw the museum's current space squeeze as a problem to be solved, but more importantly as an opportunity to improve the museum's stature in the

Kansas City community. He understood that in order to achieve the project's fundraising goals, the building project would need to be carefully aligned with the needs, interests, and capacity of the community that was going to be called upon to support the endeavor. While the community had long supported the museum, Wilson, who was not a native of Kansas City, knew he had to understand the ethos of the community and determine exactly who his audience and supporters would be. This, in turn, would help ensure the museum's long-term sustainability.

As noted in Chapter Two, Kansas City has for well over a century been a deeply philanthropic and self-reliant community. Not only are foundation assets per capita very high ($3,329 per person compared to a national average of $2,053 per person in 2007),[10] but also, historically, the community of Kansas City has long had a tendency to distance themselves from public funds and government involvement on major civic improvement projects. For decades, the citizens themselves took on the task of building public amenities commensurate with their growing city's stature and its envisioned future. For example, in the 1890s, the city's muddy landscape was transformed into an interlocking system of parks and boulevards designed by George Kessler in the "City Beautiful Movement"—an effort that was largely funded by private donors.[11] Area philanthropists also helped construct libraries and, most recently, renovate and repurpose the city's train station (the second largest in the United States) into a complex of theaters and museums), as well as the Kauffman Performing Arts Center discussed in Chapter Two.

At the time Wilson started thinking about building, there was a growing network of cultural organizations in Kansas City built and funded by key area philanthropists. Families like the Blochs (of H&R Block), the Halls (of the Hallmark Corporation), and the Kauffmans gave both leadership and enormous financial resources to cultural institutions. Upon learning she had cancer, Muriel Kauffman announced she had decided she was "going to have fun" with her money and promptly gave a million dollars apiece to a range of arts and cultural organizations that they were to put directly into their endowments. On a broader scale, an energized and like-minded group of community philanthropists whose commitment to the community was part of a long tradition regularly ensured that (in terms of financial and time commitment) the city's cultural landscape would continue to thrive. And they, in turn, helped establish and reinforce strong civic activism and generous support from the community at large. In other words, as *de facto* community leaders, they set high and very positive expectations for civic engagement and generosity, and the rest of the community followed their lead. This ethos continues to this day.

Wilson's deep understanding of the history of this Midwestern metropolis helped him to successfully lead the Nelson-Atkins Museum's large and extremely complex building project. Because he knew that the community had the capacity to pay for large capital projects with private funds (and a

long history of doing just that), and because he knew that the leading phi-
lanthropists were committed to investing in Kansas City's cultural landscape,
and because of the deep suspicion of government involvement in any under-
taking, Wilson was confident that city residents would step up with their own
funds, expertise, commitment, and time in order to ensure that the proposed
museum project would be a success. Wilson also knew that the community
believed the premise that "whatever we have [in Kansas City], we need to
make for ourselves." In fact, the independence of the museum in building its
new facility was clearly demonstrated when the city's mayor—Mark Funk-
houser—did not attend the opening night celebration, saying he had a prior
obligation. The museum did not need the city's help, and neither that help,
nor any particular expression of interest, was forthcoming in any case.

The traditions of Kansas City, however, stand in striking contrast to those
of Mobile and Davenport. The Mobile museum is owned by the city, but the
collection is owned by an independent 501(c)(3) organization. Joe Schenk,
the former director, knew that it would be a steep road sorting out the muse-
um's governance structure, but this was critical if the museum was going
to plausibly launch a major building project. First, there would be compet-
ing incentives between the museum's two most important stakeholders: the
city and the museum's board. The city of Mobile had a significant stake in
the project as it owned both the land on which the museum was built and
the facilities themselves. But since the museum (operating under 501(c)(3)
status) owned the collection itself, it had its own incentives, one of which
was to remain a responsible steward of the collections. This competition
often played itself out in the board room—not surprisingly, as the museum's
20-member governing board was composed of several government represen-
tatives, including seven city council members and three county government
officials, in addition to a few civic leaders from Mobile. Finally, adding to
this complicated decision-making structure, the museum's board would end
up having five different presidents from the time the project was conceived
to when it was completed.

Schenk's drive, plus his ability to navigate the complex relationships and
negotiations that had to take place in order for the project to become a real-
ity, had a significant impact on the overall success of the building project.
When, for example, the design of the new facility was ready to be presented
to the board, Schenk had to determine in advance what baseline elements
would make it even remotely plausible that they could get the trustees'
approval. This had an enormous effect on what the design priorities ended
up being.

But Schenk had no choice. As a museum director working under the
auspices of both a board and a municipal government, Schenk had to devise
a set of designs that both his trustees and the city administrators would be
comfortable with. Otherwise, government-backed funding would be diffi-
cult to obtain. And without the board's leverage to secure city, state, and
federal funding, the project would never get off the ground, as there was

simply no possibility that it could be undertaken without major involvement and funding from public agencies.

Unlike many museums, which are built primarily with money donated by private donors and foundations, Mobile's museum project was all about effectively leveraging political relationships. The city, for example, put in $6 million for the facility's construction. The board itself did not have a sense of personal financial obligation and responsibility for the successful carrying out of this kind of building project, a sense that many boards across the country would consider an absolute prerequisite. In the case of Mobile's museum, by contrast, board members' responsibility was not about giving money directly, but rather about putting their connections to work in order to get money from the county, the state, and the federal government. Government funding would cover a significant portion of the new museum building's construction and its subsequent operating costs.

For nonprofit boards facing the task of raising tens of millions of dollars (and sometimes hundreds of millions) for their building projects, Schenk's situation might seem almost enviable. What museum, or any other cultural institution for that matter, would not welcome significant funding from public entities? But a closer look reveals that there were some extremely complex and difficult situations to deal with throughout the course of the museum's planning and building process. At one point, for example, when county money was embezzled by three county officials (two of whom ended up going to prison), the county informed Schenk that they would be unable to give the promised $3 million to the museum even though construction had already started. This blindsided both the board and the director and required immediate action. Schenk immediately negotiated a loan from a local bank to cover the lost funding. But since the bank was skeptical about getting involved with loaning money to be used to build a city-owned building, on city-owned land, Schenk had to resort to a drastic move and one that museums use only as an absolute last resort: he used the museum's art collection as collateral. It has subsequently taken years for the museum to pay this loan down (at the end of 2010, the museum still owed close to $1 million). Despite all these difficulties, Schenk, the mayor, and the board were able to keep the project from coming to a complete halt. The museum ended up being built, and it opened in 2002.

The legal situation in Davenport was similar to that in Mobile, but in the course of planning for the new building, the concept of the museum and its role in Davenport and the larger region changed substantially. It was not until the 1990s, when the city of Davenport began to recover from the decade-long recession that had inflicted a harsh economic toll on the region—taking out several of the city's major employers and causing the city to lose almost 8% of its population—that the idea of building a revamped and greatly expanded museum facility emerged. The state had recently launched a program called "Vision Iowa" whose purpose was "to assist projects that will provide recreational, cultural, entertainment and

educational attractions" through public investment in infrastructure.[12] A variety of downtown civic improvement projects were funded through the initiative, including the renovation of an abandoned theater, the building of the Skybridge elevated pedestrian walkway along the riverfront, and new parking facilities and freeway ramps. This, in turn, set the stage and provided the necessary momentum for the possibility for a new museum project.

There were also substantial legal and administrative issues that the board of the Figge had to resolve along the way, many of them having to do with the museum's preexisting partnership with the city. Since the city of Davenport had been the owner of the original museum on the hill, a new 501(c)(3) had to be created to take control of the museum once the construction was completed and the doors opened. This meant that the museum's original board, all of whom were appointed by the mayor, were running the existing museum on a day-to-day basis, and the original museum foundation (a separate nonprofit organization that already existed and was tasked with raising funds for the museum) was doing the work of getting the Figge built (e.g., designing the new building, raising money for construction, and creating operating plans).

A new nonprofit entity, then, was being structured to take over the museum once the new facility was completed; and at that moment, the museum would have an entirely revamped organizational structure. For example, the substantial operating subsidy given by the city to the museum, which was funded by a dedicated hotel/motel tax, would have to be restructured to fund the new nonprofit museum once it opened. And plans had to be put in place to take all the city employees that worked in the museum and transition them into being employees of a private nonprofit organization. This involved the formidable task of renegotiating salaries, pensions, seniority, and so on.

While the project leadership group included a number of able and very determined individuals, this byzantine arrangement of public and nonprofit entities, boards with contiguous and interrelated responsibilities, and ample opportunity to work at cross-purposes, imposed a significant challenge. Layered onto this network of different boards was the responsibility to effect an orderly transition from a city-run institution to a privately funded museum. Finally, even though it was to receive two decades of financial support from the city for its operating budget, this brought not only accountability to city authorities, but also the obligation to think out a longer-term sustainability plan if the city of Davenport decided at the end of 20 years to radically reduce funding.

The Ohr-O'Keefe Museum in Biloxi faced a much different situation. The museum project was driven largely by the passion of Jeremiah O'Keefe and Frank Gehry, plus a very small cadre of supporters. The leadership group saw building the museum as a rare opportunity to provide something special for the region in terms of its cultural offerings. O'Keefe and Gehry's idea was to provide a real museum in a region where none existed and give the

community something that could, over time, help transform it from merely being a gambling destination. Having a world-renowned architect design the museum could also plausibly help raise the profile of Biloxi, in both architectural and symbolic terms. In other words, they wanted Biloxi to become the next "Bilbao"—a globally known museum Gehry designed and built in 1997 for the Spanish city of Bilbao, which was credited for infusing economic vitality into a once declining city.

But as it turned out, it proved very difficult to gain consensus about the project and to attract private funding. O'Keefe had been mayor, and was clearly very well connected in Biloxi, but agreement was lacking about exactly what this new museum building should look like. A conservative contingent was not interested in the prospect of Biloxi being home to an art museum. And there were concerns that art did not mix well with gambling, the city's main tourist attraction. Furthermore, the city of Biloxi, being a relatively poor region with a very modest philanthropic ethos, appeared to have limited capacity to fund capital projects with private funds. On the other hand, the region had a long tradition of high expectation and extreme dependence on federal and state tax dollars for a wide range of projects and activities.

Fortunately, garnering political and financial support was an arena in which Jeremiah O'Keefe had two very important skills. First, he was adept at fundraising for civic projects from both private and public sources. His own financial contribution—a total of $2 million—to the Ohr-O'Keefe Museum, ended up being both a direct and an indirect one. Second, as a well-known and strong Democratic voice in a largely conservative and Republican community, he was able to keep at bay the forces gathered against building the museum. He effectively counterbalanced those in Biloxi who were openly alienated by Gehry's striking architectural design, and who had no enthusiasm for spending any public money on the project. From the point of view of some of the most vociferous opponents to the project, it would have been better for Ohr's collection to just remain in its old quarters downtown on the second floor over the public library, and to forget the museum project altogether.

In the summer of 2005, the Ohr O'Keefe Museum facility had been under construction for close to a year. But the half-completed museum, which at that time included only three separate facilities, was completely obliterated when Hurricane Katrina struck the Biloxi shore. A four-story, 400-foot-long gambling barge came unmoored, drifted down the beach, and then crashed into the half-completed museum and an intact nineteenth-century plantation home next door. It took almost three years to sort out the destruction, salvage the collection, file for insurance, get new permits, and put together a strategic plan to cover the costs of rebuilding an expanded museum. After long planning and deliberation (and endless political machinations), construction began on the new museum in July of 2008.

For the museum facility's second iteration, Gehry promised to build a complex that "danced with the trees," referring to the groves of ancient live oaks that lined the seashore, many of which had been destroyed by Katrina

(including an enormous centuries old oak known as the "Councilor" with a circumference of 21 feet). Several of these historic oaks survived near the museum site, and there was consensus among museum and civic leadership about the need both to save them and to incorporate them into the planning of the museum.

In spite of the discord, and with $18 million in hand from an insurance settlement that covered the first iteration of the museum that had been destroyed by Katrina (funded primarily from federal, state, city, and county sources), the work began. Not surprisingly, however, costs rapidly escalated from the initial $19 million estimate for building the museum to approximately $38 million. This was due partly to the expanded design (now five separate buildings instead of three), but also by the impact the casinos had on everyone around them because they were still in the process of rebuilding after the hurricane, and consequently construction costs (labor and materials) spiked because there was so much competition from these massive reconstruction projects. Given their scale and the money they had at their disposal, the casinos set the bar for labor and material costs. And so the project budget expanded: to build the post-Katrina expanded version of the museum required significant additional funding. This would include $5 million in state bonds, $3 million from the Knight Foundation, $6 million from the Department of Housing and Urban Development, and a number of additional private contributions, including a second gift, this time of $1 million, from O'Keefe himself.

In the end, however, the relatively small group driving the effort to bring the project to completion managed to overcome the cost overruns, the dissension among both civic leaders and in the community, and the myriad unexpected hurdles that arose as the project unfolded. As of July 2014, the museum is almost complete, and the final stage of the campus style museum building—the multiple "pods" for Ohr's ceramics—will be finished and open in 2014.

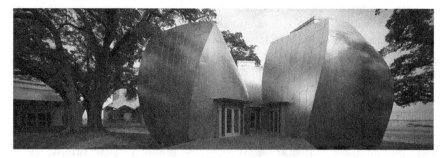

Figure 5.5 Exterior view of the John S. and James L. Knight Gallery (The Pods) at the Ohr O'Keefe Museum of Art, Biloxi, Mississippi.

Credit: Photo by Billy Dugger (2014) courtesy of the Ohr O'Keefe Museum of Art.

CONTRASTING CHALLENGES

Kansas City: Selling a Grand Vision

Beyond the obvious need for more space and better infrastructure, Marc Wilson knew that his opportunity to elevate the stature of the Nelson-Atkins Museum in the Kansas City community had arrived. He also knew that he was the man to make this happen: "I am a builder, and I believe in the museum and its potential. And this was the moment to take [the museum] to a new level." Nevertheless, he still had to take his vision to the museum's board, its supporters, and to the entire Kansas City community to get buy-in. He understood how critical it was that he communicated his vision to the museum's stakeholders and persuade them how important the project was for the city and its future. Without their support, the building project simply could not happen. While he was confident that there would be support for the project—especially once everyone fully grasped and understood the range of things that would be offered in this expanded and enhanced facility—he knew he had to articulate his vision for the museum very clearly and persuasively, such that both the vision and its supporting arguments would be fully understood by the board. With help from his staff, he framed the project as contributing to the museum's capacity to be what he believes museums, and art in general, are capable of doing for individuals and their communities. At its core, the museum and the art it contained were important to Wilson primarily as instruments of social change. While Wilson is clearly very passionate about the art contained in the museum, what really drives him is what he sees as the transformative capacity of the arts. The message that he communicated to those inside the museum (the staff) and to the community was that to execute this vision, the entire enterprise would have to be ramped up significantly.

Wilson made sure that the idea, and then the public messages containing the idea, were unequivocal and on-point from the beginning. For example, he did a lot to rationalize the museum and its procedures, including drafting a mission statement (the museum's first) and assembling detailed program manuals that covered the full range of museum activities (everything from launching an exhibition to collection maintenance and conservation). The thoroughness and care that he took in all this work made him a credible author of both the museum's mission and of a vision that could help galvanize the support of staff, trustees, and donors and other civic leaders in Kansas City.

Furthermore, to carry out the mission of the museum and to realize his ambitious vision, Wilson believed that the project had to be carried out at the appropriate scale and level of aesthetic sophistication—one that would more than satisfy even those beyond Kansas City. As Wilson said, he "knew very well how philanthropic Kansas City residents are, and how proud they are of their community. But they are Midwestern, which means they would

accept something modest as being appropriate [for them.]" In other words, the project would have to be better than just "good enough for Kansas City," and Wilson would have to help in redefining what that actually meant.

To help him reinforce the case for this ambitious new building project among the elite member of the Kansas City philanthropic community, the museum's board chairman, Don Hall—chairman and CEO of the Hallmark Corporation—worked closely with Wilson from the very start. Hall, according to COO Karen Christiansen, is a man who believed "you should either go big, or go home." He bonded with the mission and the strategic plan that was being presented by Wilson and effectively persuaded the Kansas City community, as Wilson said, "that they needn't settle for second best." Wilson had the task of convincing the community and its leaders that they needed a facility commensurate with the importance of the mission and vision. They should not settle for some minimal, practical structure; not garish certainly, but one that was as dynamic and exciting as the vision itself.

With the vision now outlined in detail, the hard work and planning could begin. Early on, an architectural programming firm was hired to both diagram and to quantify the entire contents of Wilson's strategic plan, and then put it down on paper in spatial terms. It was only after this work was completed that the search for an architect began. Since all of this work had been completed prior to the architect's selection, whoever was selected could immediately start designing the building with a very clear understanding of what would constitute a successful new building for the Nelson-Atkins Museum. For the project's leaders, the final design might win an architectural award (and indeed it has won many), but that was not the operative definition of success. To Wilson, his staff, and his board, success would be a design that fully incorporated the values laid out in the museum's mission, and the vision for an expanded and transformed facility that emerged from that mission. This vision included the philosophy behind the art experience the museum was intent upon providing, an understanding of the long-term strategic plan they had embraced, and the comprehensive physical mapping that had been conducted, based on this plan. Using the building project as a tool, Wilson and his architect, Steven Holl, along with the museum's board, worked hard at implementing (and creating in terms of spatial scale and organization) what the museum's leadership identified as the explicit and the tacit core values of the museum.

With Wilson at the lead, the careful effort they made to sort through the fundamental values of the organization (i.e., what was really important to the trustees and senior staff) proved to be a critical factor in the success of their building project. The values they articulated informed the ideas they came up with in terms of the design and programs. In the end, the project's leadership was confident that what was built was what they had articulated. Because the process was so successful, Wilson could also honestly say that they built "what architect Steven Holl designed," even though Holl had

been given everything he needed to understand what the vision and purpose of this museum was, and how the building would need to incorporate and embody both.

To further strengthen the mission of the museum and Wilson's vision to provide a spectacular venue for displaying art for the public, the museum's staff and board made the decision to expand the museum's very successful "free-day each week" program by boldly abolishing entry fees altogether in 2004. As Wilson explained, "Why shouldn't access to the best art be free and accessible to all?" He explained that he had to help trustees understand the precariousness (and what he felt was actually delusional thinking) about earned income possibilities at museums. He told them, "Don't be counting too much. The yardstick is not this year or next year . . . the impact and pay-off will only be seen over time, in succeeding generations of museum-goers." Therefore, in designing the Bloch Building, both Wilson and Holl believed that it needed to be designed not simply as an architectural *tour de force*, but as a facility that functioned effectively for the purposes for which it was being built. And it needed to be a building that would work for the entire community, in keeping with Wilson's notion of the mission.

Therefore, in the case of the Nelson-Atkins Museum, it was not the dream of a particular board trustee, nor of a wealthy donor, but of the Nelson-Atkins's then-director, Marc Wilson, that enabled the museum to realize its vision in this new building. Sure enough, planning the right facility, at the right time, helped make this vision—to embed the museum in the heart of the Kansas City community and to make art accessible and free to all—possible. But also important was the deep confidence and passion that Wilson had for this vision. This enabled him to effectively communicate it to those around him so that they, in turn, were able to help make it happen.

While Wilson does acknowledge that the decision-making process was decidedly "top-down," inasmuch as it was the executive leadership (which is to say Wilson) and the board that drove the planning and building process, he argued that it was in fact simultaneously a highly consultative process. Over time, a nearly seamless consensus was created, not only within the board of trustees, but also among the foundations, donors, and community members that offered support for the project. As Wilson said, "It's not a linear process to develop and get consensus around a vision like this." In other words, it takes a tremendous amount of work, both long and short term; meeting people individually and in groups, going back and meeting with them again, and keeping them apprised as things develop. In the end, everyone who worked on the project needed to buy into the comprehensive vision that Wilson worked so hard to develop and then communicate if it was going to be a success.

The museum's leadership relied on the vision to inspire support for the project, because as Wilson believes, "A vision will take you much further with donors than a naming opportunity. And in the end, if done properly, it works very well. If you can get individuals to commit to the project, they

will be inclined to give significantly more money than if you just gave them a simple naming opportunity somewhere in the building."

In the end, he was right: all $200 million was raised even before the architect was chosen or the design completed—a striking success for the museum's leadership (and an unusual feat given the outcomes of the majority of cultural building projects). Inspiration came from the institutional vision itself, not from an elegant and inspiring architectural rendering.

When asked to summarize what they did differently from most other museum building projects, Marc Wilson said the following:

- We asked ourselves why the museum exists in the first place, to get at its core values, which, in turn, became the foundation for all that follows.
- We raised all the money *before* we built.
- We avoided the trap of depending on earned income.
- We articulated a vision that people could buy into at any level.

The Nelson-Atkins Museum building project has been a striking success and has undeniably carried the museum and its former director to the next level. In a press release announcing Wilson's retirement three years after the Bloch building opened, Estelle Sosland, the museum's former chairman of the board, gave credit to the museum's former director: "The Bloch Building would not be as spectacular as it is without Marc's constant attention and his oversight of every detail of this project. The results, deserving of all accolades, was due to Marc's creativity and tenacity."

But now, it is Julian Zugazagoitia—the museum's new director—who is responsible for implementing the core values that Wilson worked so hard to articulate. While Zugazagoitia may have a radically different approach than Wilson (his efforts have largely included expanding the museum's programming and focusing less on collections), he utilizes the museum's transformative new space that Wilson was so pivotal in creating to present content appropriate to today's contemporary art.

Mobile: Did the Building Meet the Need?

In Mobile, one of the troubling outcomes of the complex public–private governance structure that had to be sorted out was that the elaborate planning process itself, guided by so many players, had gradually eclipsed the museum's initial goal of aligning the new space with the needs and preferences of the community. Equally pressing was figuring out how and from what funding sources the costs of constructing the museum's new building would be drawn. The community's actual capacity to use the new building may have not been fully thought out, and thus consensus had never really been reached. A flexible, easily usable space (which did not ultimately become part of the plan) would have provided the community and the museum with

a much wider range of opportunities for making full use of the new structure. For example, the facility lacks adequate public space to host outside events, and the acoustics throughout are disappointing. Furthermore, the retail space is underused, the theater space is too small, and its acoustics are compromised. If the public-space elements of the new facility had been more carefully thought out, and if more consideration had been given to the issue of how the museum might offer its space to the community in creative ways, it is possible the museum would have been able to significantly supplement its earned income. But this did not happen. The design has prevented the museum from successfully capitalizing on its new space and sadly has not resulted in the community seeing the museum as an important resource.

Deborah Velders, the museum's director since late 2011, remarked to us that, with hindsight, it likely would have helped the museum if it had responded positively to the mayor's invitation and relocated downtown. While the museum's location in the park made it less expensive to build, she said, and it provided all the room the museum needed for the collections, and protected the space from the threat of flooding, she acknowledged that not being part of the revitalization effort taking place in downtown Mobile hurt the museum's bottom line. Velders said, "In the museum not being part of the [downtown] resurgence, it has consequently found itself left out in the cold."

Velders accepts that the museum is now where it is, and also sees distinct and important opportunities for the museum's future. In terms of the collection, the period of somewhat indiscriminate acquisition of art through purchase or gift is over, and it is now time to carefully refine what the museum currently has: "We can have fewer objects, but better ones." To "trim and shape" requires that the museum also "assess" its collection. In other words, with an upgraded cataloging system the museum could also figure out what pieces it has and where they might fit in. "A comprehensive database of [our] holdings is needed, as is a detailed assessment of the conditions of the collections, and appraisals. [So this gives us an opportunity to] better understand what we've actually got," said Velders.

Beyond that, however, Velders acknowledges that the museum needs to become more responsive to the needs of Mobile's residents. Identifying herself as a "populist," she argues that museums are changing primarily because society itself is changing. This means that, "in the era we now live in, you need to retool your facility to fit the needs and wants of your community." In other words, museums are increasingly becoming places for social interaction, as opposed to just treasure houses.

"People want information, and they want to be entertained," and one way to do that, she argues, is "to move into the interactive mode with them." How to do that, and do it effectively, is what she is working on now.

In the end, Velders argues, you need to have the majority of those that come to the museum like what you are doing, and to sense that you are providing a valuable service—"Only then can you get the really substantial gifts

that will help support the museum." This will, she hopes, be the case in the future. For now, the city of Mobile contributes approximately $2 million in public funds annually to help with operations.

Velders went on to say about the city: "They own the museum itself, [but] not the collections. And we need to develop a partnership built around a renewed sense of trust. Given that there is clearly not enough philanthropic capacity in Mobile to make the museum a privately financed operation, this is really the only way forward for us."

Did the investment in the building pay off for the Mobile Museum of Art? It depends on one's definition of success. Even though the museum took on significant debt, the fact that the new building is completed and open may illustrate success for Schenk and for those who had the goal of building. And even though the museum is not a central, visible part of the growth and enhancement of downtown Mobile, the fact that it still exists and will likely serve as an important cultural anchor for the city's residents for years to come says something about its success as a community institution.

But Velders, who believes the new building was necessary, posited a different definition of success: "I think that whether you're a small organization, a mid-size organization, or a large one, fiscally prudent management, the quality of decision-making, the quality of your outreach to the community, and the quality of your programs" are things that will have the primary influence on whether you survive or fail.

Davenport: Uncertain Mission

For close to a decade, the Figge Art Museum project went forward without the leadership cadre having clear consensus about the mission of the institution and the purpose of the building project itself. An energetic, devoted, and tenacious group of leaders made the project happen, but they acknowledged that when they first embarked, they had little idea how complex (both in political and practical terms) the project would be to complete or how long it would take to accomplish. As Dee Bruemmer, a county administrator and key player in the leadership group to build the Figge, said, "The project took on a life of its own over the 10-year period we were planning and building; and it ended up turning out quite differently than what we thought [it would] at the beginning."

Initially just a museum, the project quickly evolved into a component of a broader effort to help develop, at the time, Davenport's rather moribund downtown area. "We weren't planning to redevelop the downtown area; other people gradually drew us into their development plans," said Bruemmer. There was the assumption that [a] new museum facility located downtown could help the rest of downtown grow and "even the people who didn't like art would appreciate it."

There were other moments throughout the planning process where the vision for this new facility was debated and then modified. In order to receive

state-contributed funds from the "Vision Iowa" program, the project had to be voted on in a public referendum. Much to everyone's astonishment, 71% of the county population voted in favor of the project, which at that time represented a general endorsement of the idea of spending tax dollars on a museum facility as opposed to voting on a specific, detailed proposal. This resounding endorsement was deployed by the leadership group as a signal that "people believed we needed to make a statement about who [as a community] we were. If we were going to try to develop the downtown, we all needed to make a contribution to that effort. And we realized it was now *our* turn—not our parents, or someone else's responsibility—it was *our* role to do this," said Bruemmer. So, motivation was not an issue. But what exactly the new building would actually be for the community was not entirely resolved.

When the meetings and discussions began to take place with, for example, local artists and community arts groups, it became clear that there was a sizeable and audible group who felt that in light of the major contribution of taxpayer funds, the new facility should be a community center for the arts, and one with a strong participatory component. They were not interested in it being just a traditional art museum. In fact, the project was referred to as the Figge Art Center for a long time before it was finally decided it would be a museum. But given that so many of the people who wanted the new facility to be a community arts center could not provide substantial financial support (i.e., artists), the idea for a traditional art museum took precedence. Nonetheless, many city residents were deeply disappointed and made it known that the Figge had become something quite other than what they had initially hoped.

Ultimately, the project's pieces fell into place—a site was selected, a building plan was created, and, most importantly, the city made an agreement with the board to contribute $753,000 a year for 20 years to support the new museum once it was built. Despite this momentum, and a successful conclusion to the construction project, there had never been a clear and succinct articulation of the vision and mission for the Figge; it was simply not clear what exactly would be going on in the new building once it opened.

The Figge is now fully operational and, as of 2013, the museum had only a modest debt (approximately $2 million) on the $45.5 million structure. It contains a substantial art collection, much of which is on display, and it has an ambitious and well-regarded educational outreach program in place. Furthermore, the museum is in a partnership with the University of Iowa whereby it temporarily houses its art collection (over 12,000 works). The partnership was arranged by the Figge's previous director, Sean O'Harrow— now the director of the University of Iowa Museum of Art (UIMA)—after serious flooding forced UIMA to evacuate its collection. But UIMA now has its own plans to build a replacement facility for the one that was rendered unusable, so it is unclear how long the Figge will be able to capitalize on being the showcase for the important collection of UIMA.

While the new Figge, located on the edge of the Mississippi River in the heart of Davenport's downtown district, did in fact get built, the job of securing the museum's future is far from complete. The Figge has a very modest endowment (which is earmarked for acquisitions, not for general operations). Without its partnership with UIMA, it is questionable whether the Quad City communities are up to the task of supporting this expanded and cost-intensive endeavor. But, Bruemmer points out, "Money has not really been the problem." The most serious issue that faces the museum, still, eight years after its opening is, says Bruemmer, is "trying to define what the museum's mission was going to be once we were built, and then to get other people to understand [and support] that mission. I don't know if we're over that hurdle yet."

Biloxi: Community Acceptance

Denny Mecham, the museum's director from 2008 until 2013, character-ized the lack of consensus for the project among the Biloxi community as follows: "Mississippi doesn't have a museum culture to speak of, so the frame of reference just doesn't exist here." To her, this meant the project needed to become, in one way or another, "an aspirational, optimistic act of will" on the part of those who wanted to see it built, or else they should simply abandon the idea altogether. So, "Just do it!" had to be the motivat-ing maxim. Fortunately for the museum, there turned out to be just enough local pride—even among some who were not particularly enthused with Gehry's eclectic design—to see the project through. All in all, the small but energetic group of supporters had the motivation to prove that "Missis-sippi could handle something like this and see it through to the end," said Mecham.

"At one level, though," she admits, "Building [this museum] really made no logical sense." The Biloxi community, which is actually the seashore area plus several smaller contiguous settlements, tends to be quite competitive and somewhat fractious. Not only does the area not have a lot of wealth, but the wealth that does exist rests in the hands of a very small number of individuals and foundations. And, historically, this cluster of small and separate communities a short distance inland from Biloxi is not known for its inclination or ability to collaborate on projects. From the outset, it was clear that the Ohr-O'Keefe Museum was not going to be one that brought them together. In addition, town officials, like Mayor A. J. Holloway, made little effort to conceal how much they disliked Gehry's design. Holloway made his point by publicly expressing his lack of enthusiasm about spend-ing taxpayer dollars on the new facility in an article that appeared in the *New York Times*: "It wasn't really a popular thing for the city. The residents of the city were never really behind it."[13]

The significant challenge for the future of the museum, now that it is built, is making it sustainable. It is no secret that the museum is having

difficulties attracting visitors. In 2011, the museum's board president, Larry Clark, was quoted in the *New York Times* as saying, "We'll need some intervention in a matter of weeks or we'll be totally out of funds." As a result of the museum's financial difficulties, in October of 2011 the Biloxi City Council voted to assist the museum by covering its general operating costs. Despite his opposition to the project in the beginning, even Mayor Holloway was in support of helping the museum.[14] Not surprisingly, persuading the city to pay for a significant portion of the annual operating budget was a long, complicated, and arduous process. And though it got done, it is not a permanent fix. It will be terminated at some point, so if it wants to remain open for future generations, the museum needs to create multiple reliable income streams—and to build a substantial endowment. How the museum will continue to function over the coming years and decades, should taxpayer support evaporate, is still unclear.

Denny Mecham, a key player in the campaign to get the five-building complex completed and opened announced her resignation in 2013: "After getting through now three capital projects in my career (Mecham is also the previous director of the North Carolina Pottery Center and the Waterworks Visual Arts Center, Inc. in Salisbury, North Carolina, both of which underwent building projects during her tenure there), I'm worn out."

* * *

For those considering building a new museum facility or doing a major renovation or addition, much can be learned from the stories behind the building of these four very different museums. Not only is it clear that the communities that undertake these projects are vastly different, as are the range of expectations that a project's stakeholders are driven by, but the following is also clear:

- Having a keen awareness of the financial capabilities and interests of the community and determining strategies to leverage these capabilities is essential to the immediate and long-term success of the project.
- Given the complexity of projects like this, any amount of focused work done in advance to define the mission to develop a detailed work plan will pay off in the end. Once the actual building process begins, the benefits for doing both of these in a comprehensive and thoughtful manner becomes evident. Not doing this in advance almost always leads to significant problems.
- Creating and sustaining consensus among leaders and supporters of the project is critical to a project's success, particularly in the case of public–private partnerships.

The Nelson-Atkins Museum emerges as the front-runner in nearly every respect. The museum's mission and the purpose of its building project were clearly defined at the outset by the director and then fully corroborated

by the board of trustees and the project's key donors—all of whom shared the director's vision and his passion for what the enhanced museum could become for Kansas City. The museum's director and the trustees had a keen and thorough understanding of the nature of the community they were going to be working with. This made it easier to build consensus among those overseeing the building project, which was sustained throughout the process, and actually continued on once the doors opened. They all knew what they were engaged in trying to create for Kansas City, and why they were spending so much time, effort, and money. It was the clarity and the compelling nature of this vision that made raising the money so much easier.

The philanthropic community, taking their cue from the museum's director and the board, got financial commitments to cover the entire project even before they had an architect or design—a very rare accomplishment. The depth of the community's commitment and the remarkable level of buy-in became fully evident when donors made it possible through a subsidy for the museum to become free and open to the public in perpetuity.

But Kansas City is unlike most other communities in the degree of civic commitment to the independent underwriting of cultural amenities. The Nelson-Atkins Museum is an inspiring model for other cities in the abstract, but without the network of deeply engaged community organizations and civic leaders in place, and a stunning history of homegrown corporate philanthropy, a project of this magnitude would have been much, much more difficult to execute.

The Mobile Museum of Art, which has become the largest museum on the Gulf Coast between New Orleans and Tampa, had the disadvantage of being forced to make a decision about whether to become part of the downtown revival project launched by the mayor (that would have placed them at the heart of the downtown renewal effort) or to stay on the outskirts of town in a location that protected the museum and its collection from hurricanes and flooding. The director charged with planning the facility came down emphatically for the latter, and that determined the museum's future identity and trajectory. The building project they embarked upon was relatively modest in cost and the money was raised without huge difficulty. But there is no endowment and only a small fund available for acquisitions.

The planning process for the Mobile museum was not one that suggests that there had been a careful assessment of how to align the project with the needs, desires, expectations, and capacity of the community. There was, for example, clear disappointment with the inadequacy and poor design of some of the multiuse spaces in the new facility. The future of the museum lies in the hands of its new director and board, who will try to maximize the possibilities for what is clearly a less than optimum location, and continued regret and residual resentment among some civic leaders that the museum chose not play a leading role in the downtown regeneration of Mobile.

The Figge Art Museum, with its dramatic riverfront architectural presence, finds itself in a challenging situation. Those who built it did not have a clearly defined and elaborated mission and set of goals when they began, which meant that there was not adequate consensus among the trustees and in the community as the process unfolded. The museum does not have an operating endowment, and the city's commitment to fund its operations expires in a little more than a decade. And a substantial part of its formidable collection will return to the University of Iowa when the museum there is replaced. They have experienced high turnover in their executive staff, and so going forward from this point they will need to focus on deciding what their mission is, what they want the museum to be over the long term, and how it will be supported.

Biloxi's Ohr-O'Keefe museum, launched in an underserved and economically challenged community that had only a very small contingent of philanthropically disposed individuals and foundations, was constructed and opened despite the odds. The vision and mission were clear, but there was almost no consensus in the community, even though the board itself was unified and determined in its efforts throughout the project. Dependence on federal, state, and regional funding was enormous (over 90% of the building costs), so political adeptness was a crucial factor and a highly valued skill. Given that there is no significant endowment, and it is dependent upon a demonstrably unsympathetic city government in Biloxi to continue funding operations over the longer term, the future of the Ohr-O'Keefe is not clear.

In the end, the initial vision and the clarity of the institutional mission-definition are the key components that help bring all the others together—including financial support and the task of creating board consensus. It takes a strong organization to pose the question about its reasons for being, its current relevance, and its envisioned role for the future and to then take this information and assemble the conclusions into a strategic plan. Sometimes these conversations take place, and sometimes they do not. The consequences of not doing it well can be profound, just as the payoff for clear and visionary leadership can be correspondingly inspiring and profound for a community.

NOTES

1. American Alliance of Museums website. "Museum Facts." www.aam-us.org/about-museums/museum-facts.
2. In 2013, a lawsuit was filed against the Metropolitan Museum of Art claiming that the museum deceives the public by not clearly communicating its admission fee is pay-what-you-can. Thomas Campbell, director and CEO of the museum responded with a message on the museum's website.
3. Much of the information we report on the Nelson-Atkins Museum of Art we retrieved from our interviews with museum current and former staff, Marc Wilson (former director) and Karen Christiansen (chief operating officer).

4. Nelson-Atkins Museum of Art website. "Architecture and History." www. nelson-atkins.org/art/HistIntro.cfm.
5. Much of the information we report on the Mobile Museum of Art we retrieved from our interviews with museum current and former staff, Joseph Schenk (former director) and Deborah Velders (director).
6. Stanford, Scott, and Osborne, Jonathan. "Mobile Builds a String of Pearls." *Corpus Christi Caller-Times*. November 1, 2000.
7. Much of the information we report on the Figge Art Museum we retrieved from our interviews with museum current and former staff and board trustees, Glenn Gierke (trustee), Dee Bruemmer (trustee), Dana Wilkinson (trustee), Henry Neuman (trustee), and Sean O'Harrow (former director).
8. Much of the information we report on the Ohr-O'Keefe Museum of Art we retrieved from our interview with Denny Mecham (former director).
9. Ohr-O'Keefe Museum website. "George E. Ohr." www.georgeohr.org/Content. aspx?ID=62&P=2&C=465.
10. "Growth of Giving in Kansas City Exceeds National Average." *School of Philanthropy News*. Lilly Family School of Philanthropy. Indiana University-Purdue University Indianapolis. July 9, 2009.
11. Wilson, William H. *The City Beautiful Movement (Creating the North American Landscape)*. Baltimore, MD: Johns Hopkins University Press, 1994.
12. Iowa Economic Development Organization website. "Vision Iowa." www. iowaeconomicdevelopment.com/CommunityDevelopment/VisionIowa.
13. Severson, Kim. "A Gamble on Art on the 'Redneck Riviera' May not be Paying Off." *The New York Times*. July 27, 2011.
14. "Museum Gets City's Help to Stay Open." *The Sun Herald*. October 7, 2011.

6 Conclusion

Many of the projects we studied appear to have gone through what psychologist Daniel Kahneman—a specialist in decision making, judgment, and behavioral economics—has called the "planning fallacy."[1] It is characterized by both optimism and overconfidence that one's plans are going to work out in the manner one has predicted they will. Kahneman sees this as a natural outcome of one of the fundamental characteristics of the way in which humans think and make their decisions, and consequently it is very difficult to override.

Take, for example, a group of civic leaders and arts patrons who decide they are going to build a major performing arts center. The types of leaders who provide the passion and drive to build structures of this sort are successful men and women who are accustomed to relying on their own experience and judgment. They depend on what they might describe as "inside knowledge"—knowledge gleaned from their own experiences, as well as those of their collaborators. What tends to be absent in their thinking, however, (and they are most often not even aware of this) is "outside knowledge," such as what statisticians refer to as "the base rate" regarding the distribution of projects that did *not* go as planned (e.g., how many of them went a little over budget, how many went moderately over budget, and how many went significantly over budget). While these civic leaders might be very experienced in many aspects of management within their spheres of expertise, very few of them would have had occasion to work on a variety of building projects, which if they had had that experience would have given them a sense of how often projects actually do go well over budget and how they end up, one way or another, taking much longer to complete than initially forecast.

Psychologists point out that one of the best ways to mitigate the planning fallacy is to gather data on the experience of as many similar projects as possible and then carefully evaluate your own plans in light of others' experiences. For example, knowing that fully 91% of the newly constructed PACs went over budget; 73% of PACs went over by at least 50%; and 40% of these projects took longer than originally planned could certainly help diminish the impact of the planning fallacy. Even if you believe strongly that

your own experience will be different—that your project is worthwhile and has a great team working on it, and that you will not fall into those traps—the hard data can provide a stark warning that a range of unexpected things can and almost certainly will happen that can overturn even the most carefully planned and managed projects.

While most of the leaders we interviewed had visited three or four other recently constructed buildings that seemed analogous to their own, they were mostly interested in looking at architectural features and at how the buildings themselves actually functioned. Approximately 85% of all organizations hosted "field trips," sometimes to other countries, for the project planning group (e.g., executive staff, board trustees, and architects) where they would visit other cultural facilities. But these trips typically did not focus on investigating the problems their counterparts had faced in completing these buildings or determining how big the cost overruns were. For example, leaders in Omaha traveled internationally and let their enthusiasm for the architectural and design elements of the Musikverein in Austria guide their decision making for the Holland Performing Arts Center. But even if all of the leaders who went on these field trips *had* focused on logistical and planning issues, the sample they were looking at was too small to get a full understanding of the probabilities of various degrees of planning failures, and thus would be easy to dismiss as being the exception rather than the rule, and therefore not of real concern.

Another psychological factor that results in vulnerability to the planning fallacy is excessive optimism that things will simply proceed smoothly as the project unfolds. One reason this optimism prevails is that there tends to be a clear image in mind of what the successful outcome will look like, while possible ways in which the project could actually go off the rails are only dimly perceived, if they even come to mind. We have the beautiful architectural pictures and mock-ups, opening night gala plans, and press releases to think about, but we have only vague images of the possible ways our enterprise might go wrong (i.e., what costly change orders are going to have to be issued when an unexpected construction crisis arises or what unanticipated discoveries will be made like a major element of the project being inadvertently left out of the budget). "Value engineering" is what these changes in plans that require cutting out some planned element or amenity are euphemistically called. Planners customarily do not highlight, in concrete terms, the range of things that can go wrong, nor do they develop contingency plans to cope with them should they come to pass. Not to say that contingency budgets in construction projects are not used—they are—but anticipating the specifics ways in which these budgets are likely to be utilized tends to be amiss. The distinct asymmetry that stems from the clarity in our minds of the outcome we desire on the one hand, and the many things that can frustrate or undermine that outcome on the other, comprises a powerful case for the pervasiveness of the planning fallacy. The projects that went

well, such as the New World Center, the Kauffman Center, and the Goodman Theater, tempered their optimism by careful exploration about what might go wrong and equally careful planning for how they would cope if any of these problems erupted.

In writing this book, we also sought to better understand the "revisionist narratives" that often emerge about these building projects in the months and years following construction and to supplement this with hard data and careful analysis. What is often included in the narratives that the public hears are what the organization, the civic leaders, and building project team want and need them to hear: what a building project was initially intended to deliver, even if in fact that project's purpose and function significantly changed since it opened. Perhaps a performing arts facility is built with the expectation that it will function as a home to multiple local arts organizations, creating an economy of scale that helps arts groups that do not have the means or the capacity to sustain a purpose-built structure of their own. After a few years, the facility begins to function increasingly as a presenting house, and not just the performance venue for the resident companies, because the PAC needs more income to avoid operating at a deficit. In Chicago, the Harris Theater for Music and Dance was built primarily to serve as a home to small and mid-sized area arts groups—and even states this in its mission. Years after opening, the PAC functions increasingly like a presenting house, bringing in performance groups from across the globe, as opposed to a resident performing arts center for utilization by local groups. This is, in part, because of financial realities, and because the organization is responding to what audiences are expressing interest in seeing. The notion of a theater for resident groups got the facility built and its doors open, but given that this PAC will be operating for decades, the trustees and executive staff needed to remain nimble and responsive. And so the narrative needed to change somewhat.

Or, maybe a new museum building is completed that was initially intended to provide additional space for a growing collection, but has ended up becoming largely a rental space for weddings, bar mitzvahs, and other special events. The Figge Museum, in Davenport, earns much of its program revenue from these types of ancillary functions, and struggles with attracting an adequate number of visitors to view its collection, especially on an ongoing basis.

The reasons behind these transitions and evolutions are many. But the outcome is often that an initial conception and motivation for a building gets supplanted, out of necessity, and the mission changes to something better suited to the facility's current circumstances. When this happens, the public explanation for it needs to be carefully recalibrated. Sometimes those who had the idea originally have moved on, and the institutional history fades from view in terms of the public record. At that point only careful research can produce a clear picture of what actually happened and what the project was originally intended for.

So why do these narratives so often undergo significant revision? One reason is that success is often simply assumed to be synonymous with the achievement of the initial stated goal. A task is set and agreed upon. A team undertakes to lead the building project and completes it, and everyone assumes that one way or another it will get done. And if it does, the hope is that the effort will be considered a success. If a new facility's opening contributed to its neighborhood's revitalization or helped increase attendance at its host organization, then the project will be considered a triumph. If the project fails to achieve what its leaders set out to do, for some at least, it will be considered a failed endeavor.

Psychological research also demonstrates that our memories are both fallible and malleable. At the time of our interviews with project representatives, which in some cases occurred decades after the initial idea for the building project, recollections about project decision making may have been subtly altered (and not necessarily with any conscious intention to do so). Memory researchers refer to this as "hindsight" bias. We reconstruct and amend our memories of the past in the light of what we know now.[2] Sometimes this serves to make the memories of what happened in the past look better than the actual circumstances and events would support, and sometimes it makes it look worse than it actually was. The direction and degree of distortion depends, in part at least, on whether things turned out better or worse than we, and others, expected. Take, for example, the Durham Convention and Visitors Bureau (DCVB) and their early opposition to the construction of a new performing arts center in downtown Durham. Now that DPAC has consistently contributed revenue to the city's budget, the DCVB's narrative has changed: "Now you fast forward 14 years, and they were one of the early supporters of the theater," said Bill Kalkhof, one of PAC's planners.

A related type of bias is "consistency" bias. This is the tendency to make a narrative consistent so that what is reported as being part of the chronicle of past events is consistent with the present situation.[3] For example, events that took place and had an impact on the decision to build are subsequently amended or altered to make them consistent with what actually took place. One striking example of this kind of bias is simply misremembering (or submerging) the original reasons for undertaking the building project. While the Philadelphia Orchestra originally embarked upon a building project for the purpose of constructing a new single-purpose concert hall, the opportunity to make it an economic development anchor in downtown Philadelphia persuaded its leaders to morph the idea into something entirely different—a PAC. Today, the reason for building the Kimmel Center is frequently remembered by its community as being to revive a distressed former industrial city's downtown.

In summary, the components of a building project narrative are part of an ongoing revision process whose goal is to present a project as being successful and to keep the organization moving forward. Part of why this happens is that people's memories are—to put it bluntly—far from perfect.

In our interviews, we used methods to reduce the amount of interviewee bias that may have altered the conclusions we came to regarding cultural facility building. For example, by using a structured questionnaire—where we asked the same questions of all of our respondents—(as opposed to conducting an unstructured interview, which is similar to an everyday conversation), we can easily compare across respondent's answers and identify deviations in common themes relative to the total group. We also designed questions meant to "double-check" previous answers and probe the respondent on issues requiring more detail. Furthermore, the mere consistency between what we heard from the over 100 people we interviewed on issues related to the management and financing of a wide variety of projects suggests that the validity of the information we collected is solid, and that we can trust our analyses of these data and their resulting implications for building.

The goals of our study have required us to go well beyond anecdotal evidence (something there is a great deal of in the popular press and via hearsay). We have used the data we collected and analyzed on a representative sample of cultural building projects to provide a context with which readers can gain a better understanding of the individual projects we have described in detail. A key goal was to get as close as we could to a full and accurate narrative about what actually took place—how decisions were made, what changed along the way, what hurdles were encountered, and how the project got from conception to opening night. With these narratives in hand, we hope that organizations and cities in the future will find it easier and less stressful to build viable and sustainable (and hopefully also inspirational) facilities for arts organizations.

GUIDELINES FOR BUILDING

Throughout the various case studies we present, and the discussion surrounding them, we illustrate common practices—and themes—that arise in cultural building projects. While in the previous chapters we have tried to avoid giving prescriptive advice to organizations and cities either contemplating the pursuit of a cultural facility project or already in the process of planning and building, we do point to successful (and unsuccessful) practices we have seen in both the planning and the building stages. For some readers, however, we realize that a more detailed description of the practices of planning and building that lead to successful projects would be valuable. We provide a brief summary of our recommendations below.

Passion

Early in Chapter Two, we discussed the pivotal role passion plays in the process of formulating the idea for a cultural building project, as well as in the idea's tangible development and expansion over time. In the two case

studies we highlighted—the Goodman Theater and the Kimmel Center for the Performing Arts—passion played a key role in getting those two building projects off the ground. The Goodman's executive director, Roche Schulfer, exhibited both passion for the organization's art form—theatrical performances—and for achieving something substantial as part of his own career. Together, these led him to propose to the board of trustees that they think about creating a new facility. The theater company had been experiencing notable success as a repertory company, and Schulfer was quickly rising in the ranks of leading theater executive directors. He concluded that a building project could accelerate his company's achievements, as well as his own career.

Similarly, Riccardo Muti, the Philadelphia Orchestra's music director, as well as the orchestra's executive director, Stephen Sell, saw that the way to ensure that their orchestra remained one of the best in the world was by giving it what it needed—its own concert hall. A new concert hall meant better accommodations for the audience, technical equipment that maximized the quality of sound, and finally that they could continue to make strides in producing high-quality electronic recordings, which, in turn, would enhance Muti's own reputation as a leading conductor.

Without this enthusiasm—meaning in this instance passion for a particular art form—these two facilities could have never been built. In all of the projects we looked at, passion always served as the initial catalyst and one of the sustaining elements required for turning a mere idea for a new facility into a tangible reality. In Kansas City, the passion of Muriel Kauffman's recognition that her beloved city deserved a new performing arts center commensurate to its growing stature was finally realized when her daughter, Julia, decided to launch and then lead the project to build the Kauffman Center for the Performing Arts following her mother's death. Further south along the Gulf of Mexico, Biloxi's Jeremiah O'Keefe's passion to give the work of a noted local artist a fitting space to exhibit a lifetime of output as a ceramicist helped transform the city of Biloxi from a gambling haven to a cultural destination. This passion energized O'Keefe to lead a campaign to build the Ohr-O'Keefe Museum of Art, in the face of unfavorable odds.

Furthermore, it was passion—articulated through visionary leadership—that enabled many cultural facilities to stay the course and come to completion, even after enthusiasm for the project had died down. At the Smith Center for the Performing Arts in Las Vegas, tenacious project leaders held on to the passion they felt about building "the living room for Las Vegas" even though Las Vegas took a ferocious hit during the country's worst economic recession since the 1930s. It was something they believed the city's residents deserved, needed, and ultimately wanted, and this gave them the drive to spend a decade and a half pursuing this enormous and architecturally complex project.

In sum, a leader's passion—be it for an art form or an artist, for one's career, for potential advances in an artistic field, or for the development

of community—is a vital component in the process of encouraging and stimulating the development of an abstract idea into a full-fledged facility. Through all of the hurdles and challenges that building projects bring with them, it is passion that helps people and organizations avoid abandoning an envisioned plan just because things start to get difficult. Visualizing how it will feel when the new building opens its doors for the first time and welcomes its audiences, especially in the midst of things like construction delays and contract negotiations, is what can energize a project and see it through to its completion.

Collective Impact

There are some additional themes that emerge in the stories of successful cultural facility projects, and these fall into the category of *collective impact*. Described as "the commitment of a group of important actors from different sectors to a common agenda for solving a specific social problem," collective impact has recently begun to gain traction in the nonprofit community as a mechanism for achieving social change.[4] As opposed to *isolated impact*— "an approach oriented toward finding and funding a solution embodied within a single organization, combined with the hope that the most effective organizations will grow or replicate to extend their impact more widely"— *collective impact* focuses on cross-sector coordination toward the achievement of a common goal.

Successful cultural facility projects, even those pursued by a single organization, tend to embody the same "conditions" that other collective impact initiatives are characterized by.

Even if a facility project is pursued by a single organization, there is often a core leadership group (i.e., backbone support) composed of people from different sectors, each with a distinct set of skills. There is a shared vision (i.e., a common agenda) that this core group is striving to bring to fruition. With this vision in place, the goal is to deliver on the nonprofit organization's mission, and thereby affect social change.

In the context of a cultural facility project, having a common agenda involves clearly communicating the vision that stands behind the project, and how that vision will help advance the organization's mission. It also involves identifying what "problem" or need the project is attempting to respond to. It is often the case with a cultural facility project that there exists a clear need for an enhanced facility at the time the idea for the project is introduced (e.g., the building is old and falling apart, the organization is excessively spending on facility repairs, a performance group requires upgraded acoustics, audiences need better amenities). But frequently, the specific need, or needs, gets eclipsed by other more compelling and attractive benefits the project hopes to produce. For example, the idea for a new concert hall emerges from a discussion of the need to have better acoustics and sound reproduction, but because of the pressure to get traction with the general public the concert hall

Table 6.1 The Five Conditions of Collective Impact

Common agenda	All participants have a shared vision for change, including a common understanding of the problem and a joint approach to solving it through agreed-upon actions.
Shared measurement	Collecting data and measuring results consistently across all participants ensures that efforts remain aligned and that participants hold each other accountable.
Mutually reinforcing activities	Participant activities must be differentiated while still being coordinated through a mutually reinforcing plan of action.
Continuous communication	Consistent and open communication is needed across the many players to build trust, ensure mutual objectives, and create common motivation.
Backbone support	Creating and managing collective impact requires a separate organization with staff and a specific set of skills to serve as the backbone for the entire initiative and to coordinate participating organizations and agencies.

project morphs into something around which downtown economic regeneration might begin to take place. Such morphing, or alteration of vision, greatly impacts the probability of project success.

Having a business plan is a strategy that can assist project leaders, not only to ensure that their vision will be achieved through a set of "agreed-upon actions," but also that their collective efforts will include some type of shared measurement system, and a set of mutually re-enforcing activities—two other key conditions necessary to achieving collective impact. It is impossible to be confident that all members of a facility project's leadership group are pursuing a shared vision if the plan for achieving it is not clearly laid out in writing. A business plan—decided upon at the very early stages of a cultural facility project—can serve as a contract for all involved parties that what people say is going to happen will actually occur. For example, the leadership group for the Smith Center for the Performing Arts in Las Vegas wrote a business plan at a very early stage that stated the PAC project was going to be a 50/50, public–private partnership. If this goal, and the manner in which it was going to be achieved, had not been clearly articulated in the Smith Center's business plan, at the point when private support started to

get extremely difficult to obtain it would have been far too easy for project leaders to argue for more public support, and in doing so veer away from the PAC's original vision. In this instance, the business plan the leadership group created enabled it to stick to the original plan. Perhaps if the Philadelphia Orchestra had written, and followed, a business plan to create a new concert hall, the Kimmel Center for the Performing Arts never would have been built. Furthermore, the articulation of a business plan can also tamp down the temptation to indulge in a revisionist narrative when things begin to go awry. It is much more difficult to amend a narrative when it exists in writing rather than informal oral versions.

A business plan can also help hold members of the leadership group accountable by including agreed-upon metrics within the plan that can measure project success. Thus a cultural facility project's business plan can partly serve as a shared measurement system. Take, for example, a business plan that clearly states that a leadership group will not break ground for construction until all of the necessary funds are raised. (This is exactly what the Goodman Theater's project leadership group did when they made a commitment to one another that they would not start building until they reached their goal of raising $53.2 million.) By including a clear metric (e.g., the amount of money to be raised) within a business plan that must be achieved before taking the next step (e.g., breaking ground), a leadership group has a mechanism by which it can keep individual member's efforts aligned and hold one another accountable.

Furthermore, a business plan can help clearly enumerate the participants' various responsibilities and simplify the task of coordinating and carrying out these responsibilities. An effective cultural facility project leadership group is composed of participants whose range of skills enables them to understand and address the complex array of tasks that must be carried out in order to build a facility. A group may include an attorney tasked with doing oversight on the project's contractual issues, a contractor with carefully monitoring project management, or a financial services executive who can assist with keeping tabs on the project's expenses. And while members of the team are performing their different tasks simultaneously, all of those tasks need somehow to be integrated and coordinated so that everyone knows when tasks are getting completed and next steps being taken. For example, an attorney must review the terms and conditions of a bank loan in order for a banker to apply the loan to the facility project's budget. A banker must provide an approved budget before the contractor can place an order for construction materials. It is the detailed and carefully thought out business plan that can coordinate these activities so that they are performed at the appropriate times, which, in turn, mutually reinforces the entire plan of action.

What is assumed here, of course, is consensus about the need for "continuous communication" among the leadership group (easy to say, but much harder to do, especially if some of the communications contain pointed questions and criticisms). Particularly in the beginning stages of a facility

project, there can be expressions of skepticism or dissent from members of the board, or key people in the donor pool, about the viability of a project—as there were in the majority of projects we studied. These people may be concerned that they will be expected to make a large capital gift, even though they may not be in a position to do that, or not be confident that they even want to. Whatever the issues might be, the leadership group needs to offer safe forums in which these participants can express their concerns, and then the entire group can consider them. This is a critical step on the way to creating consensus about the objectives of the project, and then gradually building a collectively held conviction about why it is important to bring the idea for the project to fruition. Ideally, this is what happens. Alternatively, the key leaders' close ranks (perhaps to help avoid a slow-down or halt in progress on getting things to move forward) provide no opportunities for expressing dissent, and make it clear that they do not want to hear the thoughts of those with doubts about the viability of the project. In the former instance, groups can build ties of trust within the group, while in the latter, individuals who remain silent—not wanting to appear to be spoilers or a negative force—grow frustrated and resentful and sometimes leave the leadership group altogether.

Several board members of the Philadelphia Orchestra, for example, were initially stifled in expressing their opinions about the concert hall project, which led to a fractured board and project management structure. This is a difficult balance to strike: continuous doubts and fears being expressed can be corrosive to morale, but suppressing people's opinions can create a harsh and divisive atmosphere as well. Embracing the idea of open communication requires ample opportunities for talking to one another, so systematically planning meetings at scheduled times provides the necessary forum to keep everyone up-to-date about specific steps being taken towards reaching the project's goal. The New World Symphony, for example, held regular meetings throughout the entire project's course at designated times so that the entire staff and planning group could stay up-to-date on their building project's details.

Finally, every successfully managed cultural facility project will include one primary leadership group responsible for overseeing the project's many moving parts. Given that multiple entities are involved in the building of a new facility (e.g., nonprofit organizations, local governments, economic development groups, foundations, etc.) this is a crucial function. This is particularly true for resident performing arts center projects where multiple performing arts groups—each with its separate nonprofit 501(c)(3) status—are included in the planning and development process. While each group's integration into the overall planning process, as well as the actual business plan for the facility, is certainly necessary for the project to come to a successful conclusion, it is important that only one entity serves as the entire initiative's "backbone support," otherwise known as the project's core group of leaders. At the Kauffman Center for the Performing Arts, this

leadership group was composed of seven individuals, with very clear roles and responsibilities. These individuals continue to support the organization today now that the center is in operation.

This pivotally important management group has several important characteristics, including some mentioned above—like the diverse set of skills and experience they bring to the task. The majority of boards we studied had a large contingent of professionals ranging from attorneys, to finance executives, to real estate developers. At least some of these people also need to have experience with actually planning and completing construction on a building (and preferably a cultural facility). A contractor or developer, or a structural engineer, who maybe has been involved with building a number of facilities before, but perhaps has never built a performing arts facility, will find it a challenge to work on a structure that must conform to design specifications specific to performance facilities. The same goes for architects—those unfamiliar with the particular challenges of designing a cultural facility are likely to contribute to the proliferation of delays, change orders, and budget overages. (The second time they undertake such a project would certainly be much easier.) For example, in the case of the Adrienne Arsht Center for the Performing Arts, the local construction architects who were working with the lead architect, Caesar Pelli, were producing poor-quality working drawings. Pelli's firm took over the construction architects' responsibility, but it had neither the expertise nor the resources to take on this role. In addition, within nine months of the beginning of construction, a subcontractor discovered a major flaw in the steelwork design that would frame out the buildings. As a result, Pelli and PACB were drawn into an extensive redesign effort, which further distracted them from their work, slowed down the construction process and accelerated the cost overruns.

Finally, and perhaps one of the most difficult aspects of projects of this sort is to facilitate engaged and continuous participation within the leadership group throughout the project's entire span. Given that the average for moving from articulated idea to opening night for a new building is nine years, staff and trustee changes are more rather than less likely. Individuals coming and going in leadership roles, particularly when a building is being planned and then constructed, is extremely disruptive and often results in things going off the rails. Sometimes, of course, leadership transitions are unavoidable, but managing those transitions carefully and having a detailed plan laid out in advance for doing so is key to the success of any major facility initiative. As we discussed in Chapter Two, the loss of the Philadelphia Orchestra's two key leaders—Muti and Sell—had a significant impact on the building project as a whole.

It appears that there are distinct points in the project's life at which leadership transitions occur: in the very beginning when the idea for a facility project is announced to a board and one or more trustees not in support of the project decide to step off the board; near the end of a capital campaign, when tasks shift more toward managing the actual construction process

and away from raising money; and immediately after a building project is completed, when the organization's chief executive who helped direct the project is suddenly faced with running the new facility. The key, in the end, is to make it clear to those who do sign on willingly to undertake a project of this scale, that they understand how important it is to stay committed for the duration—that the consequences of frequent arrivals and departures from the leadership has only damaging consequences. There can be disagreements, and frustration over how and how fast a given problem is or is not being resolved, but there needs to be unanimity about the project's mission and the overarching goal to bring it to fruition and a corresponding sustained commitment from those in the leadership or "backbone" group.

Architects and Architecture

Every project we studied or highlighted in this book had some element related to either architects or architecture that played an important role in the overall project's trajectory. The selection of Renzo Piano and Moshe Safdie to design the Kimmel Center and the Kauffman Center, respectively, was strategic in its purpose in that it drew attention to the facility from a broader population than the organization's audience pool. The Goodman Theater's leaders' decision to forgo the selection of a well-known local (Chicago) architect was a point of contention that had to be resolved in order for the project to move forward. "Starchitect" Frank Gehry's preexisting relationships with Michael Tilson Thomas at the New World Symphony and Jeremiah O'Keefe in Biloxi at the Ohr-O'Keefe Museum was a primary determinant of how these organization's facilities were built.

In building these facilities, and virtually all others, project leaders that undertake building programs often consider them to have a dual nature: not only are the facilities to be sites of cultural activities, such as plays, musical performances, and displays of artistic objects, but they will also be signature structures that might gain attention not just nationally, but internationally— they are, in other words, aesthetic statements in themselves. By situating a David Chipperfield design directly on the Mississippi River so that it can be easily seen by its neighboring communities, the Figge Museum made a bold statement that downtown Davenport could serve as the Quad City region's artistic center. Steven Holl worked closely with Marc Wilson at the Nelson-Atkins Museum to reimagine an almost century-old facility and bring it into the twenty-first century.

While rarely the main reason for commissioning a new building, the desire to have a striking and memorable (and maybe even iconic) architectural signature is high on the list of priorities of many funders. The passion that is a driving force behind the decision to build in the first place often incorporates the desire for an architectural statement that will both embody and validate that passion. Additionally, it also may give rise to many headaches, arguments, and tension during the construction phase. It may lead to

decisions on budgets that in the end put terrible strains on the finances of the organization as it begins to sort out the realities of the operating plan and the attendant expenses. It may even end up making the cost of using the building greater than can be afforded by the users for whom it was built, as we saw with the Art Institute of Chicago (AIC) after the opening its Modern Wing designed by Renzo Piano. After the expansion's 2009 opening, the AIC raised admission fees by 50%.[5]

That a major aesthetic statement is part of the vision for many cultural organizations (about 45% of the organizations we studied) is well articulated by the executive director of a museum who said, "The first [statement in the vision statement] was: a new museum will be an architectural statement that symbolizes the beginning of the twenty-first century; to be a signature building that raises the level of architecture for [our] city."

In this case, the selection committee had a difficult time selecting the architect who would meet these requirements, and not everyone was in agreement about the final choice. "[The selection] did get a little hard on the committee because there were two people on the selection committee who thought the proposal was . . . weird and ugly while the rest of us thought it was just gorgeous and spectacular." In the end, while not everyone was happy with the choice, a majority of the trustees and the director all felt it achieved what they wanted.

The reputation of the architect may also be an important consideration for some members of the project leadership group. For example, in deciding on an architect for the new wing of the Art Institute, the opinion of the Pritzker Prize public mattered a great deal to some trustees. On two of the three previous occasions when the Pritzker Prize ceremonies took place in Chicago, the Art Institute had served as the site. Coincidentally, Renzo Piano, a Pritzker Prize winner, was selected as the expansion's architect in 1999.

But in other instances, project leaders were more concerned about the past experiences of the architect with the type of facility that they were trying to build and were focused on practicality more than aesthetics, as at the Goodman Theater when its directors insisted on choosing an architect with theater-building experience. Another theater director noted ". . . in pursuing this project, we really had to look at the design from the inside out and we had to be absolutely committed to creating a theater that functioned well for audiences and artists not a building that was going to [just] be a monument."

A bold architectural statement may also be viewed as way to put one's city on the map. The success of Gehry's Guggenheim Museum in Bilbao, Spain, in transforming the seaside city into a cultural destination has created the concept of the "Bilbao effect"—that is to say the ability of a stunning and memorable piece of architecture to stimulate visitors to come to a previously little-known locale. This putative effect appears to have been a major factor in convincing the board trustees of

the Taubman Museum in Roanoke to embark on an architecturally bold building that stretched their budget beyond their ability to finance it.[6] Similarly, the leaders of the Ohr-O'Keefe museum in Biloxi hoped that the Gehry-designed museum would change the image of Biloxi from that of a gambling center and beach resort to one that at least included some culturally important institutions.

Seductive as it is to donors, it is difficult to find evidence that the "Bilbao effect" is a durable and sustainable one. So far the Taubman and the Ohr-O'Keefe have not brought many visitors to Roanoke and Biloxi just to see their new buildings. Even the local citizens are divided over the aesthetics of these structures, although as time goes on there appears to be at least some grudging respect.

Working with architects can sometimes be frustrating when their ideas diverge from those of their clients, particularly when these ideas involve going over an established budget. Even in the absence of a major vision change, fully 80% of the projects we studied experienced cost increases due to changes in design and architectural features. Sometimes the disagreements come from a lack of experience on the part of the architects, and sometimes from starkly different ideas about what how space should be designed. In several cases, the clients got so frustrated with the architects that they fired them and hired another. In one instance, it was the first museum the architects had built, and they had difficulty understanding the specific requirements for parts of a museum like conversation labs. As this director bluntly described it, "They weren't listening to our needs."

Architects, particularly well-known ones, are full of creative ideas and see an endless set of options for making buildings more beautiful and interesting. But often it is difficult to rein these ideas in. At the Art Institute, the original plan was for a 70,000-square-foot addition to the main building. After Renzo Piano was engaged as the architect, he convinced the trustees that the addition should be 270,000 square feet and should be on the north side of the building facing the new Millennium Park. Positioning the wing there highlighted the need for a pedestrian bridge to the park. The solution proposed was to build a bridge over a major street from the Art Institute into the park. The addition of the bridge meant that an extra floor had to be added to the wing in order for the bridge to work. Obviously all of these additions significantly increased the costs of the addition. Planning for the addition took seven years, during which time Piano continued to revise the design—changes which everyone agreed improved the building, but made it increasingly difficult to estimate the final costs. The final building is considered a great architectural success, even though it imposed serious financial pressure on the museum.

Scope for architectural revisions to the initial design, creative and brilliant as they may be, can be limited if the vision and requirements for the building are thought through before the architect is hired. If the requirements for the building are not carefully considered before the architects

start to sketch out ideas for the building, there will be a huge proliferation of changes and alterations as the design takes on its final shape. As one executive said about a famous architect he has worked with, "You know, as long as you let the pencil stay in his hands, he'll keep changing things." The addition of the Bloch Building to the Nelson-Atkins in Kansas City is a good example of the value of an intense internal planning effort in which what was being asked for in the new building was explicitly laid out and clearly articulated in writing, in advance. The architect was then challenged to build the actual building that was described in the documents and which the clients wanted. Their goal was to get their needs met *and* provide space for the creative vision of the architect. The result is a building that has won architectural awards, but also was delivered on time and within the established budget.

Therefore, while architects and architecture can be important elements of a new cultural building's overall program, and a vital component of an organizations' vision, there are a variety of instances of designing cultural facilities that serve as cautionary tales for placing too much emphasis on architects and architecture. Certainly, it is important to have an architect with experience designing cultural facilities, since, as one museum director put it, "There are things that aren't native to people who don't work with museums all the time." But, architecture that is too complicated and whose costs fly out of control can increase organizational operating expenses beyond anticipated levels. Especially in the case of unique designs (where something like it has never been done before), it is difficult to plan with any accuracy how much maintenance and upkeep of the space will contribute to overall costs. Focusing disproportionately on a building's aesthetics, as opposed to its function, can create unwanted and costly surprises and pose limitations in actually being able to utilize a new space. And rather obviously, the selection of an architect for his or her celebrity profile is a very easy way to spend a lot more on a building project than commissioning a lesser-known architect. As one director we spoke to put it, "Rather than hiring a big name architect to glorify themselves, they did this with a local firm, which was not only less expensive, but they also didn't have enormous egos."

Building Sustainable Organizations

Any executive director or trustee who has gone through a building project will likely confirm that perhaps the greatest challenge is sustaining the organization's finances after the doors open. Perhaps this is why we see so many directors that lead a building project resign shortly after the project came to an end. With the completion of the Bloch Building addition to the Nelson-Atkins Museum, former executive director, Marc Wilson, announced his retirement. Multiple resignations and leadership turnovers at the Kimmel Center for the Performing Arts and the Adrienne Arsht Center for the

Performing Arts have occurred since the completion of these organizations' facilities. These directors, and others who left shortly after the completion of a building project, decided that they had accomplished what they had set out to do or that they had already devoted enough of their time to just one organization and needed to move on.

Furthermore, because it is easier to build a facility than it is to sustain an organization over the long term, we saw few cultural building projects that were started but not finished. Once a leadership group decides to go ahead with a cultural building project, the decision to halt the project midstream rarely happens. This is because project leaders come to feel a sense of reciprocal obligation. They bond as they go through the demanding process of figuring out how to make the building happen, and they are obliged to work together for long periods. Walking away out of fatigue, or simply because you want to direct your efforts elsewhere will likely elicit negative responses within these tight-knit groups. If you walk away, your colleagues feel as though you have abandoned them, that you have given up on your responsibilities and left others to pick up your unfinished tasks. The result can be intense social pressure. In short, it is not easy to just walk away. Of course, these positions tend to be seen as civic responsibilities and are almost always voluntary, so no one is absolutely obliged to see a project through. But if one can make it through the gantlet, it can potentially deliver significant social prestige and regard from the community. We met many board members who made it seem that this was a tremendously important accomplishment in their life, sometimes equal to what they had achieved in their careers.

So, while following the guidelines we suggest above for building cultural facilities will certainly assist leaders in their efforts to complete a project successfully, these suggestions do not comprise an exhaustive list. Basically, there are two primary things that organizations that build or renovate facilities can do to help secure the sustainability of their operations: first, organizations need to do everything possible to identify and then diminish the risks involved in an endeavor like this by taking into account the full range of perspectives, questions, and doubts expressed by those who are taking on the task of building; and second, by incorporating into its operations the ability to remain flexible and nimble an organization can learn to adapt to changing conditions and circumstances.

Predicting Demand

The prospect of building a cultural facility, be it a renovation, an expansion, or new construction, is something that not only a majority of arts organizations feel the need to confront periodically, but also something communities themselves frequently explore. At the most basic level, arts organizations may decide to launch a building project because existing structures age and deteriorate and need to be maintained or altogether

replaced. On another level, organizations may think that building an entirely new cultural facility will help generate future demand. In addition to that new demand, communities that decide to invest in a new cultural facility may hope that they will simultaneously be stimulating economic development more generally by increasing tourism via the addition of enhanced cultural amenities.

The idea of purposely increasing demand is inherently very problematic. It is often something that is hypothesized and projected into the future as being nearly certain—this, because it is a tool of persuasion by and for trustees, donors, foundations, and city governments. It essentially both justifies creating a new or expanded facility, and then (in a somewhat ironic turn) becomes dependent upon the existence of that new facility. In other words, increased demand is only *potential* and it requires a new building to bring it into being. Intense optimism and passion among key leaders at the institution (whatever its source) move them to argue that *if* a new structure comes into being, it will, simply by merit of its existence, create sufficient excitement and interest that attendance will increase, and then, over time, both earned and contributed revenue streams will follow the same upward arc. And in this fashion the vision will become reality. The assumption here, of course, is that there will be a permanent, not just a momentary, spike in audience interest, attendance, and generosity.

To assess the potential demand for a cultural facility, arts organizations and communities will often commission a feasibility study (or more than one—perhaps about potential audience numbers, donor capacity, community interest, and competition from other venues) during the early phase of exploring the idea of a new building. Consultants generally make predictions about what will happen under different scenarios (i.e., conservative, mid-range, optimistic) that are being considered.

In the projects we studied, many of these predictions turned out to be simply wrong, particularly the projections concerning future revenues and expenses. Specifically, 54% of projects we studied had *lower* revenues than projected, and 59% had *higher* expenses than projected. It appears that there are inherent flaws in the methods used for many of these studies, and this can lead to significant problems for the institution looking to build. For example, in assessing future demand, many studies survey small subsamples of an organization's current audience. But in so doing, these studies neglect to obtain information on a broader population that can provide insight into how a current audience might change in the future. Studies also typically do not account for project risks, such as evidence of fiscal instability in the organization's history or factoring in the declining trends in overall arts participation. Despite these flaws with how feasibility studies are conducted, the bigger issue is that making predictions about what will happen after a facility project is completed is anything but a precise science.

As Duncan Watts, in his book, *Everything Is Obvious—Once You Know the Answer: How Common Sense Fails Us,* writes:

> There are two kinds of events that arise in complex social systems—events that conform to some stable historical pattern, and events that do not—and it is only the first kind about which we can make reliable predictions.[7]

The events that are being contemplated by boards and city councils when organizations and cities embark on major cultural building projects are quintessentially of the second sort. It is not just that there is insufficient information about the process of planning and building cultural facilities and then sustaining them. It is that the future itself is uncertain. Any outcomes will be influenced by the actions of project leadership, as well as by a whole host of external events over which they have no control, such as community reactions, political events, the larger economic climate, or totally unexpected events, such as Hurricane Katrina, which abruptly destroyed the half-built O'Keefe-Ohr Museum in Biloxi. The project about which the feasibility study is being done is in itself a break with the historical pattern of the organization. The new facility will offer opportunities for new types of theater, increased space for new art or exhibits, or a chance to present new or higher-level artistic productions. The greater the aspiration for a new and improved building, the more radical the discontinuity between what has actually been in the past and what is anticipated in the future. Feasibility studies are based on extrapolating past experience into the future, with some attempt at adjustments for known demographic and economic changes. But precisely because the project is designed to produce something more than incremental change, it is impossible to predict with any accuracy what the future will look like.

What can one do about this inherent uncertainty? As Watts says,

> The one method you don't want to use when making predictions is to rely on a single person's opinion—especially not your own. The reason is that although humans are generally good at perceiving which factors are potentially relevant to a particular problem, they are generally bad at estimating how important one factor is relative to another.[8]

The solution, then, is to consult with as many people as you can—some experts, some knowledgeable about local conditions, some just wise individuals with accumulated experience, and then somehow combine their diverse opinions. This is not something we saw happen often enough. In many, if not most, of the projects we studied, leadership tended to commission one or two consultants, *one at a time,* but not compare different consultants opinions, or assemble all of the differing opinions from a wide variety of sources and then systematically review them and try to find the common conclusions. So many project leaders only drew up one or maybe two sets

of operating *pro formas* and then were surprised when the organization's operating budget did not play out as expected.

It is wise, then, to amass as much information as possible in order to illustrate the different possible scenarios that might unfold, however unpleasant (and unlikely) some of them might appear. Only in the situations where we saw leaders generate a variety of potential outcomes based on a range of possible events did we see organizations that were really prepared to encounter the unexpected. For example, in Chapter Four, we wrote about the how the city manager of Durham, at the request of the mayor, came up with dozens of "worst case" scenarios in terms of how a new performing arts center could impact the city budget. And in Chapter Three, we saw how Miami's New World Symphony held regular meetings with the utilities companies so that they could update their projections for their new facility's electrical and natural gas expenses. It was these situations, and others like them, that leaders had a real impact on their organization's sustainability once the building project came to an end. Conversely, in situations where a project leadership group relied on the input of one consultant, or one perspective, we saw results that put the organizations in some jeopardy.

Being Flexible

From examining trends in arts participation, charitable contributions, and public funding for the arts, it is easy to see how arts organizations might be susceptible to a variety of factors well beyond their control. Over the past four decades, the data available demonstrates decisively that the proportion of the population in the United States who engage in what we consider to be "traditional" arts attendance has rapidly declined.[9] Adjusting for inflation, trends in total contributions to arts, culture, and humanities-related organizations since the early 1970s have not only been volatile and erratic, but also have headed sharply downward, both in total dollars contributed around the 2008 economic recession and in the rate of change in this type of giving.[10] Finally, governments at a variety of state and federal levels are allocating less and less public money for arts and cultural programs as a proportion of their budgets. The total budget of the National Endowment for the Arts (NEA) has declined precipitously just between 2010 and 2012,[11] and declines in federal funding have also trickled down to the state and local levels. While in 2013, projected levels for state arts agency (SAA) legislative appropriations were following a trend upward, in aggregate the total sum of all SAA appropriations was 21.3% lower than the prerecession (2008) level.[12]

Many arts organizations have responded to changes in the environment by amending their programs and services. Some theaters have begun allowing food and beverages in their performance halls; symphony orchestras have started to permit handheld device usage for activities like "tweeting" during live performances (and even providing "tweet seat" sections); operas are broadcasting live opera on large high-definition screens in spaces other

than theaters; and many museums are encouraging participatory activities. All of these efforts are intended to make an organization marketable to the new and rapidly evolving tastes and preferences of arts audiences.

These changes in the factors that govern the operations of arts organizations are hardly new, though. In fact, organizations of all types—not only in the arts—have always been obliged to respond to change. Take, for example, the advent of the online fundraising platform, Kickstarter, and its demonstrated ability to raise more money each year for arts-related projects than the NEA does. In this instance, Kickstarter responded to declines in public funding for the arts, improvements in web-based technologies, and people's enhanced familiarity and comfort with conducting business in a virtual environment by offering a service that is now more effective, and arguably much easier to work with, than traditional grant-making organizations. More importantly, for Kickstarter, the service offered has produced valuable returns (the company takes 5% of all contributions it takes in). In a competitive environment, like the arts and culture sector, where multiple organizations compete for similar audiences and donors, it is the ability of organizations to respond effectively to changes like this that will give them a comparative advantage, both in the short and long term.

In brief then, organizations that can respond to change both quickly and efficiently will, not surprisingly, be more competitive than those that cannot. And those that cannot or will not are at increasing risk of becoming sidelined or irrelevant. In deciding upon physical infrastructure needs, arts organizations that choose to pursue plans that can be adaptable to changing environmental conditions will have a greater likelihood of long-term sustainability. For example, in the projects we studied, organizations that adopted flexible designs (e.g., retractable concert hall seating, modular spaces, outdoor performance facilities) had an easier time arranging programming that served a variety of audiences. And, we should note, organizations that do not own and operate their own dedicated facilities may also be fiscally more stable overall. While we did not specifically study these types of organizations, we did see evidence based on our observations of organizations suddenly finding themselves responsible for the either the maintenance of a facility or for paying substantial rental fees (e.g., the Philadelphia Orchestra).

Building flexible facilities can also prevent the organization from having to build or renovate again, or at least the timeline between building projects can be longer. It is costly, burdensome, and stressful to go through a cultural building project. Not only do building projects take years to complete, they inevitably have enormous impacts on an organization's financial stability— sometimes positive, but very often not. For this reason, it is rare for an arts organization to go through a major building project more than once every few decades. The Nelson-Atkins Museum had its first building project in the 2000s, more than 70 years after its main building opened its doors during the Great Depression. In Chicago, the Goodman Theater's last building project, prior to 2001, was in 1925—the year the organization was established.

With any bricks-and-mortar project, an arts organization is essentially deciding what it wants its future to look like, quite literally. And for an organization to remain relevant, it must try to be and remain both flexible and nimble: flexible, in that the organization demonstrates willingness to deviate from established and familiar paths, and nimble, in that the organization should have the capability to respond thoughtfully and quickly to change. Since predicting the future is not possible, an organization's best strategy to maintain sustainability is to be ready for whatever will occur.

* * *

As long as there are economic and demographic shifts, building booms will happen periodically in the cultural sector. While the modern building boom appears to be slowing in the United States, other countries around the world that have experienced decades of economic growth are building cultural facilities at an astonishing rate. China is just now experiencing its great cultural building boom—opening 390 museums in 2011 alone.[13] Abu Dhabi is investing enormous sums in satellite facilities for the Guggenheim and the Louvre, in addition to multiple other building initiatives.[14] A longtime consultant of cultural facility projects across the world, Adrian Ellis, reports, "Much of the current activity in this field is in rapidly growing economies in the Middle East, the CIS, China and South East Asia that are seeking to catch up or leapfrog Western economies." Cities and countries all around the world will continue to build cultural facilities in their quest to be known not only as venues for commerce and business, but also as cultural capitals; a cultural infrastructure project is one tool in which regions and cities compete with one another in order to do this.

Despite the differences in political and funding structures for cultural facility projects around the world, the dynamics of international projects are virtually identical to those we studied in the United States. In almost all cases—domestically and internationally—it is a combination of civic leaders, boards, executive directors, and philanthropists who are at the helm of major projects. As a result, the situational logic that unfolds during the project development process is the same no matter where the project takes place. Those who take part are motivated by similar incentives, be it to buttress their own careers or to increase their city's cultural status on the international stage. Additionally, the tools they have at their disposal are limited— unless of course someone comes up with something new, something that has not been done before. Yet, generally, the group's focus tends to be much more on the aesthetics and functionality of the building to be built, and very often with too little attention paid to the practical implications of the design or the rapidly escalating costs of change orders. The result is not only serious and chronic budget overruns, but (ironically) compromising the building's aesthetic impact and decreasing its functionality. Consequently, much of what we observed for cultural facility projects in the United States is directly

relevant to international projects. The only real difference is the mechanisms that make these projects possible (e.g., bond initiatives versus sales taxes versus lotteries). The outcomes appear to be very much the same.[15]

As we saw with the great economic recession in 2008, arts organizations will continue to feel the brunt of economic lows, particularly if in times of economic highs organizational leaders invest without considering the potential long-range consequences. The fallout of the latest cultural building boom is still playing itself out today with dozens of organizations that built new facilities struggling to make ends meet. This is a similar outcome to other times in history when we saw "booms" and "busts" occur. The U.S. economy slipped into recession in the early 1990s following a cultural building boom that took place in the middle of the twentieth century; this had devastating effects on many of the arts organizations that built. Both the Los Angeles County Museum of Art and the Detroit Institute of Art suffered as a result of a loss of public appropriations.[16]

While the recession of 2008 certainly exaggerated the harsh effects building and maintaining a major facility can have on an arts organization's finances, it also provided an opportunity to get a clear picture of how overinvestment in bricks and mortar can lead to fractured organizations and distress for the communities they inhabit—something that is also not new phenomenon among arts organizations. For example, with the building of the Philadelphia Museum of Art in the 1920s, "Squabbles and cost overruns at the construction site became the stuff of newspaper scandal. They reached a boiling point in the winter of 1923–24. The papers reported that the museum project, originally expected to cost $3.5 million, would now cost over $13 million."[17]

During the modern building boom as well, we saw instances in which decisions were made to increase project budgets and add unnecessary design elements based on loose arguments of the potential for buildings to generate future demand. When the forecast for a spike in demand did not materialize, either the organization or its community was left to shoulder the burden.

Using the data we collected and the interviews we did with those who both conceived these projects and then guided them to completion, we were able to provide real accounts of a range of successful and unsuccessful projects. As a result, there is now a large body of research that can help guide project managers in their decisions about building cultural facilities. Not only do we illustrate cultural building in practice, we also emphasize important themes that can lead to more successful projects. Now there is no excuse for any cultural building project leader to fail to gain at least outside perspective about how to build a cultural facility.

Finally, while there have certainly been many difficult cultural building initiatives that have been pursued for reasons that might have seemed plausible at the time, but which turned out to be detrimental to the long term sustainability of their organizations, we also saw many arts organizations that succeeded in achieving their goals, and even going well beyond them. We highlighted some throughout this book, but there are also many others.

There are cities, and their leaders, and cultural organizations that skillfully guided their infrastructure projects in ways that ended up benefiting the organization and the community. Furthermore, there are project leaders that possess a thorough understanding of how a building project can contribute to an organization's financial strength or turn into a serious deficit. Using these people and organizations as guides and understanding the experiences others have gone through will help us build better art facilities that contribute to the overall sustainability of arts and culture organizations everywhere.

NOTES

1. Kahneman, Daniel. *Thinking Fast and Slow.* New York: Farrar, Straus and Giroux, 2011.
2. Neal J. Roese and Kathleen D. Vohs identify 818 scholarly articles that study hindsight bias and define the phenomenon occurring "when people feel that they 'knew it all along'" or "when [people] believe that an event is more predictable after it becomes known than it was before became unknown." See Roese and Vohs's 2012 article, "Hindsight Bias" in *Perspectives on Psychological Science* 7(5).
3. Daniel L. Schacter proposes and defines consistency bias in his 2001 book, *The Seven Sins of Memory: How the Mind Forgets and Remembers.* Boston: Houghton Mifflin.
4. Kania, John, and Kramer, Mark. "Collective Impact." *Stanford Social Innovation Review,* Winter 2011.
5. Mullen, William. "Art Institute of Chicago Raises Admission 50 Percent." *Chicago Tribune.* March 12, 2009.
6. Kolendo, A., and Frumkin, P. *Case Study: Can Roanoke, Virginia, Become the Next Bilbao?* Cultural Policy Center, University of Chicago, 2012.
7. Watts, Duncan. *Everything Is Obvious—Once You Know the Answer: How Common Sense Fails Us.* New York: Crown Business, 2011.
8. Ibid.
9. National Endowment for the Arts. *2008 Survey of Public Participation in the Arts.* Washington, D.C., 2009.
10. *Giving USA 2013: The Annual Report on Philanthropy for the Year 2012 Data Tables.* Chicago: Given USA Foundation, 2013.
11. National Endowment for the Arts website. "National Endowment for the Arts Appropriation History." http://arts.gov/open-government/national-endowment-arts-appropriations-history.
12. National Assembly of State Arts Agencies website. "State Arts Agency Legislative Appropriations Preview Fiscal Year 2014." www.nasaa-arts.org/Research/Funding/State-Budget-Center/FY2014-Leg-Approp-Preview.pdf.
13. Cotter, Holland. "A Building Boom as Chinese Art Rises in Stature." *The New York Times.* March 20, 2013.
14. Shadid, Anthony. "An Ambitious Arab Capital Reaffirms Its Grand Cultural Vision." *The New York Times.* January 24, 2012.
15. We thank Adrian Ellis (AEA Consulting), a consultant on international cultural investments, for sharing his perspective on how our conclusions relate to his observations of projects outside of the United States.
16. Conn, S. *Museums and American Intellectual Life, 1876–1926.* Chicago: University of Chicago Press, 1998.
17. Ibid.

Appendix

Our methodology for studying cultural building was composed of four parts in order to answer each one of our research questions. First, we wanted to know, "What was the extent of building that took place in the cultural sector?" The second question we wanted to answer was, "What are the economic and demographic determinants of building cultural facilities?" And third, "How are building decisions made?" Each phase of the study was designed with these three questions in mind.

To answer our first question—"What was the extent of building that took place in the cultural sector?"—we assembled and analyzed a census and taxonomy of building projects that were started between 1994 and 2008. The data for this phase of the study mainly took the form of building permit data on all cultural construction projects (i.e., new construction, renovations, and additions) purchased from McGraw-Hill Construction, Inc. We purchased the data in 2008, and the data went as far back as 1994. These data were precategorized by type (i.e., museums, theaters, auditoriums), but to refine them we conducted our own cleaning, which mainly included eliminating unwanted observations (e.g., movie theaters), and we changed the label "auditoriums" to "performing arts centers." The final dataset includes a total of 846 observations in 191 MSAs, including 65 individual projects in non-MSAs. For each observation, the following variables are included: unique project ID, MSA, project title, project category, project address (street address, city, county, state, zip), project value, project square footage, owner, owner contact name, owner address (street address, city, state, zip), owner phone, owner fax, architect, architect contact, architect address (street address, city, state, zip), architect phone, architect fax, construction start date (year, month). Square footage is the only variable that contains a high proportion of missing/inaccurate values. The range of project values was between $620,001 and $335,142,700 in 2005 dollars. For our analyses in this phase of the study, we only included projects over $4 million in 2005 dollars.

Next we coupled the building permit data (projects both less than or equal to and greater than $4 million) with a series of economic and demographic variables for each MSA a construction project was located in and

conducted a multivariate analysis of these data in order to understand "What are the economic and demographic determinants of building cultural facilities?" This dataset consists of 287 MSAs and a variety economic and demographic variables listed in Table A.1 with accompanying sources.

County Business Patterns data on establishments in arts-related industries included those in Standard Industrial Classification (SIC) industry codes 7900 ("Amusement and Recreation Services") and 8400 ("Museums, Botanical, and Zoological Gardens") between 1993 and 1997 and North American Industrial Classification System (NAICS) industry code 71 ("Arts, Entertainment and Recreation") between 1998 and 2008. Decennial Census and American Community Survey data on workers in arts-related occupations included musicians and composers (186); actors and directors (187); painters, sculptors, craft-artists, and artist printmakers (188); dancers (193); artists, performers, and related workers n.e.c. (194); and artists and related workers (260) in 1990, and actors (270); producers and directors (271); dancers and choreographers (274);

Table A.1 Variables and Data Sources

Variable	Data Source
Number of establishments in arts-related industries	U.S. Census Bureau, County Business Patterns (CBP) (1993–2008)
Number of employees in establishments in arts-related industries	U.S. Census Bureau, CBP (1993–2008)
Number of workers in selected arts-related occupations	U.S. Census Bureau, Decennial Census (1990, 2000); U.S. Census Bureau, American Community Survey (ACS) (2001–2008)
Number of arts organizations in selected National Taxonomy of Exempt Entities (NTEE) codes	Urban Institute, National Center for Charitable Statistics (NCCS)
Total net income of all arts organizations in selected NTEE codes	Urban Institute, NCCS
Population	U.S. Census Bureau, Population Division (1993–2008)
Proportion of population with at least a bachelor's degree	U.S. Census Bureau, Decennial Census (1990, 2000); U.S. Census Bureau, ACS (2001–2008)
Median household income	U.S. Census Bureau, Decennial Census (1990, 2000); U.S. Census Bureau, ACS (2001–2008)
Proportion of population between 21 and 35 years of age	U.S. Census Bureau, Decennial Census (1990, 2000); U.S. Census Bureau, ACS (2001–2008)
Interest rate (state and local bonds)	Federal Reserve

musicians, singers, and related workers (275); entertainers and performers, sports and related workers, all other (276); and artists and related workers (260) between 2000 and 2008. National Center for Charitable Statistics data on arts organizations included those in National Taxonomy of Exempt Entities codes A40 (Visual Arts), A51 (Art Museums), A54 (History Museums), A60 (Performing Arts), A61 (Performing Arts Centers), A62 (Dance), A63 (Ballet), A65 (Theater), A68 (Music), A69 (Symphony Orchestras), and A6A (Opera).

The method of analyzing these data in order to understand the determinants of cultural facility building in MSA involved using a two-part model to estimate relationships between investment in cultural building at the MSA level and the listed economic and demographic variables. This method, and its results, are clearly documented in Woronkowicz (2013).[1]

The third and fourth phase of the study helped us understand exactly, "How are building decisions made?" First, from the census of all building projects (i.e., the building permit data), we sampled 56 organizations that started building projects between 1998 and 2007. We wanted projects to be recent enough that project representatives could still remember and speak to the process of planning and building, but also far enough removed that we could observe operations following completion of the project. In order to draw conclusions about the population of building projects, we needed the sample to be representative of the population launched during this window, and thus we employed a stratified probability sampling method. The process of picking a random sample of 56 focal projects for in-depth analysis was done in several steps. First, we cleaned the data in order to filter out types of projects that did not fit the study criteria. Next, we stratified the projects based on a number of criteria, including the size of the MSA, the cost of the project, the number of projects in each MSA, and the type of project.

All in all, the sample distribution compares quite well with the distribution of projects in the population. The biggest differences lie in the percentage of small MSAs that had only one project (17.9% in the sample versus 43.1% in the population) and the percentage of large MSAs that had five or more projects (37.5% in the sample versus 11.6% in the

Table A.2 Stratification Design

Stratum	Criteria
Size of MSA	Small MSA: Population under 2 million
	Large MSA: Population over 2 million
Cost of project	Small MSA: Projects valued over $10 million
	Large MSA: Projects valued over $25 million
Number of projects in MSA	Small MSA: 1, 2, 3, or more projects
	Large MSA: 1–2, 3–4, 5 or more projects
Type of project	Museums, theaters, performing arts centers

Table A.3 Sample and Population Comparison

Stratum Type	Sample Proportion of Projects	Population Proportion of Projects
Museums	33.9%	38.8%
Theaters	16.1%	11.0%
PACs	50.0%	50.2%
Size of MSA		
Small	58.9%	45.4%
Large	41.1%	47.3%
Cost of projects	Average	Average
Small MSA	$49,600,000	$28,050,000
Large MSA	$55,600,000	$71,223,330
Number of projects	Proportion of MSAs	Proportion of MSAs
Small 1 project	17.9%	43.1%
Small 2 projects	16.1%	20.4%
Small 3 projects	25%	23.2%
Large 1–2 projects	0%	0%
Large 3–4 projects	1.8%	1.7%
Large 5 or more projects	37.5%	11.6%

population). Also, the average cost of projects (over $10 million in small MSAs and $25 million in large MSAs) was higher in the sample for small MSAs and lower in the sample for large MSAs.

After we chose the sample, we conducted one-hour phone interviews with project representatives. Usually the representative was an executive director or board trustee of the project's organization, but if someone else (e.g., a donor or civic leader) had more detailed knowledge on the project process, we interviewed that person instead. In certain cases where one representative would have limited information on the project's process, we interviewed multiple people. These were structured interviews that covered the planning process, funding, and usability of building projects, as well as the governance structure and future plans of the organization.[2] Respondents also filled out an extensive worksheet that provided financial operating data and information about their governing boards. We also collected financial information from IRS 990 forms for the focal 56 projects for at least five years before and after the project opening date. Finally, we used LexisNexis and Google to get contemporary press reports regarding the planning and execution of the project and what had happened to the institution since the completion of the project. Table A.4 details the response rate from the survey we conducted of the managers of building projects.

Table A.4 Manager's Survey Response Rate

I = Complete Interviews	P = Partial Interviews	R = Refusal and Break-Off	NC = Non-Contact	0 = Other
52	4	13	1	20

Notes: The response rate of the survey was 62.2 percent.
The response rate was calculated by the formula (I + P)/(I + P) + (R + NC + O), which uses partial interviews as respondents. This is a response rate of 2 on the American Association of Public Opinion Research Response Rate calculator; R includes situations where contact was made, there was an agreement to participate, and a worksheet was in progress, as well as situations where contact was made and there was a final refusal; O includes situations where contact was made but there was no agreement, and situations where a case was replaced due to a lack of cooperation.

The fourth and final phase of the study involved site visits to 12 U.S. cities and 13 cultural facilities and interviews with 35 project and community representatives with knowledge of planning and building processes.

Our goals for conducting site visits and face-to-face interviews were twofold. First, we strived to visit a range of cities and facilities in terms of geographic location, population size, and project type. Second, our intention was to collect data that were not anonymized (such as the sample data were in the previous phase). The latter goal was pertinent to our intention to write a book that could be accessible to practitioners in arts and culture.

Table A.5 Cities and Facilities Visited

City	Cultural Facilities
Biloxi, MS	Ohr-O'Keefe Museum of Art
Mobile, AL	Mobile Museum of Art
Paducah, KY	Carson Center for the Performing Arts
Durham, NC	Durham Performing Arts Center
Greensboro, NC	Planning meeting for potential Greensboro Performing Arts Center
Miami, FL	Adrienne Arsht Center for the Performing Arts
Miami Beach, FL	New World Center
Las Vegas, NV	Smith Center for the Performing Arts
Philadelphia, PA	Kimmel Center for the Performing Arts/Bames Foundation
Kansas City, MO	Kauffman Center for the Performing Art/Nelson Atkins Museum of Art
Omaha, NE	Holland Performing Arts Center/Orpheum Theater
Davenport, IA	Figge Museum of Art

As a result of this study, we now have a vast range of data on cultural building. Some of these data, specifically the census data and data on the representative sample of projects we studied, are available by permission to researchers who wish to use them in future studies through the Data Enclave at NORC at the University of Chicago.

NOTES

1. Woronkowicz, Joanna. "The Determinants of Cultural Building: Identifying the Demographic and Economic Factors Associated with Cultural Facility Investment in U.S. Metropolitan Statistical Areas between 1994 and 2008." *Cultural Trends* 22 (2013): 192–202.
2. The study's materials, including a copy of the questionnaire, can be accessed via the study's website at the Cultural Policy Center at the University of Chicago (http://culturalpolicy.uchicago.edu/setinstone/).

Index

Printed in the United States
by Baker & Taylor Publisher Services